AFTER THE FALL

PETER LANG
New York • Washington, D.C./Baltimore • Bern
Frankfurt am Main • Berlin • Brussels • Vienna • Oxford

NOEMI MARIN

AFTER THE FALL

RHETORIC IN THE
AFTERMATH OF DISSENT IN
POST-COMMUNIST TIMES

PETER LANG
New York • Washington, D.C./Baltimore • Bern
Frankfurt am Main • Berlin • Brussels • Vienna • Oxford

Library of Congress Cataloging-in-Publication Data

Marin, Noemi.
After the fall: rhetoric in the aftermath
of dissent in post-communist times / Noemi Marin.
p. cm.
Includes bibliographical references and index.
1. Rhetoric—Europe, Eastern. 2. Dissenters—Europe, Eastern.
3. Post-communism—Europe, Eastern.
4. Europe, Eastern—Politics and government—1989–.
5. Europe, Eastern—Intellectual life—1989–. I. Title.
P301.3.E852M37 808'.00947—dc22 2007001950
ISBN 978-1-4331-0055-0

Bibliographic information published by **Die Deutsche Bibliothek**.
Die Deutsche Bibliothek lists this publication in the "Deutsche
Nationalbibliografie"; detailed bibliographic data is available
on the Internet at http://dnb.ddb.de/.

Cover design by Joni Holst

The paper in this book meets the guidelines for permanence and durability
of the Committee on Production Guidelines for Book Longevity
of the Council of Library Resources.

Printed in Germany

TO MY HUSBAND

JOHN

MY LOVE AND GRATITUDE

CONTENTS

ACKNOWLEDGMENTS

This book is the result of years of research on the notions of freedom and dissent in communist and post-communist discourse. Most of the analysis comes from my dissertation at the University of Maryland at College Park and special thanks are due to James F. Klumpp for his generous guidance and support. Many of the ideas in this book have been discussed and further developed during conferences and graduate seminars on post-communism at the University Maryland at College Park and at Florida Atlantic University.

I would like to express my gratitude to friends and colleagues whose relevant comments and suggestions have influenced my own perspective on the discourse of exile and dissent in societies in transition. Special thanks to Cezar Ornatowski, Robert N. Gaines, Vladimir Tismaneanu, and Slavenka Drakulić, for offering incalculable insight and support for this project. Grateful acknowledgement is due to Florida Atlantic University, Division of Research, for its generous publication grant.

Shorter versions of two of the chapters were published earlier in *East European Politics and Societies* and *Realms of Exile: Nomadism, Diaspora, and Eastern European Voices,* and the author wishes to express her thanks for their editors' useful suggestions.

I am, as always, grateful to my daughter, Oana, for her love and support throughout. Many thanks are due to Linda Allen and Irina Bazavan for their patience and friendship during an at times difficult process. Finally, I would like to thank my husband, John Malmrose, for his continuous commitment to this book in terms of editorial support, intellectual stimulation, and moral encouragement.

INTRODUCTION

Public Intellectuals and Eastern and Central European Discourse

Communism was and is still fought with words of freedom, liberty and emancipation. "Wars are fought for words. They are man's most deadly weapon," warned Arthur Koestler once.[1] In Eastern and Central Europe of 1989 words with history, as Havel reminds the world, gather in a discourse for social and political change, creating revolutions, chanting hope, freeing people as publics of democracy, transforming forever the countries once known to be behind an Iron Curtain.[2] With words of democracy, words of resistance and oppression populated the unofficial public realms of discourse, turning speakers of freedom from communism into exiled rhetors, voices isolated from the publics in communist times. In spite of communist propaganda, people fought constantly to reinforce democratic values, freedom, and human rights, within and beyond these countries' borders. Yet, due to communism's oppressive politics, some of civil society's most eloquent representatives chose exile and expatriation as their way to voice democratic beliefs from beyond the Iron Curtain.[3] Public intellectuals, dissidents, democratic speakers and voices of resistance all struggled with

legacies of communism, articulating discourse of moral stance and political truth, anti-politics and visions of civil society.[4]

By 1989 most of the communist regimes of Eastern and Central Europe fell, trading vocabularies of oppression for problematics of legitimacy and identity, for nationalist and antinationalist discourse, for a civil arena where words were and remain in transition. The rhetors of resistance, some still in exile, others continuing resistance to communist and post communist practices, found themselves glorified for a short time, soon to be dismissed or treated with suspicion within their countries or in the West alike. All of a sudden, most of the same speakers of dissent responsible for transforming the meanings of the word 'Europe' in 1989, were (again) dismissed or discredited, appearing "naive and out-of-touch with local sentiment," accused. As Tony Judt points out, "of being spokesmen for a cosmopolitan interest" antagonistic to the needs of their nations. [5] But even in decline, the critical stand of dissidents and exiled intellectuals continued to proclaim efforts to bring civil society and anticommunist critiques within the public arenas of Eastern and Central Europe.

Within their approach of resistance against communist practices and nationalist venues for discourse, speakers of dissent from most countries in Eastern and Central Europe found themselves confronting also ontological and rhetorical questions of identity and public voice. Exiles and dissidents had to face delegitimized identities as public voices of democracy, cultural and reflexive conflicts of rhetorical existence in the opened discourse of their countries freed from communism. After 1989, these public voices bore a double burden in their discourse. For, as they spoke to the necessity of democratic values and civil society, in doing so, they communicated from their condition of expatriation and resistance.

Exile from communist Eastern and Central Europe has a long cultural history, as Solzhenitsyn, Kundera, Milosz, Cioran and Eliade are among those who, while pursuing literary careers in new lands, continued to speak and write as "exiles" from their home countries.[6] Their accounts tell us that expatriation, being both their stigma and their redemption, marks them forever and exile, their "condition," remains a constant in their disrupted discourse.[7] Joseph Brodsky, in his appeal to other exiled writers, defines the problem of exile as a linguistic confluence of discourse, questions of identity, and legitimacy of voice, a rhetorical "pendulum" oscillating between moments of "expulsion" into the "capsule" of one's native language, and "the necessity of telling about oppression."[8] Similarly, Kristeva captures the

antinomic existence of dissidents in language: "if meaning exists in the state of exile, it nevertheless finds no incarnation, and is ceaselessly produced and destroyed in geographical or discursive transformations."[9] Codrescu, expatriated from Romania, considers his exilic experience a "countertext" to the mainstream conversations of the world.[10] Thus, living with what Baranczak calls "tongue-tied eloquence," Eastern and Central European intellectuals in exile struggled to redefine their identity and participation in new social contexts at the borders between their native and host languages.[11]

Significantly, once outside the political oppression of communism, these dissidents sought to voice their presence in the public arena, bringing their appeals for democratic values to transnational audiences.[12] As writers of exile and dissent from communism, Brodsky reveals the authors' urgent need to act through language and speak out against communism.[13] Believing in the power of words to bring democratic change into her country, Drakulić struggles to settle in her dissident life outside a newly independent Croatia, as she points out that words are the exile's only weapon against the horrors of the Balkan war.[14] Within their exile and resistance, these critical voices' articulate their identity as a locus for rhetorical invention. For how can they otherwise reiterate complex political, social, and cultural functions of dissidence under communist regimes, if not by creating clusters of vocabularies contingent to their ethos?

Exile, then, becomes a significant rhetorical site for multiple investigations of public discourse. Why do such expatriates, while continuing to contribute to their literary or journalistic fields, come back to exile as a recurrent rhetorical weave of multiple identities and public participation? Can exile become a redemptive rhetorical locus for their new voices in the public arena? Can the discursive construction of public intellectuals who revisit exile redefine their identity as Eastern and Central European intellectuals of resistance? And how, in response to living in dissidence and exile, do public voices of dissent from Eastern and Central Europe recapture their rhetorical voices?

Exploring in particular the reconstruction of identity in a liminal space between democratic and anti-democratic contexts post 1989, the book proposes an examination of Konrád, Codrescu and Drakulić' discursive construction of identity as articulations of a rhetoric of exile and resistance in a post-communist world.

Exilic and dissident discourse represents a complex rhetorical nexus where speakers appeal to audiences' experiences and to their very own while

invoking discontinuous and complex dissidence into the rhetorical voice. Rhetorically, these critical rhetors have lost their power. Limited or prohibited to participate within the cultural and political discourse of their countries of origin, exiled and dissident intellectuals from Eastern and Central Europe become rhetors without public voice, rhetorical actors with no words in the public sphere, silenced. And yet...

Dissidents and exiles can be viewed as some of the main contributors to the re-creation of a democratic public sphere during and immediately after the fall of communism. As Vladimir Tismaneanu identifies them, when providing some of these dissidents' rhetorical work for Eastern and Central European civil society:

> Civil society can thus be defined as the ensemble of grassroots, spontaneous, nongovernmental (although not necessarily antigovernmental) initiatives from below that emerge in the post-totalitarian order as a result of a loosening of state controls and the decline as the ideological constraints imposed by the ruling parties. KOR or more recently, the 'Orange Alternative' semi-anarchist group in Poland; Charter 77 in Czechoslovakia; various forms of dissident activities in the Soviet Union; the 'Peace and Human Rights Initiative' in the GDR; and all the independent peace and human rights activities, including the underground presses, samizdat publications, and the flying universities as they existed especially in Hungary and Czechoslovakia in the 1980s, can be considered components of the growing civil society.[15]

Looking at how critical intellectuals from Central and Eastern Europe reconstitute their cultural and rhetorical identity, the book argues that in this process, such writers re-legitimate their rhetorical participation in the public sphere.

Dissidents also shape their works on expatriation as personal narratives and literary or cultural commentaries on host and native countries. George Konrád, among the most influential Hungarian writers,[16] adds to his successful writing career passionate commentaries on the status quo of communist Hungary and on existence at the margins of democracy.[17]

A "critical intellectual," creator of the famous and infamous essay "Antipolitics" and a political and cultural troublemaker, "sticking to anachronistic ideas of individual freedom," Konrád represents what Vladislav calls an "interior exile."[18] Never allowed to leave the country under the communist regime, Konrád found expression in underground writing,

aware that his voice was silenced in the official arena, and thus, for large audiences.[19]

In spite of all the political restrictions, Konrád was declared a literary talent throughout those years.[20] In addition to his literary production, like Vacláv Havel in Czechoslovakia and like Adam Michnik in Poland, Konrád contributes to *samizdat* literature by becoming a spokesman for antipolitical and democratic views on civil societies throughout Europe.[21]

After the fall of communism, Konrád publishes *The Melancholy of Rebirth: Essays from Post-Communist Central Europe, 1989-1994,* revisiting his exilic existence to reinforce his views on democracy and political change in Hungary.[22] Writing from the margins of discourse, and emphasizing the civic responsibilities necessary for the ethical, professional, and cultural profile of the public intellectual, Konrád redefines himself as a rhetorical voice both in a communist context and in a post-communist, still problematic world in and of transition.

Andrei Codrescu is one other scholar who revisits, rhetorically, his exile from Romania.[23] Despite all the linguistic, cultural, and social difficulties, he succeeds to acculturate as a voice of the counter-elite in his "new" country, the United States. Acknowledged for his contributions to contemporary poetry and literature as well as for his cultural perspective on the role of consumerism in a democracy, Codrescu's participation in the international arena is well known and respected.[24] And yet, his writings on exile add another important dimension to his rhetorical and literary voice, the voice of *the Other,* caught between geographical or metaphorical borders of existence.

Andrei Codrescu left Romania as a young poet. Fortunate to work with a famous group of literati in the United States during the 1960s, Codrescu is a prolific writer, a professor of literature at Louisiana State University in Baton Rouge, and a familiar voice on the National Public Radio show "All Things Considered." Editor of (the late) *Exquisite Corpse: A Journal of Books and Ideas,* and a poet of cultural dissent, Codrescu has had an accomplished international career, with no need to revisit his life as an expatriate from Eastern Europe. And yet, after the fall of communism, as he traveled back to Romania, Codrescu again engaged his exilic experience. Seeing his native country in the aftermath of the 1989 revolution, the poet and writer on cultural resistance reflected on the locative and temporal powers of cultural uprooting in discourse. Written immediately after this journey, *The Disappearance of the Outside: A Manifesto for Escape* (1990), and *The Hole*

in the Flag: A Romanian Exile's Story of Return and Revolution (1991) chronicle his re-visitation of exilic identity through and in discourse.[25] Providing detailed accounts during and after the 1989 revolutions in Eastern Europe, Codrescu offers extensive commentaries on the social, political, and cultural texture of communist countries like his native Romania along with his own reconstruction of poetic voice as an expatriate. Codrescu's story of cultural fragmentation adds dimensions of existence "in-between" cultures, time, and locations, weaving identity in disparate cultural experiences into his discourse.

Slavenka Drakulić reveals similar experiences of dissent, but from a post-communist perspective.[26] For, although 1989 marked the "end" of the communist era, for some of the Balkans' critical intellectuals, exile remains a political, cultural, and ethnic reality. A Croatian writer and journalist, located between the clashing cultures of Eastern and Western Europe, Drakulić can be seen, to this day, as a critical voice of exile. Nationalist movements have forever taken away her Yugoslav identity; her opposition to the Croatian government makes her *persona non grata*; the war makes her a refugee; and the authoritarian public sphere of her new country makes her a critical intellectual with no platform. And yet, Drakulić refuses to settle into any single voice of exile in her rhetorical action.

Exilic voices as the three ones representing the focus of this volume are multiple, significant, in consonance with each of the public spheres of every single country under communism in Eastern and Central Europe. One of the most famous exiles from Yugoslavia during the communist times is Danilo Kiš, who, according to Susan Sontag, "did not consider himself to be in exile, any more than he would have said he was a 'dissident writer': it was too clear to him that writing worthy of the name of literature had to be unofficial"(x).[27] Kiš, in his own account on exile and nationalism offers a specific Yugoslav dissident's perspective, feeling caught "between two kinds of reductionism: ideological and nationalistic."[28] As for post-communist era, dissident intellectuals, like Drakulić or Dubravka Ugrešic, add to the range of exilic voices in contemporary Balkans. Like them, Vidosav Stevanovic and Predrag Matvejevic are leading writers from former Yugoslavia whose self-imposed exile reflects political and cultural responses to the chaotic and oppressive situation in the Balkans

From a rhetorical perspective, Slavenka Drakulić offers a significant instantiation of dissidence in post-communist former Yugoslav Croatia. In *The Balkan Express* and *Café Europa*, Drakulić addresses her expatriation

from a position of denial.[29] With the world around her in political and cultural chaos, the only coherent location for her rhetorical identity was in the margins.[30] A critical intellectual in dissent, Drakulić questions her identity throughout her essays, seeking to recreate "normalcy" in her life as an Eastern European.

Along with her coverage of nationalist political activities in the area, Drakulić's discourse advances a conflicted rhetorical relationship between her imposed exile from Croatia and her insistence to remaining "in-between" cultural and political borders.[31] Her commentaries on Eastern and Central European societies carry the unsettled voice of expatriation. Drakulić's work offers a rich narrative of a post-communist and communist area, where issues of political power remain essential to public intellectuals' redefinition of identity.[32]

In order to articulate a discourse of resistance, such intellectuals merge personal experiences of life in the margins of different cultures and recuperate identity in relation to a place called "home," reiterating within their liminality public and moral responsibilities of civil society after the demise of communism.

Rhetorically, the discursive construction of public intellectuals as identities of exile emerges in and as the liminal space between democratic and anti-democratic cultural forces of discourse. Concurring histories, famous and infamous use of their words within contextualized languages of democracy or nationalism, conflicts of cultures and political powers, all coexist as loci of resistance. Rosteck in his collection *At the Intersection* advocates that culture and rhetoric interrelate continuously creating productive approaches to critical investigations of public discourse.[33] This volume presents Eastern and Central European writers of resistance as public voices at the intersection of culture and rhetoric, a transformative place within the global discourse of democracy.

Notes

[1] Arthur Koestler, "The Urge to Self-Destruction," in *The Heel of Achilles: Essays 1968-1973* (New York: Random House, 1974): 14.

[2] Vaclav Havel, "Words on Words," *Writings on the East: Selected Essays on Eastern Europe from the New York Review of Books* (New York: The New Work Review of Books, 1990): 7-20. To note that the same work with the same translation appears in a different collection with the title "A Word About Words," see Vaclav Havel, *Open Letters: Selected Writings 1965-1999* (New York: Vintage, 1992).

[3] Vladimir Tismaneanu, *Reinventing Politics: Eastern Europe from Stalin to Havel* (New York: Free Press 1992).

[4] Tismaneanu, in several of his writings, follows the changing of terminology in reference to "public intellectuals" in Eastern and Central Europe. Moving from "public," to "critical," to "democratic" dissidents like Havel, Michnick, and Konrád continue to be remain part of the same group. See Tismaneanu, Vladimir."Fighting for the Public Sphere: Democratic Intellectuals under Postcommunism," *Between Past and Future: The Revolutions of 1989 and Their Aftermath*. Eds. Sorin Antohi and Vladimir Tismaneanu. Budapest: Central European UP, 2000: 153-75.

[5] Tony Judt, "Nineteen Eighty-Nine: The End of Which European Era?" *Daedalus*, 123.3 (Summer 1994): 4.

[6] Some of these dissident intellectuals' works that deal specifically with exile and anticommunist ideas, such as: Aleksandr I. Solzhenitsyn, *The Gulag Archipelago, 1918-1956: An Experiment in Literary Investigation*, trans. Thomas R. Whitney (New York: Harper and Row, 1974); Milan Kundera, *Milan Kundera and The Art of Fiction: Critical Essays*, ed. Aaron Aji (New York: Garland, 1992); Czeslaw Milosz, *The Captive Mind*, trans. Jane Zielonko (New York: Vintage, 1981); Emile M. Cioran, *Temptation to Exist*, trans. Richard Howard (Chicago: Quadrangle, 1970); and Mircea Eliade, *1937-1960, Exile's Odyssey*, trans. Mac Linscott Ricketts (Chicago: U of Chicago P, 1988).

[7] Joseph Brodsky calls "exile" a condition. See Joseph Brodsky, "The Condition We Call Exile," *Altogether Elsewhere: Writers on Exile*, ed. Marc Robinson (San Diego: Harcourt Brace, 1994) 3-12.

[8] Brodsky, "The Condition" 9-11.

[9] Julia Kristeva, "A New Type of Intellectual: The Dissident," *The Kristeva Reader*, ed. Toril Moi (New York: Columbia UP, 1986) 298. In a more general sense, Said maps similar territories of exile, writing that: "exiled poets and writers lend dignity to a condition legislated to deny dignity--to deny an identity to people;"see Edward Said, "Reflections on Exile," *Altogether Elsewhere: Writers on Exile*, ed. Marc Robinson (San Diego: Harcourt Brace, 1994) 139.

[10] Andrei Codrescu, *The Disappearance of the Outside: A Manifesto for Escape* (Reading, MA: Addison-Wesley, 1990) 108.

[11] Stanislaw Baranczak, *Breathing under Water and Other East European Essays,* (Cambridge: Harvard UP, 1990) 238.

[12] In light of traditional perspective on the history of communist Central and Eastern Europe, I use interchangeably the terms "critical intellectuals," "public intellectuals,""democratic intellectuals," and "dissidents." Such usage emphasizes these critical voices' *political, social, and cultural function* of *dissidence* under communist regimes. Vladimir Tismaneanu has used all mentioned terminologies in his extensive studies on Eastern and Central European politics in the 1980s and 1990s. See Vladimir Tismaneanu, "Fighting for the Public Sphere: Democratic Intellectuals under Postcommunism," *Between Past and Future: The Revolutions of 1989 and Their Aftermath*, eds. Sorin Antohi and Vladimir Tismaneanu (Budapest: Central European UP, 2000) 153-75. In addition, see Katherine Verdery, "Intellectuals," *National Ideology Under Socialism: Identity and Cultural Politics in Ceaușescu's Romania* (Berkeley: U of California P, 1991) 15-19.

[13] Brodsky writes in "The Condition" that: "our [exiled writers] greater value and greater function lie in our being unwitting embodiments of the disheartening idea that a freed man is not a free man, that liberation is just the means of attaining freedom and is not synonymous with it"(11).

[14] Slavenka Drakulić states in the very beginning of *The Balkan Express*, one of the books analyzed in this study that, as the war became a reality, "the urge to write about it and nothing else grew stronger and stronger. I ended up writing a book because, in spite of everything, *I still believe in the power of words, in the necessity of communication* (my emphasis). This is the only thing I know I believe in now"(4). See Slavenka Drakulić, "Introduction: The Other Side of War," *The Balkan Express: Fragments From the Other Side of War* (New York: Harper, 1993) 4.

[15] Vladimir Tismaneanu, *Reinventing Politics: Eastern Europe from Stalin to Havel* (New York: Free Press 1992) 170-71

[16] Konrád was banned to publish his works during the communist regime in Hungary. Konrád's "successful" career as a writer is mainly due to the circulation of his literary and political essays in the samizdat literature. See Vladimir Tismaneanu, "A Glorious Resurrection," *Reinventing Politics: Eastern Europe from Stalin to Havel* (New York: The Free P, 1992) 146-48; and Ivan T. Berend, *Central and Eastern Europe, 1944-1993: Detour from the Periphery to the Periphery* (Cambridge UP, 1996): 254-301.

[17] Konrád's first name is, in Hungarian, György. In some of the collections comprising his writings, the author is quoted with this first name. For example, see György Konrád, "Antipolitics," 1984. *From Stalinism to Pluralism: A Documentary History of Eastern Europe Since 1945*, ed. Gale Stokes, 2nd ed. (New York: Oxford UP, 1996) 175-83.

[18] Vladislav, in agreement with other writers from Eastern and Central Europe, explains that "interior exile" is when "even in your own country, you can find you are in exile. You can be made into an exile, an alien, or a Jew by the opinion of other people"(27). See Ian Vladislav, "Exile, Responsibility, Destiny," *Literature in Exile*, ed. John Glad (Durham: Duke UP, 1990) 14-28.

[19] Konrád participates in the *samizdat* literature, the main political response to the official regimes in Eastern and Central Europe during communist times. Skilling acknowledges Konrád as a participant in this kind of political literature, explicating he is one of the writers "who dissented from established policies and attitudes sought alternative forms of communication," see Skilling, *Samizdat*, 20.

[20] Although famous as a *samizdat* writer pre-1989, and already published in the West, Konrád gets world recognition in 1993, when he is named the President of PEN Congress, one of the most significant literary nonpolitical organizations in the world. In addition, he has been awarded numerous literary prizes, a recent one being the Peace Prize of the German Book Trade. See "Prizes," *World Literature Today* 65 (1991): 782.

[21] Tismaneanu, *Reinventing* 151.

[22] See George Konrád, *The Melancholy of Rebirth: Essays from Post-Communist Central Europe, 1989-1994*, trans. Michael Henry Heim (San Diego: Harcourt Brace, 1995). Michael Heim, who translates the volume, writes that Konrád rejects in this collection "both the has-been state socialism developed by Communist regimes and the would-be state nationalism of certain successor regimes" as he continuously "reaffirms his faith in that used to be denigrated (by the communist regime) as 'bourgeois democracy'"(193). See Michael Henry Heim, "Translator's Afterword," *The Melancholy of Rebirth: Essays from Post-Communist Central Europe, 1989-1994* by George Konrád (San Diego: Harcourt Brace, 1995) 191-96.

[23] I refer mainly to his two books on exile dealing specifically with his expatriation from Romania. See Andrei Codrescu, *The Hole in the Flag: A Romanian Exile's Story of Return and Revolution* (New York: Avon, 1991); and *The Disappearance of the Outside: A Manifesto for Escape* (Reading, MA: Addison-Wesley, 1990).

[24] Aside from his own literary creations, Codrescu is well known as an editor of anthologies and of an independent avant-garde literary journal, *Exquisite Corpse*. See Andrei

Codrescu, "Literature at the End of the Century: An Editorial Perspective" *Literary Review* 33 (1990): 157-62. His prolific participation in the American public discourse is demonstrated by numerous books and essays published throughout his more than twenty-five years of literary career. While his essays after 1989 demonstrate Codrescu's continuous participation in the American public discourse, his four visits to Romania and his Romanian cultural "recall," as I name it, appear in large number in his latest collections. In *The Muse Is Always Half-Dressed in New Orleans and Other Essays*, Codrescu has an entire section (five essays) related to Romania and his exile. His later collection, *The Dog with the Chip in His Neck* also contains essays on Romania. Andrei Codrescu, *The Muse Is Always Half-Dressed in New Orleans and Other Essays* (New York: St. Martin's P, 1993) 85-127; and Andrei *Codrescu, The Dog with the Chip in His Neck: Essays from NPR and Elsewhere* (New York: St. Martin's P, 1996) 121-195.

[25] These two accounts will be used in the analysis to follow in Chapter Three: Andrei Codrescu, *The Disappearance of the Outside: A Manifesto for Escape* (Reading, MA: Addison-Wesley, 1990); and Andrei Codrescu, *The Hole in the Flag: A Romanian Exile's Story of Return and Revolution* (New York: Avon, 1991).

[26] Slavenka Drakulić, *How We Survived Communism And Even Laughed* (New York: Norton, 1991); Slavenka Drakulić, *The Balkan Express: Fragments from the Other Side of War* (New York: Harper Collins, 1993); and Slavenka Drakulić, *Café Europa: Life After Communism* (New York: Penguin, 1996). Texts from the last two books will be analyzed in detail in Chapter Four.

[27] Susan Sontag, "Introduction," *Homo Poeticus: Essays and Interviews*, by Danilo Kiš (New York: Farrar, Straus, Giroux, 1995) vii-xv.

[28] Danilo Kiš, *Homo Poeticus: Essays and Interviews* (New York: Farrar, Straus, Giroux, 1995) 113.

[29] These two collections will provide the main textual excerpts utilized for rhetorical analysis in Chapter Four: Slavenka Drakulić, *The Balkan Express: Fragments from the Other Side of War* (New York: Harper Collins, 1993); and Slavenka Drakulić, *Café Europa: Life After Communism* (New York: Penguin, 1996).

[30] Danilo Kiš, *Homo Poeticus: Essays and Interviews* (New York: Farrar, Straus, Giroux, 1995) 113. See Predrag Matvejevic and Vidosav Stevanovic, "Between Asylum and Exile," interview with Jasmina Sopova, *UNESCO Courier*, 50.4 (1997): 4-8.

[31] In terms of the question whether Croatia is a democracy after its independence establishes in 1992, Markovich provides an ambiguous answer, namely that: "constitutionally Croatia is a democracy but in practice this democracy is qualified. It is qualified, they [eight opposition members] claimed, because Tudjman[the President] is too strong, the government

controls the media, and the elections are not fair" (84). See Stephen C. Markovich, "Democracy in Croatia: Views From the Opposition," *East European Quarterly*, 32 (1998): 83-94.

[32] Throughout her writings in the 1990s, Drakulić has not changed her perspective on communist and neo-communist political situation in her country. In her exilic discourse, Drakulić repeatedly claims that in Croatia "communism is not gone. Briefly, the new political leaders [Franjo Tudjman] used democracy to establish their authoritarian system, much alike one-party system during communism." Slavenka Drakulić, e-mail to the author, 1 Feb. 1999.

[33] Thomas Rosteck, introduction, *At the Intersection: Cultural Studies and Rhetorical Studies*, ed. Thomas Rosteck (New York: Guilford P, 1999) 1-25.

CHAPTER I

Political Culture as Master Trope of the Revolutions of 1989

The discourse of Eastern and Central Europe around the revolutions of 1989 and especially at the end of the communist period offer extensive opportunities to investigate cultural, political, and social dimensions of existence in the margins in countries that currently carry former or different names on the map of a New Europe. Contrapuntal and controverted, communist and post-communist "debate over words" in Michnik's terms infuses competing arenas of legitimacy in public discourse. For, during the years of communist regimes in Eastern and Central Europe, most of these societies lost their language.[1] Histories, counter histories, narratives of nationalism and reiterations of nostalgic reconstructions of national identity, all collapsed in 1989 within political complex spheres of discourse.[2] With them, political controversies, cultural legitimation of people, territories, and actions collapsed in creating a most complex cultural, political, and social history of democratic discourse.

Relevant for the 1989 revolutions in Eastern and Central European "déluge" the strong relationship between culture and politics present democracy and legitimation of discourse as successes and failures of civic action, offering important questions on the role of public voice in

democratization of such complex political arenas. By 1989, cultural vocabularies burst into being within the public sphere of political discourse: new public languages, new elites, "agitation" of meanings for words and actions of political power.[3] As Ash explains in a lucid analysis of these revolutions, "[M]any things contribute to this inchoate discontent. Partly it is that, having known no other power holders than the Communists, people do not distinguish between what is common to all power holders and what was peculiar to Communist ones"(22).[4]

Readings of political contexts and competing arenas for public discourse and creation of publics call for a conceptualization of political culture as part of the Habermas' public sphere and the concept of democratic communication.[5] After the fall of the Berlin wall, Habermas[6] develops somewhat the concept, as public sphere is "characterized by at least two crosscuttting processes: the communicative generation of legitimate power on the one hand and the manipulative deployment of media power to procure mass loyalty, consumer demand, and 'compliance' with systematic imperatives on the other."[7] He immediately continues that: "a public sphere that functions politically requires more than the institutional guarantees of the constitutional state; it also needs the supportive spirit of *cultural traditions* and patterns of socialization, of the *political culture*, of a populace accustomed to freedom"(emphasis added).[8]

As political culture, the contexts of discourse become salient terms for any rhetorical investigation of the events of 1989 or for explorations of appeals for dissent within the political arena of communist and post-communism. Appropriating political realm to culture, I argue that *culture* becomes an enthymematic trope for efficacy in creating public appeals and recreating identities of democracy. I realize that singular definitions of "culture" will be ineffective for this book, as the discourse of exiles and dissident intellectuals from Eastern and Central Europe reveals multiple contexts of interaction and different readings of communist and post-communist culture. However, a basic definition of "culture" stemming from the intercultural research in communication might represent a productive operational assumption. Accordingly, *culture* involves a *holistic set of values, interrelationships, practices, and activities shared by a group of people, influencing their views on the world*.[9]

Looking at the creation and recreation of multiple public sphere(s) in Eastern and Central Europe, one realizes the historical and political lessons that culturally are pertinent to both successes and failures of democratization

in the transition from communist to post-communist discourse. As such, linked inevitably to politics, culture formulates normative and informative loci for political action and for discourse of social change. As forms of expression in civil societies, culture provides important yet unstable resources for civic advocacy. And in the form of public culture, more specifically as articulations of the public media in a free(d) world, culture might function under important yet precarious conditions of democratic polity. Hence, linked inherently with politics, cultural memory and history when accompanying the turmoil and change in the former communist countries, culture reveals itself as a master trope in articulating novel public discourse and ideas of democracy.

Providing ample exploration of rhetorical publics as an inherent part of the public sphere, as "interdependent members of society who hold different opinions about a mutual problem and who seek to influence its resolution through discourse," Hauser addresses also culture.[10] For him, culture provides the resources for creating and recreating political spheres as realities of post-communism:

> Cultural narratives were used for more than inspiration: they were a vernacular source of models for the type of society to which they wished to belong. . . These models for belonging were located in the very features that were sui generis to that society.qualitatively different from the controlling quiescence often induced by administrative narratives of nostalgia. These models were appropriated not as patterns to be reproduced but as a stock of resources with which to reframe political realities.[11]

Taking into account the political odyssey of Central and Eastern Europe as "an object lesson in the material process of discursive reconstruction of society" the contextualized praxis of cultural narratives of past and present history roots culture within the self-reflexive publics reconstructing their articulations of freedom.[12] Identified by Hauser as historicity where publics engage as self-reflexive social actors and reconstruct discursive space through narratives that legitimate political actions, culture becomes a concomitant social and political discourse where rhetors and rhetorics concur.

In the post-communist arena of heated debates over the political role of public or critical intellectuals as "citizen-scholars" or "clever lunatic(s)," speakers of narratives of democracy engage culture and mostly political culture as an actively recursive and reflexive resource of for their public

legitimation.[13] Hence, it is through political culture that rhetors of dissent and democracy can articulate their discourse, and with it, their identity.

As mentioned, the debates over political role of public or critical intellectuals[14] as "heroes and victims"[15] of the 1989 revolutions also engage identity of dissidents in discourse. More than a decade later, critical intellectuals are being "punished for having failed to take revenge on their former tormentors,"some ridiculed, some supported but most of them facing cultural and political issues of legitimacy and ethos in post-communist Europe.[16]

Does the public intellectuals' history as workers in the underground of discourse (pun intended) matter in the aftermath of 1989? Does exile and dissidence impact the political culture of new Europe?[17] Do speeches of freedom and political broadcasts from the Voice of America or Radio Free Europe or in samizdat literature assist reconstitution of democratic citizenry past revolutionary moments in history?[18]

Dismissed or debated, critical voices, exiles and dissident intellectuals from Eastern or Central Europe transgress mere questions of culture. Their public *identity* reflects and empowers their cultural narratives, legitimizing contexts for the discourse of the underground or *samizdat* within and outside these countries.[19] Along with culture, dissidents' power as legitimate voices of public discourse emerges within the liminal space between culture and politics, re-inscribing contexts of identity within the public sphere of post-communist Eastern and Central Europe.

Exile and Identity: Discourses of Otherness

Locating exilic discourse in liminality, expatriation, identity, and culture become confluent dimensions in the cultural creation of foreigners' public role in the world.[20] Exile as a public space of discourse from the margins instantiates struggles for legitimation and negotiation of cultural identity in diasporic contexts. Accordingly, the condition of isolation invokes continuous articulations of antinomic existence in sociopolitical borderlands.[21] Said defines the condition of exile, emphasizing in particular the existence in the Outside, in the "nomadic," as a "contrapuntal" *Other* to the dominant social culture.[22] Discussing precisely issues of identity in relation to social and political power, Said reveals like Brodsky, that exilic condition is "the state of never being fully adjusted."[23]

Exile and life in the margins of discourse becomes another salient trope to re-conceptualize the discourse of resistance for critical intellectuals living outside of the official public arena of post-communist new Europe. A rhetorical locus where cultural identity and diasporic context merge within a twofold process of recreating frames of reference, Hall explains that common historical experiences and shared cultural codes provide people with stable, unchanging and continuous frames of reference and meaning.[24] Adding a second dimension, he articulates that exilic identity offers expatriates the ability to transform themselves through processes of difference, engaging in an identity of 'becoming' as well as of 'being.'[25] For, Hall continues, exile "belongs to the future as much as to the past. It is not something which already exists, transcending place, time, history, an d culture. Cultural identities come from somewhere, have histories. But like everything which is historical, they undergo constant transformation. Far from being eternally fixed in some essentialized past, they are subject to the continuous 'play' of history, culture, and power."[26]

Hall describes the diaspora as having "a necessary heterogeneity and diversity," a "hybridity," and identifies its existence "through, not despite, difference."[27] In Hall's view, what exile contributes to the postcolonial *position* (Hall's emphasis) is precisely the representation of the "in-between," the marginal existence in relation to political power.[28]

Living within or outside borderlands, in multiple contexts of publics and cultural narratives of resistance, dissident intellectuals engage exile as public and cultural locus legitimizing their discourse for civil society.[29] For, in order to explicate the salience of exile and identity as rhetorical loci for resistance in the history of Eastern and Central European discourse, such advocates need to re-instantiate legitimacy within their construction of ethos.

Crafting an Ethos of Resistance

What does exile or dissidence from communist oppression represent from a *rhetorical* perspective and how, in response to life in political and cultural borderlands, do authors from Eastern and Central Europe recreate their rhetorical identity through discourse?

Communist or post-communist politics, Western and Eastern European societies, and journeys through cultures and languages offer writers like Konrád, Codrescu, and Drakulić opportunities to voice their life in the margins of discourse. Their rhetorical participation as civil intellectuals and

as social or cultural commentators on the history of democratic discourse in Eastern and Central Europe opens new paths for critical research in contemporary rhetorical studies.

Investigating identity of dissent primarily as a complex *locus* for public voice and reconstitution of legitimacy, this exploration reveals how rhetorical agents respond to specific contexts of expatriation.[30] Once in exile, the lives of dissidents change since their experiences across cultures transform their socio-cultural, political, and *rhetorical* voices. The dialectical or transformative forces of the exilic scene, in Burkean terms, offer rhetorical opportunities to explore distorted identities and negotiations of difference in distinct social contexts.[31] In their discourse, these elites invoke both past and present identities in order to motivate their participation in the public sphere. Thus, exile as a nexus of rhetorical forces presents a repository of rhetorical resources for dissident writers who attempt to recreate their public voices in relation to an audience.

Furthermore, this study brings an expanded view on how *cultural discourse* empowers the speaker's rhetorical action in relation to his/her audiences. Traversing cultural and political boundaries, expatriates and dissidents learn to live simultaneously in more than one culture. Between host and native cultures, between official and underground public arenas, critical intellectuals from Eastern and Central Europe adapt and adopt rhetorical strategies to regain their identity in the public sphere.

While numerous public intellectuals have addressed their exile in discourse throughout communist and even post-communist times, the selection of the three writers studied here, all well-known throughout Europe and in the United States, is intended to reveal the rhetorical impact of their strategic reconstruction of public voice in the post-1989 world. George Konrád, an internal exile, still lives in his native Hungary, the country that prohibited his freedom of expression as a writer throughout communist times; Andrei Codrescu is a poet in exile from Romania, whose life in the United States prompts him to reflect even more on the metaphoric powers of exilic life; and Slavenka Drakulić, a Croatian journalist whose recent expatriation challenges the political, neo-communist practices continuing under the Tudjman regime in Croatia.

Although these writers are by no means the only Eastern and Central European critical intellectuals, Konrád, Codrescu, and Drakulić posit complementary problems of identity, language, and political power. All three exilic authors address issues of their rhetorical reconstruction of identity in

relation to language, culture, and power. All are critical writers whose works transcend their (initial) literary field of research, and, aside from literary works, they all create democratic appeals calling for the participation of both host and native audiences. In other words, all three, in their rhetorical discourse, attempt to redefine themselves while creating social, political, and cultural appeals to various audiences in order to express their views on democracy in this part of Europe. Each, due to an individual history of exile, demonstrates complex and unique strategic redefinitions of voice in rhetorical action which will be analyzed in the chapters to follow. Looking at how authors like Konrád, Codrescu, and Drakulić negotiate interstitial relationships between exile and discourse in their writings bears, the book argues for transformative powers of dissidence as rhetorical strategies of public legitimation.

Exilic discourse, in a sense, represents a complex rhetorical nexus where speakers appeal to their own and their audiences' experiences in order to invoke the discontinuous, plural complexity of these experiences in the rhetorical act. Either limited in or barred from participation in the cultural and political discourse of their countries of origin, dissidents became rhetors without a public voice, rhetorical actors with no words in the public sphere, silenced. How then did Konrád, Codrescu, and Drakulić revisit past and present, places of memory or different countries in order to recapture their rhetorical identity and legitimacy in discourse? What is their rhetorical identity? And how does it transform their discourse?

Identity or *voice,* key terms I use interchangeably, constitutes a speaker's rhetorical power in discourse.[32] Inherent in using terms like *identity* or *voice* in this rhetorical analysis is that exile questions a rhetor's powers as a speaker. In a sense, the rhetorical relationship between identity and voice does not create equally interchangeable instances. Rather, due to my interest in revealing the strategies dissident and exilic rhetors utilize to recapture their rhetorical powers and voice(s) in discourse, the dimension of rhetorical identity invoked throughout the book comprises of *multiple* rhetorical loci of voice in response to exile.

Accordingly, identity or voice, in my view, becomes both a dynamic and an inherent dimension of the rhetor's reinvention of the self in response to exile. *Identity* for a rhetor in exile is both a revisitation of the traditional *ethos,* transforming itself, at the same time, into a *relational* construction of the speaker within the cultural, political, and social context of his or her exile.[33] Defining identity in rhetorical studies can be a difficult and debatable

task. While Aristotelian definition of *ethos* represents an inherent part of the cluster of identity and voice categorization, the artistic proof becomes a bridging rhetorical concept, enabling the rhetor to recapture his or her power within a context such as exile. Farrell's revisitation of rhetorical tradition adds practices of implication and invocation of practical wisdom and rhetorical places for discourse, in order to assess rhetoric as "more than the practice," rather 'the entire process of forming, expressing, and judging public thought in real life.[34]"

Enthymematic in public culture, ethos advances rhetors' identity and/or voice of the rhetor within the inventional realm of rhetorical practices. Dependent on authority (or resistant to it), the bridge concept of ethos engages dissident discourse within and between political culture of communist and post-communist arenas, mirroring constitutive loci of identity. The speaker-centered investigation proposed reinforces dissidents' rhetorical need to articulate the relationship between identity and public culture in order to create and recreate legitimacy for their role in the troubled and troublesome public sphere of post-communism.

Expatriation forces these critical intellectuals into a rhetorical crisis, into the silence of non-participation in Eastern and Central European public discourse. Their rhetorical *legitimacy* as speakers becomes a complex nexus for their search to reconstitute their identity in discourse. For example, in order to explore Konrád's appeals for public intellectuals, the significant rhetorical issue of his reinvention of voice is his negotiation of voice against political power. Legitimacy, however, implies a social, political, and cultural context within which voice exercises power. This requirement proposes a notion of rhetoric that *interpellates* the rhetor and his or her culture through discourse.[35]

According to Burke, symbolic action (language) constitutes the human reality by, through, and within which humans instantiate political, social, and cultural paradigms of discursive action.[36] Looking at the intricate relationships language constructs in a social context, *rhetorical legitimacy* involves primarily the cultural and political relationships that rhetor *interpellate* in order to recapture participation in the public arena. Implicating the traditional *ethos* along with the *cultural* and *political* context of their discourse, critical intellectuals like Konrád, Codrescu, and Drakulić bring to the fore the rhetorical relationships created by their identity in response to exile, political oppression, and culture.

Rhetorical interpretations of dissident strategies to recapture their powers through discourse, while facing the cultural complexities of exile are the focus here. Inherent in my analysis are cultural dimensions of exilic discourse where public space and fragmented textures of voice coexist in these intellectuals' rhetorical actions.

As mentioned, the book explores dissent and texts of resistance in order to reveal cultural, political and constitutive tensions of discourse. Three main assumptions inform this exploration. First, discourse infers *political culture* as a rhetorical context, and rhetorically constitutes the relations between authors and their audiences. Second, at stake in a rhetorical act is the authors' negotiated *identity* in personal, reflexive projections of their personae against one or plural cultures. Third, rhetors converge *evocative* powers of language in reconstituting their identity from multiple uprootings in culture.

For the critical task to unveil political culture as a cluster of rhetorical contexts, this study needs to go beyond the (traditional) rhetorical context looking for the rhetorical ways that culture creates the relationships shared by rhetors and their audiences. In this sense, culture becomes a dynamic rhetorical concept transforming speakers, audiences, and critics by revealing fragmentation of identity, previous experiences, and contexts of interaction within rhetorical texts.

Because of liminal existence within the realm of cultural, political, and public resistance, analyses of dissident rhetoric call for rhetorical interaction between rhetors and their personae shared with their audiences, implicating critical venues for strategic invention of *identity* in discourse.[37] Along similar lines of inquiry, Charland's constitutive rhetoric examines how groups constitute themselves through discourse.[38] But along with groups, *individuals* can and do constitute or reconstitute themselves in rhetorical texts.[39] As rhetors of dissent, such writers bring themselves and their cultural perspectives before an audience, while they redefine who *they* are in discourse. Their rhetorical endeavors interpellate reconstitution of identity in order to posit themselves within legitimate public discourse of resistance.

Furthermore, the book proposes that transformative rhetorical relationships between culture and identity need to focus on the rhetorical process of *evocation*. Central to this rhetorical endeavor is the reinvention of voice that rhetors invoke and evoke in their discourse, in that it transcends singular, limited definitions of their identity and creates plural ones (anew) for themselves and their audiences. When creating and recreating their identities, rhetors encourage an understanding of their personal experiences

in relation to their cultural contexts, and to audiences instantiating those cultures. Consequently, evocative powers of discourse recall multiple dimensions of exilic speakers within the text, within the context, and, along with other co-participants, in the rhetorical process in action. Thus, this study investigates rhetorical reinventions of voice in relation to place and time, to merging interactions between public and private personae, and to legitimating unsettled exilic existence in post-communist discourse.

Burke's dialectical relationship between identity and identification reveals its salience as a vantage point for exilic discourse.[40] For Burke, language *is* symbolic action, as language and action interact to define, reflect, and create human reality. Viewing rhetoric from a dramatist's approach, Burke looks at language (and rhetoric) as an intricate locus of dialectical relationships for social action. His perspective on identity and identification is useful in revealing the complex relationships that the discourse of exiles constructs with identity, cultural dimensions of space and time, and with the public sphere.[41] Burke points out how the identity of a rhetor intertwines with his or her appeals to create a consubstantial rhetorical action through language. Identification thus constitutes a dialectical process in which the speaker draws on shared interests to establish "rapport between himself [herself] and his [her] audience."[42]

For Burke, rhetoric, as he defines the art, is *"rooted in an essential function of language itself, a function that is wholly realistic and continually born anew; the use of language as symbolic means of inducing cooperation in beings that by nature respond to symbols."*[43] The simultaneous "identification-with and division-from" that occurs when speakers address an audience constitutes the dialectical relationship governing important aspects of rhetoric.[44] Burke explains that identity represents one's "uniqueness as an entity" and identification constitutes in rhetoric an "acting together; and in acting together, men have common sensations, concepts, images, ideas, attitudes that make them *consubstantial*," his dialectical relationship between identity and identification helps explain how dissident intellectuals confront rhetorical questions of identity and public voice.[45] Accordingly, dissident authors' consubstantial actions, evocative of their native cultures, interact in discourse with acculturation to their host and with problems of legitimation for transnational audiences.

As a vantage (rhetorical) point, Burke's relationship of identity and identification supports that political culture, identity, and legitimation bear inherent salience to these rhetors' position in discourse. Emphasizing the

impact of political culture within rhetorical relations between identity and identification in the public sphere, the investigation on Konrád's reconstruction of voice reveals how such elites renegotiate power and public voice rhetorically with themselves and with their audiences in a consubstantial rhetorical process. Utilizing the same overarching relationship between identity and identification, the exploration on Codrescu's exile and fragmentation of voice features the implication of time, place, and different cultures as convergent forces of discourse. As negation and negotiation of identity as resistance invoke alterations of the rhetorical construction of identity in discourse, Drakulić's refusal of exile re-inscribes the salience of dissent as a rhetorical condition of civil society.[46]

Since all three dissidents in Eastern and Central Europe highlight distinct and complementary dimensions of exile in their works, each discourse is analyzed separately, to create better understanding on rhetorical contribution of dissent to the meta-discourse of contemporary public sphere.

Chapter 2 examines how Konrád uses rhetorical strategies to merge public and private voice as a critical intellectual in different sociopolitical contexts of power. I argue that by locating reinvention of voice within the cultural arena of Central European communism and post-communism, Konrád legitimates his rhetorical personae, addressing at the same time issues of power in discourse.

Exploring Codrescu's discourse on exile in *Chapter 3,* I address his reconstruction of poetic and voluntary dissent within temporal and spatial dimensions of exilic worlds. His work on poetic exile revisiting past and present in both host and native lands prompts questions about the rhetorical relationships an author creates with historic and metaphoric contexts of expatriate discourse. In particular, this chapter explores Codrescu's rhetorical redefinition of voice against the cultural fragmentation of his existence along transnational borders. A poet of the counter-text, Codrescu relocates his exilic experiences within complex cultural dimensions of discourse.

Resisting the war and nationalism, being a Croatian and an Eastern European in a new authoritarian regime, Drakulić uses her denial of exilic existence as a powerful strategy of rhetorical legitimation. Choosing to refuse her expatriation, Drakulić redefines voice against place and time as cultural and political dimensions of her discourse. Accordingly, *Chapter 4* investigates the rhetorical relations that Drakulić's exilic identity creates in locative and temporal sites for legitimation of dissent.

A final chapter summarizes the complex relationships that exilic redefinition of voice brings to contemporary rhetorical studies. The chapter revisits discursive strategies in Konrád, Codrescu, and Drakulić' redefinition of rhetorical voice. Multiple identities, plural and discontinuous existence as well as the relationships between power and legitimation weave distinct interactions between culture and identity within the complex Eastern and Central European arena. By exploring discursive practices of dissent, this project invites novel and complex perspectives on empowering locus of rhetoric and its complex functions in the new democratic discourse of the new millennium.

Notes

[1] Adam Michnik, "What We Want to Do and What We Can Do." *Telos* 47 (1981): 67.

[2] In a monumental account, Courtois et al. write the *Black Book of Communism*. See Stéphane Courtois, Nicolas Werth, Jean-Louis Panné, Andrzej Packowski, Karel Bartošek, and Jean-Louis Margolin. *The Black Book of Communism: Crimes, Terror, Repression.* Trans. Jonathan Murphy and Mark Kramer, (Cambdrige, MA: Harvard UP, 1999).

[3] Referring in particular to Bakhtin's terminology of interrelation of meaning. See M. M. Bakhtin, *The Dialogic Imagination: Four Essays.* Trans. Caryl Emerson and Michael Holquist. Michael Holquist, ed. (Austin: U of Texas P, 1981): 345.

[4] Timothy Garton Ash, "Eastern Europe: Après Le Déluge, Nous." *Writings on the East: Selected Essays on Eastern Europe from the New York Review of Books.* (New York: The New Work Review of Books, 1990): 21-53.

[5] "Public sphere" is first described first in "societas civilis" in his early work (73). See Jurgen Habermas, *The Structural Transformation of the Public Sphere: An Inquiry into a Category of Bourgeois Society*, trans. Thomas Burger, 8th ed. (Cambridge: MIT P, 1996) 73-9.

[6] See Jurgen Habermas, "Further Reflections on the Public Sphere," trans. Thomas Burger, *Habermas and the Public Sphere* ed. Craig Calhoun (Cambridge: MIT P, 1996) 421-62.

[7] Habermas, "Further Reflections" 452.

[8] Habermas, "Further Reflections" 453.

[9] This definition is modeled after the conceptualized version provided by intercultural communication field. See Carley H. Dodd, *Dynamics of Intercultural Communication*, 5th ed. (Boston: McGraw-Hill, 1998) 36.

[10] Gerald A. Hauser, *Vernacular Voices: The Rhetoric of Publics and Public Spheres* .(Columbia, SC: U of South Carolina, 1999): 32.

[11] Hauser, *Vernacular* 157.

[12] Hauser, *Vernacular* 120.

[13] Vladimir Tismaneanu, "Fighting for the Public Sphere: Democratic Intellectuals under Post-communism," *Between Past and Future: The Revolutions of 1989 and Their Aftermath.* Eds. Sorin Antohi and Vladimir Tismaneanu,(Budapest: Central European UP, 2000): 153-75.

[14] See J. F. Brown, *Hopes and Shadows: Eastern Europe After Communism* (Durham: Duke P, 1994) and Vladimir Tismaneanu, *Fantasies of Salvation: Democracy, Nationalism, and Myth in Post-Communist Europe* (Princeton: Princeton UP, 1998). Although the post-communist body of works in political studies is extremely large, for this book I provide only the resources to be used further in the chapters.

[15] Tismaneanu, *Reinventing* 153.

[16] Tismaneanu, "Fighting for the Public Sphere," 166.There is an on-going debate on the role of intellectuals, exiles, and dissidents in Eastern and Central Europe. Tony Judt, Timothy Garton Ash, Vladimir Tismaneanu, Adam Michnik, George Konrád, and many others, have written, for almost a decade now, on this issue. A significant example of the redefinition of the role of critical intellectuals in Eastern and Central Europe is the entire Fall issue of *Partisan Review*, containing the proceedings of Rutgers Conference in 1992. See *Partisan Review*, 52.3 (1992). In addition, see *Writings on the East: Selected Essays on Eastern Europe from the New York Review of Books*. (New York: The New Work Review of Books, 1990).

[17] All the following studies reflect in one way or the other the political context and significance of exilic or dissident action in Eastern and Central Europe. See Stanislaw Baranczak, "Before the Thaw The Beginning of Dissent in Postwar Polish Literature (The Case of Adam Wazyk's 'A Poem for Adults')," *East European Politics and Societies* 3 (1989): 10-15; Miklós Haraszti, *The Velvet Prison: Artists Under State Socialism* (New York: Basic, 1987); Václav Havel, *Summer Mediations*. 1992. Trans. Paul Wilson, (New York: Vintage, 1993); Ferenc Feher and Agnes Heller, *Hungary 1956 Revisited: The Message of a Revolution--A Quarter of a Century After* (London: George Allen and Unwin, 1983); Gale

Stokes, ed., *From Stalinism to Pluralism: a Documentary History of Eastern Europe since 1945* (New York: Oxford UP, 1991); Michael Kennedy, "An Introduction to Eastern European Ideology and Identity in Transformation," *Envisioning Eastern Europe: Post-communist Cultural Studies.* ed., Michael D. Kennedy (Ann Arbor: U of Michigan P, 1994) 1-46; Tony Judt, "Nineteen Eighty-Nine: The End of Which European Era?" *Daedalus* 23.3 (1994): 1-19; George Kolankiewicz, "Elites in Search of a Political Formula," *Daedalus* 23.3 (1994): 143-157; Steven Lukes, "Principles of 1989: Reflections on Revolution,"*Revolutions in Eastern Europe and the U.S.S.R.: Promises vs. Practical Morality.* ed. Kenneth W. Thompson (Lanham: UP of America, The Miller Center Series, 1995) 149-165; Andrei Sakharov, "Our Understanding of Totalitarianism," *Towards a New Community: Culture and Politics in Post-Totalitarian Europe* eds. Peter J. S. Duncan and Martyn Rady (London: U of London, 1993); Vladimir Tismaneanu, *Reinventing Politics: Eastern Europe from Stalin to Havel* (New York: Free P, 1992); and Katherine Verdery, *National Identity Under Socialism: Identity and Cultural Politics in Ceauşescu's Romania* (Berkeley: U of California P, 1991).

[18] The particularities of communist oppression give exile a specific political meaning, somewhat distinct from already established definitions in the field. Shain, for example, offers a classification of exiles as "*refugees*, who will resettle; *expatriates*, abroad by choice; *exiles*, who cannot go home but will not resettle, and *emigres*, a subgroup of exiles" described as political exiles (15). However, the author does not specifically analyze the dissident movement as exilic in Eastern and Central Europe. See Yossi Shain, *The Frontier of Loyalty: Political Exiles in the Age of the Nation-State* (Middletown, CT: Wesleyan UP, 1989) 15.

[19] Gordon H. Skilling, *Samizdat and an Independent Society in Central and Eastern Europe* (Columbus: Ohio State UP, 1989).

[20] Since I am borrowing the "liminal" term from Victor Turner's work on social drama, I believe that the same discourse of expatriate intellectuals might offer a fruitful venue for a *performative* perspective on communication. See Victor Turner, "Liminal to Liminoid, in Play, Flow, Ritual: An Essay in Comparative Symbology" *From Ritual to Theatre: The Human Seriousness of Play* (New York: PAJ, 1982) 20-61.

[21] Edward W. Said, "Reflections on Exile," *Altogether Elsewhere: Writers on Exile* ed. Marc Robinson (San Diego: Harcourt Brace, 1994) 140-1; and Stuart Hall, "Cultural Identity and Diaspora," *Identity: Community, Culture, Difference,* ed., J. Rutherford (London: Lawrence & Wishart, 1990) 222-237.

[22] Said, "Reflections" 149. He writes along similar lines in another essay; see Edward Said, "Representing the Colonized," *Critical Inquiry* 15 (1989): 205-25. One of his most recent reflections on exile, a palimpsestic view on his cultural and political condition as Palestinian exile is comprised within Aciman's edited volume, *Letters in Transit.* See Edward W. Said, "No Reconciliation Allowed." Aciman, André, ed. *Letters of Transit: Reflections on Exile, Identity, Language, and Loss* (New York: The New Press, 1999): 87-115.

[23] Edward W. Said, "Intellectual Exile: Expatriates and Marginals," *Representations of the Intellectual: The 1993 Reith Lectures* (New York: Pantheon Books, 1994) 47. Brodsky makes similar claims to Said's problematic of exile, in terms of what constitutes the "condition" of exilic life. See Brodsky, "The Condition" 3-7. Sharing similar views, see also Zygmunt Bauman, "Intellectuals in the Postmodern World," *Life in Fragments: Essays in Postmodern Morality* (Oxford: Blackwell, 1995) 223-43.

[24] Hall, "Cultural Identity and Diaspora" 225.

[25] Hall, "Cultural Identity and Diaspora" 225.

[26] Hall, "Cultural Identity and Diaspora" 225.

[27] Hall, "Cultural Identity and Diaspora" 236.

[28] Ilie shares with Hall the concept of culture as crucial in exilic life. Ilie contends that emigres leave a culture that is well defined historically and geographically as they attempt to exist in a different world, going through a process of deculturalization. Deculturalization or loss of cultural identity in exile represents "a desensitizing process that makes reassimilation a difficult step for expatriates, . . . a falling away by residents from the original national whole," see Paul Ilie, *Literature and Inner Exile: Authoritarian Spain 1939-1975* (Baltimore: John Hopkins UP: 1980) 20. In addition, Thus, Said, Hall, Sarup, and Radhakrishnan, to name just a few among those academics examining postcolonial intellectuals in exile, offer extensive views on exilic identity as the Other in a social and political host or colonial culture. Madan Sarup, *Identity, Culture, and the Postmodern World*, ed., Tasneem Raja (Athens: U of Georgia P, 1996) 46-67; and R. Radhakrishnan, *Diasporic Mediations: Between Home and Location* (Minneapolis: U of Minnesota P, 1996) 155-85.

[29] Although a large number of scholarly inquiries in migration and diasporic identities are salient for cultural studies, they remain informative, not definitory for this book. See Kathleen M. Kirby, *Indifferent Boundaries: Spatial Concepts of Human Subjectivity* (New York: Guildford P, 1996); Stuart Hall, "Who Needs Identity?" 1996. *Questions of Cultural Identity*, eds., Stuart Hall and Paul Du Gay (London: Sage, 1997) 1-18; Zygmunt Bauman, "From Pilgrim to Tourist--or a Short History of Identity" 1996. *Questions of Cultural Identity*, eds., Stuart Hall and Paul Du Gay (London: Sage, 1997) 18-37; Mike Featherstone, "Travel, Migration and Images of Social Life," *Undoing Culture: Globalization, Postmodernism and Identity* (London: Sage, 1995) 126-158; P. I. Rose, "Thoughts about Refugees and Descendants of Theseus," *International Migration Review*, 15, (1981): 9-13; T. T. Minh-ha, "Not you/like you: Post-Colonial Women and The Interlocking Questions of Identity and Difference," ed., Gloria Anzaldua, *Making Face, Making Soul: Creative and Critical Perspectives by Women of Color*, (San Francisco: Aunt Luie Foundation Books. 1990) 371-75; Iain Chambers, *Migrancy, Culture, Identity* (London: Routledge, 1994); Homi Bhabba,

"The Other Question: Difference, Discrimination and the Discourse of Colonialism," *Out there: Marginalization and Contemporary Cultures* eds., R. Ferguson et al., (Cambridge: MIT P, 1992) 71-87.

[30] Stuart Hall explains in an interview the significance of space as an exilic site for voice, stating that it took him "fifty years to come home"(489). The context of exile, then, becomes the space where diasporic experience takes place in between discursive meanings of "home." For, like Hall, exiled writers voice their existence as "far away to experience the sense of exile and loss, close enough to understand the enigma of an always-postponed 'arrival'"(490). See Stuart Hall, "The Formation of A Diasporic Intellectual: An Interview with Stuart Hall by Kuan-Hsing Chen," *Stuart Hall: Critical Dialogues in Cultural Studies*, eds. David Morley and Kuan-Hsing Chen (London: Routledge, 1996) 484-504.

[31] When analyzing the pentad, Burke explains the rhetorical and philosophical significance of "scene." See Kenneth Burke, *A Grammar of Motives* (1945; Berkeley: U of California P, 1969) 3-21.

[32] My usage of the term entails Burke's concept of identity as one's "individual locus of motives" which he presents briefly in *A Rhetoric of Motives* (21). While Burke does define briefly "identity" he posits in mainly in relation to identification and therefore, addresses the concept in relation to an audience, rather than in relation to the speaker. Aware of this rhetorical treatment, Burke announces a further development of "identity" in *Symbolic of Motives* which he does not finish. Consequently, I consider Burke's "identity" incomplete, and therefore, partially useful. See Kenneth Burke, *A Rhetoric of Motives* (1950; Berkeley: U of California P, 1969) 20-23.

[33] Aristotle, *The Art of Rhetoric*, trans. J. H. Freese, Loeb Classical Library Ser. 193 (1926; Cambridge: Harvard UP, 1961)1.1.1356a9-10.

[34] Thomas Farrell, "Practicing the Arts of Rhetoric: Tradition and Invention" *Philosophy and Rhetoric* 24(1991): 183-212. Rpt. in *Contemporary Rhetorical Theory: A Reader*. Eds, John Louis Lucaites, Celeste Michelle Condit, and Sally Caudill (New York: Guilford, 1999): 79-101.

[35] Although the dictionary definition of "to interpellate" offers an explanation I consider inapplicable here, the meaning I use consistently for this term stems from Charland's usage of "interpellation" in his rhetorical perspective. Charland, borrowing the term from Althusser, defines "interpellation" as an active term, as follows: *Interpellation occurs at the very moment one enters into a rhetorical situation, that is, as soon as an individual recognizes and acknowledges being addressed. An interpellated subject participates in the discourse that addresses him. . . . Note, however, that interpellation does not occur through persuasion in the usual sense, for the very act of addressing is rhetorical.* (140*)* Charland's usage of the term in its active function permits my usage of "to interpellate" accordingly. See Maurice Charland,

"Constitutive Rhetoric: The Case of the *Peuple Québécois,"Quarterly Journal of Speech,* 73 (1987): 133-50.

[36] Burke's entire work is written under the assumption of "language as symbolic action," which he articulates overtly in *The Philosophy of Literary Form* and in *Language as Symbolic Action.* See Kenneth Burke, *The Philosophy of Literary Form: Studies in Symbolic Action* (Baton Rouge: Louisiana State UP, 1941) 1-138; and Kenneth Burke, *Language as Symbolic Action: Essays on Life, Literature, and Method* (1966; Berkeley, U of California P, 1968) 3-44. In addition, see Michel Foucault, *The Archeology of Knowledge and The Discourse on Language,* trans. A.M. Sheridan Smith (New York: Pantheon, 1972) 215-37.

[37] As Edwin Black explains in his study, the speaker in modern discourse is more of an "author implied by the work," rather than a real person (111). However, for this study I consider that both persona and person merge, the author remaining implicated and "implied" as a person(a) "that figures importantly in rhetorical transactions" (111). Edwin Black, "The Second Persona," *Quarterly Journal of Speech* 56 (1970): 109-119.

[38] Charland, "Constitutive Rhetoric" 133-50.

[39] Burke explains the concept of "identity" as one's "individual locus of motives" (21). It is in this sense that I consider rhetor's identity as a personal cluster of motives for rhetorical action. See Kenneth Burke, *A Rhetoric of Motives* (1950; Berkeley: U of California P, 1969) 21.

[40] Burke, *Rhetoric* 19-29, 43-46.

[41] Burke, *Rhetoric* 21-46.

[42] Burke, *Rhetoric* 46.

[43] Burke, *Rhetoric* 43.

[44] Burke, *Rhetoric* 46.

[45] Burke, *Rhetoric* 21.

[46] Hence, in accordance with my personal take on rhetoric, and aside from the above mentioned Burkean relationship between identity and identification, this book makes instrumental use of McGee's critical take on the cultural fragmentation between text and context in contemporary discourse, together with Burke's rejective mode of discourse, and with McKerrow's critic rhetoric approach in contemporary rhetoric. See Michael Calvin McGee, "Text, Context, and the Fragmentation of Contemporary Culture," *Western Journal of Speech Communication,* 54.2, (1990): 274-90; Raymie McKerrow, "Critical Rhetoric: Theory

and Praxis," *Communication Monographs*, 56 (1989) 91-111; and Kenneth Burke, *Attitudes Toward History* (1937; Berkeley: U of California P, 1969) 3-34.

CHAPTER II

Private and Public Identities in Central Europe: Konrád's *Other* Exile

For several hundred years, the educated elite assumed the role of opposition in European societies, with their critiques questioning obsolete social, political, and cultural paradigms.[1] Searching for boundaries that reflected civil society, Eastern and Central European intellectuals pursued an understanding of social and political structures within specific historic and geographic contexts. Significantly, critical intellectuals became politically active participants in deconstructing communism in countries that until 1989 formed the Iron Curtain.[2] Tismaneanu acknowledges that the public discourse of Eastern and Central European critical intellectuals inherently contributed to the "destruction of Leninism."[3] Havel, Kundera, Michnik and Konrád, among many others, became major representatives of democracy, creating passionate appeals to inscribe critical intellectuals within a unified European public sphere in the 1990s.[4] The year 1989 marked the watershed for their critical and political work, as public intellectuals witnessed the fall of communist governments throughout Eastern and Central Europe and, therefore, their victory.

Although communism fell in 1989, the role of public intellectuals remains instrumental to the discourse of democracy in Eastern and Central

Europe.[5] Today, in the re-opened space of the public arena, these critical intellectuals, dissidents, and exiles[6] write and speak against communist relapses, against antidemocratic and nationalistic politics, against the faces of a "human communism."[7] More important, some of these critical voices are again experiencing living in the margins, oppression from nationalist groups, and as in a *deja vu* scenario, political resistance to their ideas.[8] Their dissidence continues at the forefront of their political and cultural consciousness.

As critical intellectuals, such dissidents lived the life of rhetors in exile from the official public sphere of communism. Before 1989, they practiced a constrained and careful rhetorical art under communism, transformed post-1989 into rhetorical freedom for their voices to be heard out in the open. The civil society project in place, Central and Eastern European arenas of democratic existence were to be conducive to celebration of their identity as *post*-exiles or dissidents, their discursive practices of resistance left aside. And yet, in spite of political and cultural changes claimed by their active societies, their voices remain dissident in the public arena. How do these intellectuals rhetorically manage the socio-cultural and political changes in their countries? How do they adjust the power of their ethos? How do they locate their rhetorical voices relative to a different cultural time and place? And what rhetorical strategies redefine their legitimacy after the fall of the Iron Curtain?

George Konrád, well-known dissident throughout Eastern and Central Europe, "one of the intellectuals who formulated the language of dissent" is the poster child for this socio-political and rhetorical problem.[9] Never an exile in the proper definition of the term, Konrád was acclaimed for his novels, famous throughout the world due to his political commentary *Antipolitics*, and an active participant in the *samizdat* literary and democratic resistance during communist times.[10] For over a decade, Konrád was silenced by communist apparatchiks, by political censors of his writings who effectively turned him into an internal exile. He responded to his public yet personal exile with political and cultural resistance. One might expect that with the fall of communism, Konrád would have been rid of his pariah status and his voice of resistance quieted. Yet, after the 1989 revolution in Hungary, he suffered a dual rhetorical and cultural burden: the loss of his exilic identity and the loss of the rhetorical powers of his *otherness*. How did Konrád, then, adjust to the new political and cultural context of his discourse?

Relocating his identity within the margins, Konrád merged his former and present voices as important counterparts in his socio-cultural appeals for a civil society. Reintegrating his voice as a public enemy within the identity of a critical intellectual, Konrád re-established the rhetorical power of his discourse. This strategic redefinition of identity reoriented his dissidence from opposition to communism toward a critique of post-communist civil society in Hungary.

Located in the liminal space between democratic and anti-democratic public arenas, and in response to exile and marginalization before and after 1989, this study argues that Konrád merged public and private identities to reconstruct his rhetorical power and legitimacy in his writings. Playing identity against power in order to recapture a discourse of resistance, the rhetorical tensions of private and public identities empowered Konrád's socio-cultural critique of post-communism and legitimatized his *otherness*. My rhetorical analysis first explores Konrád's dissident voice in his political and cultural discourse before and after 1989. Second, looking at specific essays from The *Melancholy of Rebirth*, the chapter highlights on Konrád's strategies for creating rhetorical relationships between his private and public exilic identities.[11] Third, as public and private interactions of identity create a discourse of resistance, the chapter considers the implications of dissidence and power for post-communist rhetorical studies.

Identifying himself as a critical intellectual, living the tension between the personal identity of an exile and the public existence of a (former) dissident in Hungary, positioning his rhetorical voice against political oppression, who, then, is Konrád?

Konrád: Once a Critical Intellectual, Always a Voice of Resistance

Before 1989, for over sixteen years, George (György) Konrád was forced into "official" silence. His voice, however, was muted only in the "official" arena of communist Hungary. Silenced, exiled, yet familiar to official and counter publics for his unflinching dissidence, Konrád's identity in the margins became a public action, an inspiration for his audiences.[12] Like Václav Havel or Adam Michnik, dissidents from Czechoslovak and Polish counter public arenas, Konrád was not an "exile" in the strict, dictionary definition.[13] And yet, like them, he fought the communist government through dissident discourse from within the borders, from a private or isolated locus of public action, thus participating in a powerful and

successful underground movement.[14] From this internal exile, Konrád appears to have been more influential than expatriates and critical intellectuals outside Hungarian borders.[15] It was only after the fall of the Hungarian communist regime that Konrád resumed his right to normal participation in the public sphere.[16] Does it mean that rhetorically, he is now outside of his marginalization in his discourse?

With the demise of the Hungarian communist order, Konrád has become a constant public presence in the pro-democratic arena of Eastern and Central Europe. And yet, continuing to address neo-communist and nationalist practices resurgent throughout Eastern and Central Europe, Konrád again finds himself marginalized, compelled to advocate a discourse of socio-cultural and political changes in his native country.[17] His political, cultural, and rhetorical response to this new marginalization in the public arena is to remain a critical voice, opening his exilic identity to new narratives of resistance.

The Melancholy of Rebirth provides Konrád rhetorical and political opportunities to recreate his public voice of dissent. Comprising mainly essays, speeches and personal commentaries on the sociopolitical problems faced by Hungary and Hungarians after the communist era, *Melancholy* argues that identity and politics need reconsideration for any civil society in Central Europe. In Konrád's discourse, his voice as a rhetor can be heard speaking within an exilic, dissident, and critical mode. Capturing his *private voice* of marginalization as an internal underground writer and a Jew in Hungary, together with his *public persona* of an active advocate for democracy, Konrád merges these identities in most of his essays. My rhetorical analysis considers "Self-Introduction," "Melancholy of the Rebirth," the dyad "15 March," and "The Holiday Looks Back." In these essays, Konrád narrates his story, unveiling instances where the political regime, his private existence, and his public voice intersect. Confronted with his own exilic perspective, writing, again and again, from a place of resistance, from home as exile, Konrád remains throughout his rhetorical actions a critical intellectual attempting to regain rhetorical force in his democratic discourse.

Additionally, in "Hedonists of the Brain," "Something Is Over," and "More than Nothing" the author offers accounts of the responsibilities of critical intellectuals not only in communist Hungary, but most important, after the fall of oppression in Central Europe. Merging his dissident and his antinationalist voice, "The Melancholy of Rebirth," "Holiday Looks Back,"

"15 March: A Colorful Day," and "Hedonists of the Brain" reinforce a democratic relationship between citizens and the new sociopolitical situation in Hungary, which advocates a civil society as the legitimate and necessary step towards a free country.[18]

Throughout these writings, Konrád lives in the realm of *both/and*, where conjunctions offer a multiple nexus for locating discourse, and with it, his identity of resistance. No term seems to have *only* one definition in Konrád's personal lexicon: exile is not merely exile, but rather an internal state, since he is an atypical case, still living in his country of origin.[19] Discursively, Konrád's personal vocabulary captures social and political meanings pertaining to his cultural and political articulation of Hungarian public and counter public spheres. Along with his exile, Konrád's usage of the title of the entire collection as "Melancholy of Rebirth" refers to the term of Melancholic-Revolution pertinent for the 1989 political turn in the history of his country.[20] Considered a Hungarian "bourgeois" unworthy of membership in the Communist Party in the early proletariat era, a writer as well-known in the West as in the Eastern European communist camp, Konrád remains throughout his literary and political works, a voice of difference.[21] His literary works are not simply fiction, rather his novels present uncanny similarities to real sociopolitical dramas that occurred under communism.[22] Additionally, essays like *Antipolitics* and the ones part of the collection used for this exploration, reveal Konrád's position on political life as his public persona intersects continuously with the personal dimensions of his living in the margins.[23] Significantly for this research, Konrád's life and his appeals interact constantly at the level of discourse, bringing to the fore his public and private existence in interstitial testimony against the power structures. His essays on Hungary and the problems of Eastern and Central Europe reveal both his public and private dissent. Therefore, in order to read Konrád from a rhetorical perspective, one needs to unfold the layers of cultural, political, and exilic discourse converging in his works. Konrád's exilic identity becomes, along with its cultural and political dimensions, a locus of dissident motives. What rhetorical strategies does he use to recreate a voice of resistance? And how does he address the issues of political power so salient for his rhetorical action?

Citizen K.: Whose Identity Is It Anyway?

Konrád's rhetorical construction of identity in discourse is built against oppressive power in the political arena of Hungary. His appeals invoke civic responsibilities, calling for antipolitical resistance. The Hungarian-Jewish writer seems to be forever an outsider. Accepting difference as intrinsic to his existence, a locus for his identity of difference and resistance, Konrád realizes that his personal existence as a samizdat writer and an internal exile might encounter different reactions in the public arena of post-communism, where the public and counter public discourse opened up to novel civil society patterns. Thus, Konrád finds himself turning from "private dissident number one under Kadar" into the "public enemy under Antall."[24] In other words, the forever different Konrád understands and claims that cultural politics, nationalist arenas and opened venues for political opinions might still reinforce his repositioning again onto a locus of dissent. His public/private status of resistance and articulation towards antipolitics does not assist when his identity as a rhetor can be perceived as an "enemy" due to his Jewish origin, or in view of his political resistance all the years when legitimation in the official public discourse of communism implied at least silent compromise in Hungarian citizenry. Hence, Konrád's strategies to redefine himself after the fall of communism raise rhetorical problems of reconstitution of voice and at the same time a reiteration of a locus of dissent intrinsic for the author's views on a solid and vibrant democratic arena in Hungary.

Converging past and present voices of difference, Konrád starts his collection with a powerful account of himself as *the enemy* in different political contexts. "A Self-Introduction" uncovers the author's autobiographical journey into the present post-communist era. Presenting an autobiographic essay as an introduction to the political essays assembled in the volume, Konrád maps his discourse pertinent to his rhetorical identity of the *different*, using the third person singular and the capital letter K. to recount his long-lasting dissidence. From the very beginning, by defining his identity as *K.*(or should I call him "citizen K."?), the writer locates himself in the world of the Outside, to paraphrase Codrescu.[25] Invoking K.[26] constitutes a profound and suggestive connection to an alter ego, Kafka's own protagonist K.,[27] the forever embodiment of foreignness, "a boarder in his own house," providing a doubly allegorical political commentary on dissent, resistance, and difference.[28] Since Konrád is a writer, a Jew, part of the

resistance literati of the former Austro-Hungarian territories, his rhetorical device to invoke the protagonist of Kakfa's *The Trial* and *The Castle* reveals cultural and political palimpsestic strategies of difference. The emblematic and empowering approach on identity functions enthymematically for Konrád as a silent and tragic reiteration of his entrapment within the communist fields of discourse. It seems that Kafka's tragic and satirical voice as K might continue its 'representative anecdote' identity within Konrád's presentation of his own identity as K. throughout the periple of communist and post-communist journey towards freedom of existence in a civil society.[29]

Banned under communist rules in Czechoslovakia, Kafka's enigmatic and ambiguous K. reflects a Europe between wars as its parable continue to fascinate publics and literati throughout the world, while revealing communist fear for its rhetorical power as a voice of dissent.[30] One other K., Ivan Klima, a Czech-Jewish dissenter and Kafka's co-patriot. Klima comments on the impact of K. as a rhetorical device during communist times, "the question why Kafka was banned under Communist regimes is answered in a single sentence... '[W]hat matters most about Kafka's personality is his honesty'"(122) in a conversation with Philip Roth on other three dissident K's, who "crawled out from under Kafka's cockroach to tell us that there are no uncontaminated angels, that the evil is inside as well outside."[31] Konrád's invocation of K. as the narrator functions rhetorically as an empowered nexus of dissent. Could it also function as an intentional connection with Kafka as two writers of *otherness* in a bleak period of Central European history? It might be that the letter K. embodies rhetorically ambiguous alter egos shared by most Central European writers as powerful images of cultural and political dissent.

It might be for this very reason that Konrád's invocation of K. starts the volume as a guide for the writer's political commentaries to follow."A Self-Introduction" can be more than a mere introduction, rather the discursive outline for his identities, a "locus of motives" for his difference.[32] How, then, does he use these strategic reconstitutions in the rhetorical discourse of dissent? In Konrád's world of politics, private life and public and counter public arenas, his K. too is a *different* human being, alternating identities that create a rhetorical and operational framework of a public and private enemy.[33] For what else is he, other than a critical intellectual, a writer, a Jew who speaks Hungarian, and a bourgeois? Konrád starts his essay and the volume with the following narrative:

> K. is a fifty-seven-year-old novelist and essayist. His citizenship and native
> language are Hungarian, his religion Jewish. His father owned a hardware shop in
> the provinces; his mother is alive and well. He has four children by two marriages.
> He is by training a teacher of literature. His wife, Judit Lakner, is a historian. He
> lives in a three-room-plus-study apartment in the garden suburbs of Buda and owns
> a run-down house in the country. His wardrobe is modest, though he has several
> type-writers.[34]

Distanced by the third-person singular pronoun, constructing the voice of *the
other* from the beginning of his rhetorical action, Konrád brings in front of
his readership a succession of events and information about his private life.
Although Konrád clearly refers to his personal life, his choice of K. in the
story constructs an important rhetorical effect, layering cultural and political
nuances of his identity as *the other*. Is this character, K., a private
embodiment of difference, or a public (or counter public) one? K., or *the
other*, sets the story in the rhetorical space of ambiguity from the second
sentence of the book, as Konrád reveals that his persona speaks Hungarian,
yet is of Jewish descent.[35] Contrapuntal to this setting of identity, in the
sentences to follow, Konrád introduces new dimensions of his difference by
talking about his father pertaining to the bourgeoisie in the sociopolitical
context of antebellic Hungary. The fact that K.'s father "owned" a hardware
shop announces one of his son's political obstacles to a(ny) future
professional career in a proletariat society. Konrád comes from the
bourgeois, and, therefore, he bears the stigma of capitalism, the communists'
foe. In the second short paragraph of the essay, the author adds more
biographical information: K., or Konrád, is a Jew in fascist Hungary. Like
Kafka's satirical yet ambiguous K., Konrád retells his childhood invoking
irony and in a sense the same 'tragic horror'[36] as in: "1944 he barely missed
being sent to Auschwitz, where nearly all the other Jewish children from his
village ended up and died."[37]

Continuing the narration, Konrád alternates K.'s private difference as
Jewish with his political dissidence. The effect is a powerful depiction of
multiple rhetorical constructions of identity, adding political and antipolitical
strands of voice, and consequently, articulating the author as a public enemy
of the communist state. "While at secondary school he joined the students'
association, but he was excluded for something he wrote", reinstated, he was
excluded again later. Already suspect because he is a Jew, K. also becomes a
potential public enemy, "expelled several times from the University for his
bourgeois origins and behavior," "allowed to graduate in 1956 thanks to the

patronage of his instructors."[38] Invoking at least "residual images"[39] of antisemitic sentiment in postbellic Hungary, Konrád 's tale of difference continues on accounts of social class and political suspicion during the yearmark 1956 Hungary.[40]

Konrád's construction of K. as both a private self and a publicly different persona allows the rhetor to continue positing his identity in the context of a convoluted history of dissidence and resistance. Due to the political events in Hungary, by 1956, K. enters the rhetorical identity of a public enemy, turning into a potential voice "of critical thought."[41]

Throughout the essay, Konrád shifts K.'s personae as a "good" and "bad" identity, leaving the rhetorical powers of ambiguity to work toward his rhetorical reconstruction of voice. The author creates a rhetorical nexus for the unexpected. Contrapuntal in pace, Konrád presents K. as a political enemy of the communist government in one sentence, and follows in the same rhetorical voice, presenting him as a patriot defending his country against an even bigger evil, the Soviet troops. Constructing K.'s voice both as different and potentially dangerous politically (and culturally), Konrád leaves unresolved one of his ambiguous existence, for the next political "episodes" of his saga lie in the Hungarian revolution of 1956:

> K. joined the National Guard. He kept his machine gun under the bed. . . . His orders were to defend the University, but the Soviet troops never opened fire on it. At the time of the great exodus late in 1956 most of his friends went west: he, a family man by then, stayed put. The most obvious thing for him to do was speak and write his native language here in Hungary.[42]

Thus, depicting the political contexts of the 1950s, the writer opens both his public and private personae for his future experience of political persecution. For, when communist oppression began, Konrád, and K., re-enter together the public (counter public) and private realm of difference, and dissidence. Unemployed for three years and once again a public enemy, K. managed "to find work as a public guardianship officer," a job outside of his profession.[43] By now learning to "look upon the normal and the deviant [people] in relative terms," K. took part in "the young writers' subculture of the sixties." After 1965, he worked as an "urban sociologist," and in 1973, "pressure from secret police caused him to be dismissed from his post.[44] Subsequently, K. remained *the* public enemy for the next sixteen years, his status reinforced by his banishment from all employment, until 1989. The cultural enthymeme of sub-text in reference to the historical events in postbellic and communist

Hungary allows K. to reiterate, reconstruct, and relocate his voice of difference, accruing rhetorical power and dissident identity.

Since Konrád's rhetorical invocation of public and private self merge and reinforce his rhetorical strategy of difference, this might be the best place to explain 'public' and 'private' as the two inherent voices of dissidence for a Hungarian-Jewish writer whose major sin is resistance and political views against the communist grain. The dyad *private- public* refers specifically at the historic existence of a private citizen in the last decades of communism in Hungary (and for that matter in the entire Communist Bloc). *Private* identity for Konrád involves both the personal facts and the forced living as a "boarder in [his] own home," writing for a counter public, speaking in whispering mode, and cohabiting what Haraszti calls "our main adversary... not oppression by the police but our policing our *own* (my emphasis) minds."[45] *Private* voice acts rhetorically as an appeal to self-as-normalcy in the context where trials and castles (with small or capital letters) occupy the realm of everyday existence. Invoking his identity as a multiple personal nexus of difference, Konrád aligns the factual roll of events with the enthymematic relevance of his difference for his own self, for his own private territory of resistance, exile, and identity. Yet, *private* captures with it its dialectic counterpart of ethos, its redefining of voice through the *public* articulation of, once again, oppression and difference.

Public voice for Konrád's K. resonates within outside of his home, into the public and counter public spheres of communist discourse. His civic speech as a public dissident, a samizdat writer, and a voice in the realm of anticommunist and antipolitics resistance, all legitimize his ethos invoking the cultural, political and social relevance of his discourse outside his house, literally and figuratively. The dissonant, coexistent official arena within the context of a counter public realm of discourse create for Konrád's K. a contextualized language of *public resistance* against communism, against oppression, against anti-semitism, against authority, against political practices, and red ideologies. Explaining a similar private and public existence at the margins of speech for yet another Hungarian-Jewish dissident, Miklos Haraszti, Konrád writes in the foreword of the *samizdat* version in 1986 that "[H]ere in Central Europe, however, even the literary pantheon is state-controlled."[46]

Hence, going back to how Konrád locates himself as K. as distinctly an outsider, in doing so, the writer merges private and public lives as *the enemy* coexisted even prior to his dissidence. Whether due to his personal

experience of marginalization as a Jew, or to his political and public "problem" voice in the communist arena, the author accrued layers of difference and political status as the foe of the state.[47]

Uncovering K.'s identity as a critical intellectual, Konrád substantiates more rhetorical dimensions for his identity of *a resistant other*. Before being publicly silenced, in 1969, at the age of thirty-six, K. published his first novel, *The Case Worker*, creating "quite a furor on the Hungarian literary scene," as it was "condemned and condoned" by the officials.[48] Becoming known as a novelist in the official and unofficial literary arena, K.'s critical discourse reinforces one more merger with the existent rhetorical cluster of identities of difference, namely, his rhetorical voice as a dissident. Unemployed, yet enjoying acclaim for his novel and receiving for the first time "a decent royalty," K. and his friend Szelényi reclaim rhetorical power for dissident ideas and views on the political and cultural problems of Hungary.[49] Consequently, reprimanded for his political voice, K. is silenced in the public realm in his own country. Forced by politics into private dissidence, Konrád merges multiple *otherness* in K. as his rhetorical persona. K.'s Jewishness, his political dissidence, and his literary participation cluster together becoming a silenced voice of resistance, as he joins the underground.[50]

Rhetorically, the significance of K.'s life in the margins of communist discourse becomes his overt participation in the antipolitical arena (pun intended). Silenced publicly, and thus, ironically, empowered, Konrád created rhetorical appeals as "an active member of the semi-legal network of friends that called itself the democratic opposition." The dissident group emerged from underground in 1988.[51]

As he continuously reinforces K.'s locus of and for resistance, Konrád brings in the experience of internal exile to reconstruct his identity as *the other* in discourse. Appealing to cultural memories of the silent *other K.* and its resonating absence from the public life in communist literature, Konrád's protagonist invokes all marginalized voices to explicate his resistance in pre-1989 Hungary. Reminding of Kafkian tonalities, defiant to political oppression, for "the next twelve years he ["K."] published in the independent, underground, samizdat press" with an audience of "no more than a few thousand."As such, Konrád, or "K.," enters the public land of resistance as home for his voice against communist oppression.[52]

The desired happy ending might have occurred when K.'s rhetorical identity exited his public and private banning upon the demise of

communism in 1989. Konrád's rhetorical alter ego, K., in a sense symbolic for all dissident "K."s, should then have been freed, and his public and private enemy personae gone. [53] The last sentence of this essay presents K. as a writer contributing "regularly to newspapers and periodicals," re-entering the public realm, leaving his *Otherness* aside and, hopefully, behind.[54] Does this mean, rhetorically, that after 1989 Konrád settled into a new rhetorical locus of voice, into a novel rhetorical identity, free at last to comment on Central Europe and its emerging democratic societies? With the end of the communist era, one would think Konrád, and with him, K., stopped his living and writing on the outside, from the dissident rhetorical realm of the marginalized. Then, is it possible that, from 1989 on, Konrád ceased to be a dissident?

Konrád's strategic merger of private and public voices of difference in "A Self-Introduction" transcends chronology. Writing this essay after 1989, Konrád continues to reveal the rhetorical discourse of *the other*, in a literary yet political context of a 'Melancholy of the Rebirth,' *re-opening* questions of political and cultural resistance against the public and official arena in post-communist Hungary. Consequently, through the continued rhetorical tensions of his identity in dissent, Konrád's union of public and private voices becomes the overarching framework for his post-communist discourse.

Different Again? Continuing to Be the Public and Private Enemy

By collapsing private and public personae in his post-1989 rhetorical actions, Konrád reinvents a powerful identity of resistance. As mentioned, while his appeals for democracy and civil society seem a logical continuation of his rhetorical discourse as a critical intellectual, in post-communist times his dissident identity should have disappeared. And yet, confronting nationalist attacks on his public persona, Konrád regains legitimacy by bringing into his discourse his familiar, already created, identities of resistance, his exilic K. and his dissident voice. Therefore, challenging the post-1989 nationalist discourse emerging in the Hungarian public arena, the writer re-engages *again* public and private dissidence to reaffirm his rhetorical identity in discourse.

Prefacing the New Publics of Hungary: An Open(ed) Society

It might be useful to start with a chronology of events during the Hungarian 1989 "melancholic-revolution" in order to provide Konrád's discourse with a political context necessary for its rhetorical impact on the author's reconstruction of identity.[55] The collection of essays published by *The New York Review of Books* in1990 provides also a chronology useful to this purpose:

> *September 19, 1989*: The Ruling Communists and the opposition agree on constitutional changes, the creation of a multiparty system, and free elections to be held in 1990.

> *March 25-April 1990*: Elections and runoff elections for Parliament result in a victory for the opposition United Democratic Front.

> *May 24, 1990*: Josef Antall of the UDF becomes prime minister.

> *September 28, 1990*: Hungary and the Soviet Union agree on withdrawal of Soviet troops.[56]

Like everywhere in Eastern and Central European political arenas, changes in the public discourse and the political negotiations toward a civil society seem to comprise events, political decisions, nomination and denigration of former communists and/or of former dissidents, all moving at a hallucinating speed, in particular between 1990-1992. The Hungarian government of that period reflects precisely the distinct fractions of political views, as Ash presents the "U-shaped Hungarian parliament" having "a few independent members, then Socialists (i.e. former Communists), Young Democrats, Free Democrats, Smallholders, the Democratic Forum, and the Christian Democrats."[57] The basic political divide during the first years of post-communist changes in Hungarian government resides between "the cosmopolitan, urbanist, Western-oriented" Hungarians archetypically represented "by the multilingual Jewish intellectuals of the Free Democrats, and a nationalist, populist, sometimes anti-Semitic, Transylvania-oriented Hungary," represented by the Democratic Forum.[58]

Aside from the cultural and political clash between the Populists and the Urbanists, the government was also under attack from yet another side, "the left-liberal intellectuals in the form of the Democratic Charter initiative, which claimed that Hungary was not democratic enough, and that broader

citizen participation in political life was necessary."[59] Ardently antipolitical, both in his writings and in his views, Konrád's public discourse in celebration of the Democratic Charter legitimizes his continuous presence in the margins of political life in Hungary. And yet, in 1992, Konrád finds himself again faced with his alter ego, "the public enemy of Antall," and his all too familiar K. caught in the arena of the "martial art known as politics."[60]

An Epideictic Interlude: Konrád's Celebration of Democracy

Constructing himself as an(other) possible public enemy against this novel rhetorical and cultural context of nationalism, Konrád pairs two consecutive nonfiction essays, "Holiday Looks Back" and "15 March: A Colorful Day."[61] The first reproduces a speech Konrád delivered in Petöfi Square, Budapest.[62] This powerful rhetorical appeal on the need for a civil society in Hungary, asked his audience to act upon their democratic beliefs.[63] A signatory of the Democratic Charter, Konrád's epideictic discourse reiterates his position as a critical intellectual fighting for democracy, "a necessity" in any civil society:[64]

> We who have signed the Charter must confront the constitutional principle of freedom of the press with this clear-cut attempt to intimidate the media. We can have democracy only if we do not have intimidation. . . . Like it or not, Hungary-- together with Central Europe as a whole--is fated to be a democracy. And as the Latin proverb has it, fate leads the willing and drags the reluctant.[65]

As often occurs in epideictic rhetoric, Konrád's use of the pronoun "we" invokes a call to action from the audience. His rhetorical identity shifts from the former K., the "he" (the critical intellectual) silenced in the public realm, into the "we" of the new, transformed public arena of democracy. By reading only this essay, one might think that Konrád solves his problem of identity in discourse, becoming a settled voice in a settled cultural and political context of post-communist Hungary.

Reclaiming history as historicity, as the "basis for identity of social actors" to reposition themselves from past to present while providing "the condition for reflexive self-regulation manifested in history" Konrád positions himself on its anticommunist, pro-democratic side.[66] Hence his ethos is reconstituted within the locus of a powerful rhetor of civil society in progress.[67] In this rhetorical action, as in many other speeches reprinted in the collection, Konrád is an effervescent rhetorical voice, an enthusiastic

speaker on his political and public beliefs.[68] "Fated to be a democracy," Hungary throws open its political and cultural gates to welcome, in Konrád's view, a new era of citizenship.[69] Using the spirit of the revolutionary year of 1848 to invoke ideas of freedom and political enthusiasm for a new era, Konrád presents himself as a signer of the Democratic Charter, ready to stand up for "certain basic democratic principles," inviting others to join him:

> As I see it, the spirit of 1848 is not at all alien to our initiative in favor of a civic society, to our seventeen points, our Democratic Charter. The seventeen points are basically a civic initiative. . . . Signing the Charter is not like voting by secret ballot; it is a public gesture, a call for dialogue.[70]

Moving from the first-person singular "I" into a public "we" with a common political platform, Konrád becomes the spokesman for plural voices of political change. His speech calls for a "public gesture," explaining that "at the heart of the Charter" lie the political claims of civil society in Hungary.[71] Seeking "to counterbalance the state's tendency to absolute power," Konrád's voice gains more and more political legitimacy as a spokesman for democracy and civil society.[72] Therefore, empowered rhetorically to speak for democracy, the writer occupies the public stage of politics, no longer marginalized. Rhetorically, then, has Konrád finally abandoned his tensioned voice of resistance in discourse? Has he embraced the new victory over communism, becoming a voice of freedom? Is this author beyond marginalization, as his post-communist speeches present a powerful speaker on a luminous future?

Reflecting on events taking place the very same evening, Konrád changes his locus of identity dramatically in "15 March: A Colorful Day." Continuing the story from the very moment of the rally, Konrád adds a different rhetorical texture to his identity in the margins. During the rally, a few hecklers, members of far-right organizations, participate without too much offense, allowing the Democratic Charter participants their epideictic event.[73] That very evening, maybe too soon, the same far-right organizations take their revenge in another square, ironically named "Freedom Square." In "*their* square"(my emphasis), a "square of blunt speech," Konrád is faced with violent, physical attacks of hatred of his politics, of his Jewishness, of his writing and of his participation in the public arena.[74] Attacks *ad hominem* abound, as the author is met with slogans like "Long live Gÿorgÿ Konrád, the greatest Hungarian writer! But not too long"or with cries of "traitor,"

becoming a public "prey."[75] As he himself evaluates the event, Konrád's identity turns from "private dissident number one under Kadar to public enemy number one under Antall."[76] His entire existence under communist oppression is publicly questioned one more time. Once again, before an adversarial audience, Konrád faces the cultural enthymeme of *the other*. After all, the cultural, political, and rhetorical significance of this incident is its post-communist occurrence. The nationalistic discourse, with its anti-Semitic, antidemocratic and xenophobic nuances, represents one of the byproducts of Eastern and Central European public sphere.[77]

Before and After Communism: The Same Voice of Difference

In "15 March," responding to his marginalization, Konrád transforms his rhetorical discourse. No longer a public voice representing post-communist changes for the better, Konrád -the speaker of democracy- shifts personae. Konrád becomes aware that his rhetorical voice is transformed by a different audience into a cultural and political target. To address this political situation, Konrád again invokes his private and public *personae non grata* as historical ethos needed to present former and present dimensions of his dissidence. Differentiating between culturally-loaded collectives of 'they' and 'we-the opposition liberals, the Free Democrats," Konrád reestablishes his rhetorical place of articulation against government and political practices, a locus in the margins of the Hungarian public arena.[78] Using contrastive, ironic style of discourse when positing his voice, Konrád creates the rhetorical image of two different audiences in the name of new Hungarian ideas. His passionate appeal for democracy in Petöfi Square addresses an audience ready for democratic changes in the country, while the other experience in Freedom Square makes him face the challenge of a hostile audience, questioning his legitimacy and voice. Invoking again historicity and Hungarian culture as enthymematic associates for his reconstitution, Petöfi's patronizing shadow as the national Hungarian poet and Freedom as the national pursuit of Hungarian people, Konrád enables his place of speech with the powers of ambiguity, cultural memory and dissent.

Here, within a rhetorical location of ambiguity for his identity, Konrád invokes *both* his public voice of a critical intellectual *and* his life in the margins of the political arena as coexistent counterparts of his rhetorical persona in dissent. Does he still represent a public threat?

Engaging his public and private ethos of dissent, Konrád positions himself within the *both/and* locus, empowering with rhetorical flow the past and present dissident discourse. Accordingly, in "15 March," Konrád collapses his private and political personae, reflecting that in Petöfi Square "about fifteen thousand people applauded me: two hours later in Freedom Square about a hundred people wanted to beat me up."[79] The "we" the Hungarian democratic people from "Holiday Looks Back" leaves room for "me, George Konrád" a cultural and rhetorical ideograph of a public enemy, the "incarnation of the spirit they wanted so badly to spirit away."[80] Writing about the resurgence of nationalism in Eastern and Central Europe, Tismaneanu precisely captures Konrád's bewilderment, pointing out that "for many intellectuals in Eastern and Central Europe, the rise of nationalism in the aftermath of communism's collapse came as a surprise."[81] Can he, then, recapture his public legitimation in the adverse context of post-communist nationalism?

In "15 March: A Colorful Day," Konrád recaptures his more familiar *otherness*, his difference, the *otherness* that the Freedom Square incident re-informs. From this discursive location, the writer recalls his private existence as an internal exile. Revisiting his (old) existence of public enemy, he reaffirms his dissent, asking himself "why I am the one they've made the enemy again."[82] Appropriating past voices into resistance, Konrád adds insight into the epideictic construction of dual discourse pre-1989:

> I did not face such hatred under Communism. Officials found it interesting to run into dissidents at a play or concert. The secret police, too, showed us a certain respect: they did their homework and read what we wrote. We had an impact on them. They would try sheepishly to justify their actions, distance themselves from their roles. I have not met many people who hate me without knowing me and make a show of their hatred.[83]

At stake is his public legitimation even as a marginalized identity in new political situations. His strategic change from "private dissident number one" to the new "public enemy number one," from the *me then* to the *me now* public enemy constitutes a painful rhetorical reconstruction for Konrád's identity.[84] Yet again, his former rhetorical persona as an exiled voice accentuates the rhetorical significance of the *we* versus *they* cultural dyad.[85] As the author interjects the cultural and political implications of his public and private personae, he introduces a new powerful message of Otherness.

His strategic collapse between private and public experiences of dissent turns Konrád into an *always already* public enemy. Reminded by a different audience of his *Otherness,* facing his well known old position as public enemy in a new political context, Konrád reconstitutes himself along familiar powerless and powerful positions of dissidence.

The *otherness* of Konrád's post-communist identity is still more complex. Since the *ad hominem* attacks revolved, this time, around questions of politics and ethnic background, the writer incorporates his Jewishness when merging his private and public voices in his essays. In the rhetorical landscape constructed by nationalist discourse, Konrád explicitly reflects on his *otherness*. While he does not reveal his Jewish ethnicity in the text of "15 March," his response to marginalization demonstrates his awareness of his identity as a minority in the essay "The Melancholy of Rebirth:"

From the point of view of both regimes [communist and fascist], I was born tainted. I thus experienced their disapproval not as a person but as a creature belonging to first a racial category, then a social category doomed to extinction. What I was actually like never entered the picture: I was guilty by definition. I of course rebelled and was immediately--and rightly--classified as a dissident. And while there is nothing inherently hazardous about being born a Hungarian Jew, I cannot, as I gaze upon the current spiritual horizon of my homeland, rule out the possibility of a new vulnerability.[86]

Translating the hecklers' attitudes into xenophobic expression, Konrád cannot afford to forget his identity of difference, based, this time, on his ethnic background. As his Jewish identity lingers enthymematically in "15 March," Konrád reinforces his rhetorical and cultural voice of difference in "The Melancholy of Rebirth." In this instance and throughout his discourse, Konrád never forgets the nationalistic problem his identity posits. Depicting himself as "tainted," "guilty by definition," the author merges his deviancies in public life defining himself both as a critical intellectual and an ethnically different *Other*.[87] Similarly, in "Hail and Farewell," his last essay in this volume, Konrád incorporates Jewishness into the rhetorical merger between his public and personal identities of difference.[88] Depicting his post-communist life, the author again evokes his life in the margins, subject to telephoned threats addressing his political views and his ethnic background.

Due to his public and private exile and isolation, Konrád cannot afford to "rule out" his fragile rhetorical identity when locating himself in political contexts.[89] With his Jewish identity inherent in his public and private enemy

paradigm, Konrád never forgets his life in the margins, and remains determined to participate in the public arena:

> I tell everyone [on TV] . . . what I think. I called censorship censorship in the former regime, and I call it censorship in this one. The politicians involved can indict me and recommend the stiffest sentence in the land if they please. I'm surprised at the way their minds work. It's all so deja vu. . . . I see angry, indignant looks coming at me. "Look at him," they say, " out for a stroll." What have I done this time? . . . I get anonymous phone calls from people calling me dirty rat, dirty bastard, dirty Jew, predicting I'll die like a dog, forgetting that they too are mortal. The most venomous are my coevals [contemporaries], people who were furious with me when I was banned and who are now doing the banning.[90]

Articulating his life of difference, Konrád reaffirms the locative powers of *both/and* of his identity in discourse. His continued determination to voice his socio-cultural and political views in the Hungarian public arena in spite of his marginalization reinforces his identity of dissent. Konrád becomes aware of his fluid situation as a partisan of democracy as some members of his audience "furious" with him in the past now participate in the current "banning."[91] The invective reminds Konrád of his former life in the underground, of his ethnic difference when seen from an anti-Semitic audience viewpoint, and of his frail location of voice in the context of nationalism in his country. Both K. *before* 1989 and his new citizen K. "guilty by definition" *after* the fall of the communist regime, invoke instances of exilic voice, helping him recreate his identity of resistance.

Konrád's strategic reconstruction of voice embraces multiple rhetorical personae from the margins of public discourse. A private and a public enemy on communist and post-communist grounds, the writer emphasizes his coexistent rhetorical identities of dissent. For, due to political uncertainty, Konrád can never afford to forget *any* of his voices in the margins, neither his dissidence nor his Jewishness in a country where, as everywhere in Eastern and Central Europe, nationalist discourse has not yet been settled.

What is then the significance of Konrád's reconstruction of identity for the public culture of Central Europe? Reinforcing his strategic redefinition as a public and private enemy, Konrád's liminal locus of speech functions as a basic dialectic within particular and powerful articulations in respect to the difficult circumstances the author faces. Identity and rhetorical and political power are rhetorical companions in his post-communist essays.

Even as he preserves the identity of *the other* in the new public arena of
Hungary, Konrád adds one more rhetorical identity to his palimpsest identity,
namely, his critical intellectual persona, resisting once again the past and the
present of communist practices in Central European emergent civil society.

Citizen and Writer: A Critical Intellectual in Action

Interpellating the relationship between identity and political power, the
Hungarian writer responded to his rhetorically construed marginalization by
reconstituting his critical identity of resistance as a necessary voice in any
democracy. A critical intellectual, Konrád's appeals for civil society are
rooted precisely in the rhetorical tensions his multiple identities as *the other*
posit in discourse. For Konrád, being and acting as a critical intellectual
represents personal and public reiterations of resistance through rhetorical
discourse. The public role of critical/democratic intellectuals is articulated
and emphasized throughout "More Than Nothing: The Role of the
Intellectual in a Changing Europe." The personal context for Konrád's
appeals combines the association of his name with a solid and celebrated
work,[92] as well as a personal history of involvement within the discourse
intrinsically linked to the political, cultural, and social realm of public
intellectuals in Central and Eastern Europe.[93]

"More Than Nothing: The Role of the Intellectual in a Changing
Europe." exemplifies Konrád's strategic redefinition as he articulates his
public intellectual identity, calling for responsible academic work within the
political arena of a civil society,[94] the author is also known for his This
speech was delivered to Western intellectuals at the Conference for German
University Chancellors, in Frankfurt. Responding to this rhetorical need,
Konrád emphasized language as power, arguing that critical intellectuals'
discourse could actually change social conditions in countries like Hungary.

Identifying himself as part of the critical elite, Konrád cannot separate
any of his voices from the political context of his advocacy. In this speech,
he reiterates the role of a critical intellectual as an encompassing cluster of
resistant actions in language, creating through discourse the cultural and
political tensions much needed for a new democracy Sharing with Brodsky
the perspective on the role of critical intellectuals,[95] Konrád considers writers
as "memories of their [own] persons."[96] As advocates of democratic
responsibility to express public opinion in the volatile political arena of a
society in transition, Konrád delineates a rhetorical and public function for

such voices, "responsible for their own acts," establishing a "symbiotic relationship" with societal goals.[97] Furthermore, transcending "integration and compassion," as well as "politics and public relations," public intellectuals are called to the "profession of understanding."[98]

As Konrád embodies and redefines his identity as a critical intellectual, he captures in his persona the legitimacy of his dissent. Within this redefinition, Konrád re-instantiates the relationship between voice and power as it calls for participation in the socio-cultural and political arenas of a new civil society, opening the public discourse for democracy. Unwilling to separate private and public identity within the rhetorical persona of a public or democratic intellectual, Konrád foresees its political function:

> The intelligentsia is the keeper of legitimacies; it provides grounds for morality, allegories for ethics, and analysis for politics. In other words, intellectuals peddle clear consciences and guilty consciences. All people have cultural values to guide them and justify their existence. . . . Those values are in the hands of the intellectuals.[99]

Universities, the fora where both local and public arenas exercise power, constitute the nexus of public discourse for voices of democracy. Critical and, as he calls them, "true intellectuals" represent more than professionals in universities; they implicate themselves in the civil responsibilities their society demands.[100] Invested with authority, these social elites have a major social task, "[T]heir wisdom is their debt to the world, their duty; understanding is their profession." Konrád notes that "our times call for the knowledge of the initiate," transforming his critical intellectual voice and his audience into public commentators and guardians of social and cultural values.[101] However, does Konrád, as a critical voice, remain only a powerful rhetorical example of the potential public realm, or does he invoke his own history in order to provide more rhetorical action in his discourse?

In "Something Is Over" and "The Melancholy of Rebirth," along with similar accounts of critical voices in democracies, Konrád recalls his past experiences of internal exile and Otherness to reclaim his legitimacy in the political arena of a democracy. Unlike "More Than Nothing," where the writer restricts his personal references to an enthymematic level, each of these essays contains a paragraph of Konrád's own personal history. This direct reference to personal experiences is a strategic move in his rhetorical reconstitution of voice. He reclaims his powers in dissident discourse, again building the private and public ambiguity of resistance.

Recalling once again one of his K., his *otherness* as a Jew, Konrád does more than reminisce in this paragraph in "Something Is Over."[102] The section I refer to is almost a page long.[103] Appropriating his difference from the very beginning, Konrád evokes his earned identity of *the other*, writing that "[M]y twentieth century began the year Hitler took power: I was born in 1933."[104] His voice of difference was, and could be again, at stake in the political context. Never apart, his public and private voices merge into a locus for rhetorical and political interpellation, a nexus of ethos for potentially different political and rhetorical actions in the Hungarian public arena, past or present.

As Konrád implicates his readership in the present political realm, he invokes his past authority as a critical intellectual in the underground. In a small section of "The Melancholy of Rebirth" Konrád shifts rhetorical personae, as he moves from the rhetorical plural "we," the powerful participants in a new democracy, to the first person singular, to his own civic, dissident, and private voice of *otherness* in the political realm.[105] Konrád's strategic change of voice recalls the political implications of voice in different public arenas:

> I was twelve in 1945, when fascism was overthrown in Hungary. Until then we were under the Horthy regime, which had remained in power throughout the Arrow Cross years. Until 1945 my position as a Jew was rather vulnerable. Had the Horthy regime held for a few weeks more, I would not be sitting here making these observations.

> I was fifteen in 1948, when Communism took over in Hungary, and not until 1990, by which time I was fifty-seven, did parliamentary elections bring the monopoly of the Party to an end. After the victory of Communism, my position as a young bourgeois (that is, someone whose name was ticked off on every list as a class enemy) was vulnerable again. From the point of view of both regimes I was born tainted. I thus experienced their disapproval not as a person but as a creature belonging to first a racial category, then a social category doomed to extinction. What I was actually like never entered the picture: I was guilty by definition. I of course rebelled and was immediately--and rightly--classified as a dissident.[106]

As a reminder of past political oppression, Konrád retells the story of his life. His identities, private and public, reaffirm his political existence against the frameworks of communist or nationalist paradigms. "Vulnerable again," and "tainted" in the before and after of fascist or communist regimes, the writer legitimizes his rhetorical voice as a critical intellectual, playing his multiple

voices of *Otherness* against each other.[107] He thereby establishes a rhetorical relationship between identity and political power in his discourse. His rhetorical personae are transformed in discourse as political and socio-cultural power constitutes the background that makes his dissent significant.[108]

Hence, no singular identity within Konrád's cluster of voices can be separated from the context of communism and oppression. Power becomes the major rhetorical, cultural, and political context against which his discourse on identity emerges.[109] Political oppression invokes Konrád's identity of resistance at its core. In a sense, power functions in Konrád's discourse along the lines of Foucault's view on humans creating and recreating structures of order through language.[110]

Konrád's strategies to merge public and private identities within the discourse of a critical intellectual in post-communist Hungary are his response and his reconstitution of legitimacy in the new public arena. After all, in spite of the demise of the oppressive regime of communism, the resistance to democracy in a *freed* socio-political context remains active. Hungary after 1989 continues to be a society in transition, its public sphere full of contradictions, social and cultural animosities, fears, and *rancune*.[111] Hence, power permeates both public and private arenas, and all dimensions of cultural and political discourse. Consequently, Konrád cannot, and will not, detach his voice from the social and political context because his texts constitute political statements. His ethos remains culturally embedded in both past and present contexts, in the public and private arenas of communism and post-communism, locating his rhetorical identity again within the *both/and* realm of speech.

Rhetorically, as the author advocates critical resistance through language, he articulates dissent in order to transform power into antipolitics.[112] More important, by merging his public and private identities in relation to political power, Konrád creates a *language of resistance*.

Rhetorical Identities: What Power Does to Voice

Everything Konrád writes about his personal life, his social and political commentaries on Hungarian and other Eastern European societies, and his views on dissidence as moral action carry political and cultural implications in discourse. He strategically uses both personal and public experience to advance his discourse as, at the same time, it invokes political and socio-

cultural power in a civil society. What are the implications of this relationship between identity and power to a rhetorical understanding?

Looking at the work discussed here, three implications follow related to Konrád's rhetorical identity of resistance. First, his discourse of dissent reveals political and cultural relationships between the absence and presence of power. Second, his rhetorical action empowers the voices of the powerless, opening exilic and dissident identity to carry political legitimacy in discourse. And third, his essays call for political resistance through language by addressing the question of multiple loci of voice against political contexts.

Absent and Present Voices: Regaining Power

Significantly, the silenced identity Konrád constructs in his discourse becomes a powerful *voice* in the public arena. The salience of this strategy is that the cluster of resistant identities Konrád plays against each other in his essays is set within the framework of the absence and presence of power in discourse. The root of the power/discourse relationship has recently become a lively problematic in contemporary rhetorical theory. McKerrow, in "Critical Rhetoric: Theory and Praxis,"[113] views critical rhetoric as serving a "demystifying function by demonstrating the silent and often non-deliberate ways in which rhetoric conceals as much as it reveals through its relationship with power/knowledge."[114] Distinguishing between a critique of domination and a critique of freedom, McKerrow aligns several principles for critical rhetoric, among them the presence and absence of discourse. With Hall as his starting point to emphasize the relationship between meaning and ideologies in discourse,[115] McKerrow articulates that "*absence* is as important as *presence* in understanding and evaluating symbolic action."[116] For Hall, terms and language carry meaning in contingence with "what is absent, unmarked, the unspoken, the unsayable," becoming relational "within the ideological system of presences and absences."[117] McKerrow's perspective on absence and presence emphasizes, then, the dynamic of the said and unsaid in rhetorical discourse. Thus, rhetors whose identities are expressed in multiple locations of resistance through language might, in a sense, use this rhetorical perspective of absence and presence of power in their discourse.

Turning from McKerrow's and Hall's conceptualizations to Konrád's context of exilic "absence" in pre-1989 Hungary, what is "unsaid" in public discourse pulls its rhetorical force from the accepted discourse in the

"official" (public) sphere. In addition, as an important modification to the previous concepts presented by McKerrow, when looking at the dynamic of said and unsaid within the rhetor's reconstitution of voice, the question Konrád addresses is the silence or the presence of the sayer within the discourse. For a rhetoric of resistance, and for dissidents participating in underground discourse of communism, it is this *double frame of reference*, the absence and presence of terms, the dialectic play and reversal of vocabularies that carries rhetorical force for rhetors and audiences together.

Rhetors of resistance bridging the cultural memory and history into a vocabulary of dissent against political authority in communism locate themselves within language as a double frame, where absence and presence share rhetorical meanings for freedom and critique of communist practices for both rhetors, and their audiences in the public arena.

Reinventing discourse outside of the 'wood language" of populist appeals, relocating meanings, and with them political actions, words and their absence "have histories, too" in Havel's view, for

> The selfsame word, can, at one moment, radiate great hopes, at another, it can emit lethal rays. The selfsame word can be true at one moment and fast at next, at one moment, illuminating, at another, deceptive. On one occasion, it can open up glorious horizons; on another, it can lay down tracks to an entire archipelago of concentration camps. The selfsame word can, at no time be the cornerstone of peace, while at another, machine-gun fire resounds with its every syllable.[118]

Locating ethos within the liminal reference nexus between absence and presence of discourse, the counter-discourse emerges, thus allowing dissidents and speakers of resistance together to reconstitute identity, public consciousness, and democratic vocabularies from the past toward the future of a society. The rhetorical salience of a double frame of reference is enthymematic and always already understood by readers of communist and post-communist public discourse. Reinforcing *presence* as utterance in the public sphere pre-1989, Klima states in his conversation with Philip Roth that "writers had to pay a high price for *these* (my emphasis)words that take on importance because of the bans and persecution"[119] Absence, as a loss-of-utterance, in return, becomes a rhetorical imperative during communist times, as Konrád states about his friend Haraszti, yet another 'absent' dissident, "In state socialism, one never talks about the writer's freedom, only about the writer's responsibility. *He who talks about freedom is irresponsible*(my emphasis).[120] Hence the double frame of reference becomes

an important rhetorical locus for reconstitution of identity, for bridging ethos and publics when articulating democracy within the public sphere of pre-and post-1989 new Europe.

Accordingly, Konrád's public absence during communist times, his identity as an exile, transforms itself into a political presence within the same context. His exile and silence become contingent to what *can* be said versus what *cannot* be said in the public arena of a communist country. Looking at how Konrád recreates himself in context, his identity in discourse is always already (also) what he is *not*. The author presents his public beliefs and opinions in an *enthymematic* dialogue with all he could not have said or written in Hungary during, and even after communist times.

His *presence*, as a linguistic construction of identity, constitutes an inherent part of his speeches, essays, or literary works. Writing about Hungary before and after 1989 and about the necessary role--that is, the presence--of intellectuals in remaining the guiding force in Central and Eastern European civil societies, Konrád brings his public identity as a rhetorical persona within the context of power. However, Konrád's presence is "tainted," "guilty by definition," for he is and remains "a dissident."[121] Hence, Konrád articulates his presence in discourse after 1989 against his own absence from the public sphere in the past. His former life in the underground, outside the borders of the "official" public sphere, remains a constant rhetorical exigence in his writings.

Konrád's *samizdat* voice constitutes the silent--that is, absent--reminder of his now-public identity in discourse. Crossing public and underground participation in language, the author posits himself at the intersection between official and unofficial discourse, in the in-between of the "public" realm of resistance.

Seen from this discursive paradigm of absence and presence, Konrád's public absence as an exile turns into a political presence, a rhetorically empowered voice. During communist times Konrád was *the* forbidden writer of Hungarian literature, banned for sixteen years from any presence in the public sphere. Yet, his voice gained more and more power through his *absence* from official communist discourse, speaking, as it did, from samizdat lithographed pages. It is from what Hável calls "the hidden sphere" that Konrád crafts identity and accrues legitimacy within the open realm of democracy. [122]

Absence for Konrád is actually a complementary dimension of his identity, the seat of his rhetorical power. One can say that *absence* becomes a

necessary rhetorical exigence of redefinition.[123] Konrád's identities, public and private, gather around his own rhetorical reading of power. Readers and author remember and reconstruct a language of resistance, through his works. In post-communist Hungary, Konrád could omit the silenced rhetorical identity from his discourse. However, his power would then be void of resistance. Consequently, Konrád intentionally recaptures his silenced voice in his reconstitution of identity in order to gain its rhetorical power and legitimacy. This rhetorical action brings his dissident identity as an absent and present existence into the public arena, where Konrád evokes, for himself and his audiences, days of past evils for the benefit of a better future in Hungary.

Powerless Voice: A Powerful One

The absence/presence relationship does not constitute the only rhetorical and cultural modality for discourse to reinscribe resistance to political power when looking at Konrád's identity in his writings. Konrád's voices of dissent as a rhetorical *other*, a critical intellectual, an exile, and a Jew, enable his shift from powerless to powerful positions, as his identity in the margins invites a rhetoric of resistance. What shapes the author's fragments of identity rhetorically is precisely a number of plural relationships against communist, fascist, and nationalistic discursive formations, to paraphrase Foucault. His intersecting of multiple voices from the margins offers Konrád the opportunity to open up discourse towards plural perspectives or resistance, never seeing "things in isolation."[124] In addition, contingent to political power, dissident and exilic identity reveal intricate relationships between power and powerlessness in the political arena. Being a dissident and a public intellectual means specifically to enter the realm of articulating one's views within what Havel calls the very "power of the powerless." Havel emphasizes the empowerment dimension of the silenced voice in the political discourse of resistance: "[T]he singular, explosive, incalculable political power of living within the truth resides in the fact that living openly within the truth has an ally, invisible to be sure, but omnipresent: this hidden sphere."[125]

Dissidence, then, involves speaking from the margins of politics, and as such, allows the speaker to resist the ruling political power. Recognizing how exile becomes an almost exhilarating position, Said argues similarly,

emphasizing exilic identity as always "in the marginal," following no "prescribed path," or political system.[126]

In spite of all political oppression, exiled intellectuals like Konrád speak from their condition of marginality with no *more* fear, for there is no *Other* oppression to face beyond that already in place. This particular position of underground voices explains the rhetorical, cultural, and sociopolitical "power" of dissident writers.[127] Like Havel or Michnik, Konrád creates a unique public discourse, joining his oppressed existence with his liberated voice of dissent. Living on the fringes of cultural and political discourse, dissidents and exiles like Konrád occupy a freed rhetorical locus of "a median state, neither completely at one with the new setting nor fully disencumbered of the old, beset with half-involvements and half-detachments, nostalgic and sentimental at one level, and adept mimic or a secret outcast on another."[128] As such, Konrád invites in discourse an empowered multitude of voices, freed by his powerless resistance to political oppression.

Identity in the margins liberates Konrád to shape through words the public sphere of antipoliticians. Hence, his empowered rhetorical condition allows him to reconcile his public and private voices and continuously relocate himself in the margins of an efficient discourse of resistance.

Plural Voices: A Complex Locus of Resistance

As Konrád constructs plural loci of dissident identity in his discourse, does he favor any particular voice? Throughout his writings, the author presents himself as an inner exile, a marginalized citizen, while at the same time he depicts the political struggles of critical intellectuals as an anticommunist group and the responsibilities of participants in the creation of a civil society in Hungary. Does any element of his plural public and private existence get to be privileged?

Konrád's rhetorical merging of private and public voices seems to emphasize mainly his multiple locations of resistance as a critical intellectual, a dissident, an internal exile, and a minority in his discourse. His multiple voices of resistance and dissidence allow Konrád as a rhetor to continue an efficient and complex rhetorical action promoting the democratization of the Hungarian public sphere.

Consequently, numerous rhetorical, cultural, and political questions about Konrád's exilic voice remain open. Is Konrád only a writer whose

"words open wounds,"[129] or the "literate citizen" who never forgets the past in order to remain only "the keeper of legitimacies"?[130] Does his presence in discourse as a "tainted" Jew, a samizdat popular antipolitician, or writer from the underground always already remain within his language of resistance? Is it important to have a *central* exilic identity for all of Konrád's writings?

These questions open the rhetoric of exile for further scholarship. Significant for this study is Konrád's continuum of dissidence in discourse, pulling in a consubstantial move all his rhetorical voices.[131] His strategies to intersect public and private existence against power in his writings demonstrate the *both/and* rhetorical function of discourse.

Scrutiny of how Konrád plays the public and private identity of dissidence against power shows that his discourse reintroduces a rhetoric of marginalization in its complexity. Interpellating political and cultural power, he reconstructs ethos, pitting power against dissidence in intricate rhetorical relations pertinent to a palimpsest-like political arena. Reconstituting himself, Konrád pulls into his rhetorical voice the dynamic and transformative double frame of absence and presence as an inherent rhetorical dimension. At the same time, the Hungarian dissident empowers his powerless identities, liberating his rhetorical locus of voice from any political hegemony. Finally, Konrád's rhetorical action of merging identities regains rhetorical force as he continues to reconstitute his personal and public voices of resistance in order to create discourse in post-communist Hungary. Playing his voice of resistance against power, Konrád reasserts an antipolitical discourse, conducive to civil society in his country, and possibly throughout Eastern and Central Europe.

For Konrád 's rhetorical voice becomes an interstitial civic speech of freedom and antipolitics within the framework of historical public and counter public discourse. The consubstantial work of cultural memory and political language provide the contextualized arena where exile and resistance are reconstituted with and within enthymematic powers of dissent against communist practices of Central Europe. Konrád's rhetorical strategies are some of the ways in which culture, identity, and evocation of resistance intertwine in reconstituting ethos within the public culture of an area in transition toward democracy. In other countries of Eastern and Central Europe, communist discourse invited other responses to resistance, forcing dissidents to leave the country and provide other loci for reconstitution of voice in cultural counterpublics of the world.

Notes

[1] Zygmunt Bauman, *Life in Fragments: Essays in Postmodern Morality*, (Oxford, UK: Blackwell, 1995) 223-43.

[2] As mentioned, in the body of studies in political science and sociology, these educated elites from Eastern and Central Europe are called "critical" or "public intellectuals." See Havel, *Summer Meditations* 127; and Tismaneanu, *Reinventing Politics* 153-75.

[3] Vladimir Tismaneanu, "Knowing and Doing," *Village Literary Supplement* 10 (1995): 15-18.

[4] As mentioned, Konrád, Havel, Michnik, Klima, Sakharov, and Haraszty embody in their literary works political and national opposition to communist, antidemocratic governments in current times. Tismaneanu presents most of these critical intellectuals and their works in *Reinventing*, 133-74.

[5] At least this is the major argument pro-critical intellectuals after 1989, and Konrád is one of the key spokesmen for this political and cultural issue of democracy in the public sphere.

[6] As mentioned, I use interchangeably the terms "critical intellectuals," "public intellectuals," and " dissidents" due to the history of communist Central and Eastern Europe. In most of the research on public and critical intellectuals from this area, the scholars use the terms meaning all groups of dissidents during communism. For example, aside from Tismaneanu, see Katherine Verdery, "Intellectuals," *National Ideology Under Socialism: Identity and Cultural Politics in Ceaușescu's Romania*, (Berkeley: U of California P, 1991) 15-19; and Julia Kristeva, "A New Type of Intellectual: The Dissident," *The Kristeva Reader*, ed. Toril Moi (New York: Columbia UP, 1986) 292-301.

[7] Ion Iliescu, the former president of Romania, had coined this expression in one of his public appearances early in 1990; "communism cu față umană" in Romanian.

[8] An excellent article relating to the future of intellectuals is written by Wolf Lepenies and published in *Partisan Review*. See Wolf Lepenies, "The Future of Intellectuals," *Partisan Review*, 61 (1994): 111-20.

[9] Writing about the role the Hungarian dissident plays in the *samizdat* literature of Eastern and Central Europe, Tismaneanu states that: "Konrád was one of the intellectuals who formulated the language of dissent, and his reflections on the post-communist order are

telling. . . . Both authors [Havel and Konrád] are struck by the ambiguities, disappointments, and pitfalls of the post revolutionary period; both look to the legacy of dissent as a wellspring of moral inspiration; and both recognize that the memory of the Communist experience can protect us from new mythological fallacies" (17). Tismaneanu, "Knowing and Doing" 15-18.

[10] In different bibliographic sources, Konrád's first name is spelled in accordance with English or Hungarian languages. Thus, his name appears either as George or György Konrád. See György Konrád, *Antipolitics*, trans. Richard E. Allen, (San Diego: Harcourt Brace, 1984).

[11] George Konrád, *The Melancholy of Rebirth: Essays from Post-Communist Central Europe, 1989-1994*, trans. Michael Henry Heim (San Diego Harcourt Brace, 1995).

[12] Evidence for this statement is the number of awards and world-wide recognition Konrád has received since 1989, including an increasing number of public invitations to lecture in the world. Elected in 1990 the President of International PEN, the first Central European writer to hold this position, and winner of the Peace Prize of the German Book trade in 1991 during the famous Frankfurt Book Fair, the author receives public acknowledgments. See "Prizes," *World Literature Today* 65 (1991): 782. Visits to United States (UCLA, 1994), and to universities and other public conferences in Europe attest to his popularity. Modestly, in "Snapshot on the Day After All Saints' Day," Konrád calls himself an "itinerant" teacher (146).

[13] Both Havel and Michnik, two of the most important *samizdat* dissidents in Central Europe, spent time in prison during the communist regime. See Václav Havel, *Letters to Olga* (New York: Knopf, 1988); and Adam Michnik, *Letters from Prison and Other Essays* (Berkeley: U of California P, 1985).

[14] Both his first novel, *The Case Worker* and his political essay *Antipolitics* are published in the West first. They are reprinted in Hungary, after 1989. As Konrád retells his story, he states that his "Antipolitics" essay is published first in the West, due to a network of friends already exiled. See Konrád, "A Self-Introduction" ix-x. As for the Hungarian underground, Miklós Haraszti is another dissident writer participating in the Hungarian and Central European discourse of resistance. His work, *The Velvet Prison*, provides insight on intellectuals' dissidence. Interesting is to note the solidarity between dissidents, as the Foreward is written by Konrád. See Miklós Haraszti, *The Velvet Prison: Artists Under State Socialism*, trans. Katalin and Stephen Landesmann, and Steve Wasserman (New York: Farrar, Straus and Giroux, 1987).

[15] See Vladislav, "Exile, Responsibility, Destiny" 14-28. Konrád himself accepts this identity in his essay, calling himself a "private dissident" in "15 March." See Konrád, "15 March" 135.

[16] Tismaneanu, "The Triumph of the Powerless," *Reinventing* 198-205.

[17] There is an extensive body of political and sociological literature regarding the resurgence of nationalism in Eastern and Central Europe. Since this is not the focus of my book, I will point to only one important work that captures the essential problems in the scholarship mentioned. See Vladimir Tismaneanu, *Fantasies of Salvation: Democracy, Nationalism, and Myth in Post-Communist Europe* (Princeton: Princeton UP, 1998).

[18] The pagination for each essay is listed in the bibliography.

[19] In addition, being Jewish, the author is familiarized with being considered "different" during (and after) World War II in Central Europe. There is ample scholarship on this subject matter. For the benefit of brevity, see Deborah Lipstadt, "Anti-Semitism in Eastern Europe Rears Its Ugly Head Again." *USA Today.* (Sept 1993), 122-2589, pp. 50-54. Also, see Peter Kenez, "Antisemitism in Post World War II Hungary." *Judaism: A Quarterly Journal of Jewish Life and Thought*, 50.2 (Spring 2001):144-54.

[20] See L Joris,"Looking Back at the Melancholic -Revolution, Traveling in Hungary, 1989-1990," *Hungarian Quarterly*, 34.131(Fall 1993):117-125; and Janos Simon, "Post-Paternalist Political Culture in Hungary: Relationship Between Citizens and Politics During and After the 'Melancholic Revolution'(1989-1991)."*Communist and Post-Communist Studies*, 26.2 (June 1993):226-239.

[21] For all communist countries, the term "bourgeois"is more than a part of capitalist ideology and its terminology, for that matter. It also stands for black-listed people on basis of their "unhealthy" origin who could end up imprisoned, banned, and this might be the best case scenario in the 1950s, or killed by communist regime. Konrád uses the same term in his "A Self-Introduction." Additionally, see Katherine Verdery, "The Means of Conflict:'Elitism,' 'Dogmatism,' and Indigenization of Marxism," *National Ideology*, 137-56.

[22] Very insightful reviews of Konrád's recent novel published in English, *A Feast in the Garden* are signed by Stanislaw Baranczak and Betty Falkenberg. See Stanislaw Baranczak, "Truth and Consequences," Rev. of *A Feast in the Garden*, by George Konrád. *New Republic*, 31 Aug. 1992: 42-46; and Betty Falkenberg, "Memories Wrested From Oblivion," Rev. of *A Feast in the Garden*, by George Konrád. *New Leader*, 29 Jun. 1992: 17-19. Baranczak, in particular, refers to the literary strategy Konrád uses to integrate his own real-life person within the main character of the book.

[23] Fundamentally anti-political, Konrád explains his position as a call for de-politicization. "A society does not become politically conscious when it shares some political philosophy, but rather when it refuses to be fooled by any of them" (227) as he continues, "[W]e ought to depoliticize our lives. . . so I would describe the democratic opposition as not a political but an antipolitical opposition." See Konrád, *Antipolitics*, 227, 229.

[24] Referring to communist and post-communist regimes, Konrád invokes Kadar and Antall as metaphoric personae in his discourse. In the historical context of his country, Kadar was the Hungarian President before 1989, and Antall, after 1989. See Konrád, "15 March" 135.

[25] This is the only place in *Melancholy* where Konrád speaks about himself in the third person singular. However, in *A Feast in the Garden*, his main character, a writer, is viewed by literary critics like Baranczak, for instance, to represent the author himself. Thus, although it might be a literary device to view himself as a 'character' in the play of the world, using a poetic licence onto himself, I consider this strategic choice a rhetorical and effective one, both in terms of his readership and of his redefinition of identity.

[26] I am grateful to Robert Hariman for his suggestion, since I consider the relation between Kafka and Konrád more than significant for both this project as well as for the entire cluster of Eastern European identity of otherness.

[27] Franz Kafka, *The Trial*. Trans. Willa and Edwin Muir (New York: Schocken Books, 1995). See also George Steiner. "Introduction."to Franz Kafka, *The Trial*. Trans. Willa and Edwin Muir (New York: Schocken Books, 1995): vii-xxi. See also Franz Kafka, *The Castle*. Trans.Willa and Edwin Muir (New York: Schocken Books, 1982).

[28] See Robert Hariman, "A Boarder in One's Own House: Franz Kafka's Parables of the Bureaucratic Style," *Political Style: The Artistry of Power* (Chicago: U of Illinois P, 1995): 141-177. The literature on Kafka's K. is exhaustive and intriguing, in light of the rhetorical action accrued and constituted by such a rhetorical and literary strategy.

[29] Another intriguing rhetorical venue would be to revisit Burke's concept of representative anecdote along with Brummett's position, taking K. as a method of criticism. See Kenneth Burke, *A Grammar of Motives*, (Berkeley: U of California P, 1969); and Barry Brummett, "Burke's Representative Anecdote as a Method in Media Criticism," Critical Studies in Mass Communication, 1(1984): 161-176, Rpt. in *Contemporary Rhetorical Theory: A Reader*. Eds, John Louis Lucaites, Celeste Michelle Condit, and Sally Caudill. New York: Guilford, 1999. 479-494.

[30] In a sense I use 'parable' to reveal both an important part of Kakfa's own use of ambiguity in and through language, as well as Hannah Arendt's reflection on the emblematic function of Kafka's parable in the liminal spaces of past and present, of good and evil, of capitalist and fascist times in Europe. Hannah Arendt's "Preface" to *Between Past and Future* makes use of Kafka's parables as indicative of oppressed existence. See Hannah Arendt, "Preface: The Gap between Past and Future,"*Between Past and Future: Eight Excercises in Political Thought*, (New York: Penguin, 1995): 3-15.

[31] Philip Roth, "A Conversation in Prague."*Writings on the East: Selected Essays on Eastern Europe from the New York Review of Books*. (New York: The New Work Review of Books, 1990): 101-132.

[32] See Kenneth Burke, *A Rhetoric of Motives* (1950; Berkeley: U of California P, 1969) 21.

[33] Cited by Arendt, Kafka's parable reads as follows: "He has two antagonists; the first presses him from behind, from the origin. The second blocks the road ahead. He gives battle to both. To be sure, the first supports him in his fight with the second, for he wants to push him forward, and in the same way the second supports him in his fight with the first, since he drives him back. But it is only theoretically so. For it is not only the two antagonists who are there, but he himself as well, and who really knows his intentions?" See Hannah Arendt, "Preface" *Between Past and Future: Eight Exercises in Political Thought*, (New York: Penguin Books, 1993): 7.

[34] Konrád, "A Self-Introduction" vii.

[35] Throughout the book I use both spellings for *the other* and *the Other* to signify the marginalized position of a rhetor in the public discourse of a society.

[36] George Steiner in the "Introduction" to *The Trial* states about K.: "Rightly, we experience Kafka's vision as one of *tragic horror* (my emphasis). He stands, as we will note, in a singular relation of clairvoyance to the inhuman, to the absurdly murderous in our condition. The *tristitia*, the 'sadness unto death' in Kafka's writings, letters, diaries, and recorded remarks are bottomless. But there is also in him a *social satirist, a craftsman of the grotesque* (my emphasis), a humorist with an eye to farce and slapstick."(xv)

[37] Konrád, "A Self-Introduction" vii-viii.

[38] Konrád, "A Self-Introduction" viii.

[39] Timothy Garton Ash, "Apres Le Deluge, Nous." *Writings on the East: Selected Essays on Eastern Europe from the New York Review of Books*. (New York: The New Work Review of Books, 1990): 29.

[40] Ivan T. Berend. *Central and Eastern Europe, 1944-1993: Detour from the Periphery to the Periphery*. (Cambridge: Cambridge UP, 1996): 94-153.

[41] Konrád, "A Self-Introduction" viii.

[42] Konrád, "A Self-Introduction" viii.

[43] Konrád, "A Self-Introduction" viii.

[44] Konrád, "A Self-Introduction" ix.

[45] Miklós Haraszti. "Soft Censorship." *Media Studies Journal*, 13.3 (1999): 78.

[46] Konrád continues: 'Therefore, this intelligent , humorous, vulnerable, magnanimous, overscrupulous, and overemotional man [Haraszti]–who is considered arrogant although he is growing ever so gentle–will have to assume his rightful place here only belatedly" as he dates his comments, Budapest, October 1986(xiv). See Konrád, "Foreword." in Miklos Haraszti, *The Velvet Prison: Artists Under State Socialism.* Trans. Katalin and Stephen Landesman. New York: Farrar, Straus and Giroux, 1987).

[47] Based on my knowledge of communist argot, to become a "problem" person signified to be on the black list or potentially an enemy of the state.

[48] He continues by acknowledging its impact on the Western literary world, as this novel was "translated into thirteen languages," thus, enjoying "critical acclaim abroad." See Konrád, "A Self-Introduction" ix. His first novel appeared in 1974 in the States; see György Konrád, *The Case Worker,* trans. Paul Aston (New York: Harcourt Brace, 1974).

[49] To this day, Konrád remains friends with Szelényi. In 1977, they wrote a well known study on socialism and the intelligentsia, and another revision, later. Konrád in "A Self-Introduction," mentions his collaboration with Szelényi. Co-authoring the study, "Intellectuals on the Road to Class Power," exposing "the complicity of the Hungarian intelligentsia with the postwar regime" they both went to prison. See George Konrád and Ivan Szelégnyi. *The Intellectuals on the Road to Class Power.* New York: Harcourt, Brace Jovanovich.1979; and Konrád, "A Self-Introduction" ix-x; Heim, "Translator's Afterword,"194. In 1994, Konrád lectured at UCLA, where Szelényi is a faculty member in the Department of Sociology. And in a letter posted on the Web on Szelenyi's recent 60's birthday, Konrád starts by writing: "Thanks for being, dear Ivan!" See György Konrád, "On Ivan Szelényi's Birthday," trans. Katalin Orban, 1999, 28 Jan, 1999 < http:// www.hi. rutgers.edu/szelenyi60/konrad.htm>.

[50] Konrád adds that, from then on (until 1989) "K. was not heard from at home: because his sins kept mounting and he refused to censor himself, he fell under a total ban"(x). See Konrád, "A Self-Introduction" x.

[51] Konrád, "A Self-Introduction" ix.

[52] His "Antipolitics," a critique of the "'Yalta system' and its disastrous consequences for the fate of Central Europe" reached far more audiences than the author actually estimated. Konrád, "A Self-Introduction" x.

[53] Roth, "A Conversation" 119.

[54] Konrád, "A Self-Introduction" x.

[55] Once again, notice the title of both essays. Joris uses "Looking Back at the *Melancholic Revolution* (my emphasis)," and Simon, "Post-Paternalist Political Culture in Hungary: Relationship Between Citizens and Politics During and After the '*Melancholic Revolution*'(my emphasis) (1989-1991).

[56] Chronology. *Writings on the East: Selected Essays on Eastern Europe from the New York Review of Books*. (New York: The New Work Review of Books, 1990).

[57] Timothy Garton Ash, "Apres Le Deluge, Nous." *Writings on the East: Selected Essays on Eastern Europe from the New York Review of Books*. (New York: The New Work Review of Books, 1990): 27.

[58] Timothy Garton Ash, "Apres." 27.

[59] András Bozóki. "Rhetoric of Action: The Language of the Regime Change in Hungary." in *Intellectuals and Politics in Central Europe*. Ed. András Bozóki. (Budapest: Central European UP, 1999): 268-9.

[60] Konrád, "15 March," 135; and "Hail and Farewell," 181.

[61] I consider these two essays as one piece of discourse. My choice is substantiated by the chronology of the events as well as by the author's own position of the essays in continuation of each other in the collection.

[62] Petöfi is the national Hungarian poet; thus the location takes on more meaning for any writer living in Hungary.

[63] According to Konrád, the audience for the speech was of "fifteen thousand people." See Konrád, "15 March"131.

[64] As a (free) citizen of Hungary, his civic duty is to "counterbalance the state's tendency to absolute power." Konrád, "Holiday" 127.

[65] Konrád, "Holiday" 129.

[66] Based on Hauser's conceptual use of "historicity" as a rhetorical action, one might read 'history' and 'historicity' as emblematic synonyms for this analysis. See Gerald A. *Hauser,*

Vernacular Voices: The Rhetoric of Publics and Public Spheres.(Columbia, SC: U of South Carolina, 1999).

[67] Talking specifically about "historicity" as it applies to Central Europe, Hauser argues that in post-1989 world the members of civil society had to rely on their own historicity. "Appropriating historicity entails acts of selection and emphasis on which self-understanding is based and which provide the resources to invent publicness. It is a rhetorical accomplishment "(113). See Hauser, *Vernacular Voices*, 111-161.

[68] "Thoughts on the Border" (1-7), "More Than Nothing: The Role of Intellectual in a Changing Europe" (78-97), "Being a Citizen" (118-23), "The Holiday Looks Back" (123-30) "To the Editorial Board of the *Magyar Hirlap*" (136-9) and "To Hungarian Serbs and Croats" (139-42) are all reprinted speeches Konrád gave in celebration of democratic values.

[69] Konrád, "Holiday" 129.

[70] Konrád, "Holiday" 125.

[71] Konrád, "Holiday" 125.

[72] Konrád lists some of the Charter's points. "What lies at the heart of the Charter? The survival of humanity. Government by law. Respect for individuals and minorities. Freedom of thought. Moderation of state power." Konrád, "Holiday" 127.

[73] For Central and Eastern European nationalism, far-right means "nationalistic and anti-Semitic" as Konrád explains: "[F]ar-right organizations calling for 'genuine Hungarian and Christina media' (which translates into 'Kick the Jews out of the press') did in fact show up." Konrád, "15 March" 131.

[74] Konrád, "15 March" 131.

[75] Konrád, "15 March" 132.

[76] Konrád, "15 March" 135.

[77] "*Otherness*" identity related to being Jewish is overtly or covertly one of the continuous themes of the cultural discourse in Central and Eastern Europe.

[78] Konrád, "15 March" 133.

[79] Konrád, "15 March" 131.

[80] Konrád, "15 March" 133.

[81] Tismaneanu continues: "After all, the 'glorious revolutions' were, with exception of Romania, peaceful and gentle. Their dominant discourse was imbued with references to the universal rights of man and citizen. It was a discovery of the values of Enlightenment in a space once plagued by ethnic exclusiveness and authoritarian fundamentalism. Then, as the euphoria of emancipation dissipated, the appeal of the discourse of civil society and human rights subsided," see Tismaneanu, *Fantasies* 81.

[82] Konrád, "15 March" 133.

[83] Konrád, "15 March" 134.

[84] Konrád, "15 March" 135.

[85] Konrád, Codrescu, and Drakulić, all three writers analyzed in this book, make use of personal pronouns as cultural enthymemes for communist and noncommunist identities. In each chapter I provide specific explanations of this rhetorical and socio-cultural strategy in the context of Eastern and Central European discourse of dissent.

[86] Konrád, "The Melancholy of Rebirth" 48.

[87] Konrád, "Melancholy" 48.

[88] Konrád, "Hail and Farewell"181-91.

[89] Konrád, "Melancholy" 48.

[90] Konrád, "Hail and Farewell" 184-85.

[91] Konrád, "Hail and Farewell" 185.

[92] One of the most cited works in reference to the role of 'public intellectuals' in Eastern and Central Europe is Konrád's work in collaboration with Szelenyi on the topic. See George Konrád and Ivan Szelégnyi. *The Intellectuals on the Road to Class Power*. New York: Harcourt, Brace, Jovanovich.1979.

[93] Konrád wrote other essays pertinent to the mentioned function of intellectuals in the area. See George Konrád, "Intellectuals and Domination in Post-communist Societies." In *Social Theory in a Changing Society*. Eds. Pierre Bourdieu and J.S. Coleman. (Boulder: Westview, 1991): 337-61.

[94] The complete title and date is the following. "More Than Nothing: The Role of the Intellectual in a Changing Europe (Excerpts from the inaugural Lecture for the Conference of

German University Chancellors, Sankt Paulus Kirche, Frankfurt, 28 April 1991)." See Konrád, "More Than Nothing" 78-97. Konrád, in the speech, explicates the necessity for the "critical mind" (the intellectual's chief tool) to allow "the contours of an internal plan to emerge" in order for people to become fully responsible for their acts. Konrád, "More Than Nothing" 79.

[95] Brodsky asserts that writers in exile have the moral the function to tell "about oppression" and to warn "any thinking man toying with the idea of an ideal society." See Brodsky, "The Condition of Exile," 11. For the rhetorical investigation of Brodsky's specific writing, see also Noemi Marin, "Eastern European Exile and its Contemporary Condition," *Migration: A European Journal of International Migration and Ethnic Relations*, 33/34/35 (2002): 155-71.

[96] Konrád, "Hedonists of the Brain" 148.

[97] Konrád, "More Than Nothing" 79-80.

[98] Konrád, "More Than Nothing" 81-82.

[99] Konrád, "More Than Nothing" 82.

[100] András Bozóki edited an excellent volume on the role of intellectuals within the political realm of Central Europe. Specifically discussing the role of critical intellectuals along Konrád's views, see the studies by András Bozóki (1-19; 263-85), Irina Culic (43-73), and Marian Kempny 151-67). See András Bozóki, ed. *Intellectuals and Politics in Central Europe*. (Budapest: Central European UP, 1999).

[101] Konrád, "More Than Nothing" 83.

[102] Konrád, "Something Is Over" 69-78.

[103] Konrád, "Something" 73-74.

[104] Konrád, "Something" 73.

[105] Konrád, "Melancholy" 47-48.

[106] Konrád, "Melancholy" 47-48.

[107] Konrád, "Melancholy" 47. In his discourse, Konrád's rhetorical move back and forth, between private and public voices, constitutes a powerful rhetorical strategy. In most of the essays of the collection, the writer sprinkles paragraphs or references to his personal life and utilizing his voice in different pronoun forms, as K. or "we writers" or "I." In each of these instances, readers are introduced to the cultural and political realities of living as a dissident in

a communist country. For example, in "Something Is Over" he identifies with "writers in our part of the world" (72); in "Hedonists of the Brain," with writers as "full-fledged citizens"(149); and in "Melancholy of Rebirth," the author remembers that "*we* (my emphasis) lived in the antiworld" and that "*I* (my emphasis) was born tainted." See Konrád, "Melancholy" 47-48.

[108] Konrád makes constantly references to language, to communist rhetoric and to the always already interpellated discourse into the context of power. A discussion of this particular dimension of Konrád's works will be presented in the last part of this chapter.

[109] Power here reads "political power."

[110] Michael Foucault, "The Discourse on Language," *The Archaeology of Knowledge and The Discourse on Language*, trans. A. M. Sheridan Smith (New York: Pantheon, 1977) 215-37. Along Foucault's view that due to the relationship between power and discourse, a subject occupies multiple critical positions in the dominant paradigm, Konrád's voices of dissidence align within similar lines of redefinition through language.

[111] Tismaneanu, in the conclusion to *Fantasies of Salvation* depicts the nationalistic and political conflicts that continue to make Central and Eastern Europe a social territory of turmoil. See Tismaneanu, *Fantasies* 153-69.

[112] Konrád's position in *Antipolitics* confirms precisely this point. See György Konrád, "Antipolitics,"*Antipolitics* (1984) 93-94, Rpt. in *From Stalinism to Pluralism: A Documentary History of Eastern Europe Since 1945*, ed. Gale Stokes, 2nd ed., (New York: Oxford UP, 1996) 175.

[113] Raymie McKerrow, "Critical Rhetoric: Theory and Praxis," *Communication Monographs*, 56 (1989): 91-111.

[114] McKerrow, "Critical Rhetoric" 91-92.

[115] I mentioned in the first chapter that cultural studies scholarship is extremely salient to rhetorical criticism, and McKerrow's article offers an exemplification of my statement.

[116] McKerrow, "Critical Rhetoric" 107.

[117] Stuart Hall, "Signification, Representation, Ideology: Althusser and the Post-Structuralist Debates," *Critical Studies In Mass Communication*, 2 (1985): 109.

[118] Havel, "Words on Words"12-13.

[119] Klima, in Philip Roth, "A Conversation in Prague." *Writings on the East: Selected Essays on Eastern Europe from the New York Review of Books*. (New York: The New Work Review of Books, 1990): 122.

[120] Konrád, "Foreword"xii.

[121] Konrád, "Melancholy" 48.

[122] Václav Havel, "The Power of the Powerless," 1979, Rpt. in *From Stalinism to Pluralism: A Documentary History of Eastern Europe Since 1945*, ed. Gale Stokes, 2nd ed., (New York: Oxford UP, 1996) 168-75. In a sense, the "hidden sphere" in communist times needs a more developed rhetorical study, for in it and through it, dissident intellectuals managed to express their ideas to their native audiences.

[123] Konrád, "Antipolitics" 93-94.

[124] Said makes this point, when explaining exile as a powerful location of voice. See Said, *Representations* 60.

[125] Havel, "The Power" 172.

[126] Said, *Representations* 62. Codrescu expresses an almost identical position, as he expresses the freeing experience of exile. See Andrei Codrescu, *The Disappearance of the Outside: A Manifesto for Escape* (Reading, MA: Addison-Wesley, 1990) 53-57.

[127] I am aware that I am using "power" in its multiplicity of rhetorical and political meanings.

[128] Said, *Representations* 49. I want to reiterate that I treat "dissident" and "exile" as a single rhetorical concept throughout the entire chapter. In my opinion, these two identities fulfill similar sociopolitical functions in communist times in Eastern and Central Europe.

[129] Konrád, "Identity and Hysteria" 98.

[130] Konrád, "Melancholy" 82.

[131] I would like to reiterate that Burke, when explaining consubstantiality within the identity and identification relationships in discourse, writes that: "[F]or substance, in the old philosophies, was an *act*; and a way of life is an *acting-together;* and in acting together, men have common sensations, concepts, images, ideas, attitudes that make them *consubstantial.*" See Burke, *Rhetoric* 21.

CHAPTER III

Andrei Codrescu: Exile or (An)*Other* Way To Be Poetic

De-framed, retrospective, and fundamentally discontinuous, a writer in exile[1] always faces fragmented images of the self.[2] Describing divergences of past and present identity, revealing dislocated and disparate sequences of memory, or seemingly speaking from several locations in the same moment, all expatriate writers recognize that exile always entails a clash between cultures. Edward Said describes exilic condition as "fundamentally a discontinuous state of being. Exiles are cut off from their roots, their land, their past" as they feel "an urgent need to reconstitute their broken lives."[3]

Living in different languages and cultures at the same time creates a continuous struggle to recreate voice in several worlds. Eva Hoffman, in her account of exilic redefinition, points to language as the intimate territory challenging expatriate intellectuals:

> The thought that there are parts of the language I'm missing can induce a small panic in me, as if such gaps were missing parts of the world or my mind--as if the totality of the world and mind were coeval with the totality of language. Or rather, as if language were an enormous, fine net in which reality is contained--and if there are holes in it, then a bit of reality can escape, cease to exist. When I write, I want to use every word in the lexicon, to accumulate a thickness and weight of words so that

they yield the specific gravity of things. I want to re-create, from the discrete
particles of words, that wholeness of a childhood language that had no words.[5]

Joseph Brodsky reminds us that the problems exile brings into a writer's
discourse are compounded because the power to articulate an identity, and to
establish one's character as a speaker, is itself subject to the disintegrating
effects of multiple languages.[4] Likewise, Baranczak calls himself and all
exilic writers "tongue-tied" due to linguistic fragmentation as these
expatriates try to balance "between two worlds, two cultures, two value
systems, and two languages" putting them "in more ways than one, at special
risk."[6] Aciman's response is by positioning them as "bewildered by narratives
that pullulate everywhere he[she] looks," answering "a far more fundamental
question: in what language will he[she] express his[her] confused awareness"
of personal existence in a paradoxical world. For, having chosen a career in
writing, exiled authors use "the written word as a way of fashioning a new
home elsewhere," doing an "absurd thing all exiles do, which is to look for
their homeland abroad, or to try to restore it abroad, or, more radical yet, to
dispose of it abroad."[7]

Pertaining to this group called writers-in-exile, Andrei Codrescu
identifies similar problems of multiple languages and fragmented voices as
inherent to migrant living. Returning to his native Romania in the aftermath
of the revolution of December 1989, twenty-five years after creating an
American identity, Codrescu reflects on his struggles to redefine his voice in
exile.[8] In a personal account of his experiences with expatriation, *The Hole
in the Flag: A Romanian Exile's Story of Return and Revolution*, Codrescu
faces the challenge of reconstructing his identity as a writer of exile. In this
part memoir-part political narrative of the fall of communism in Romania,
the writer details his struggles of dislocation and discontinuity in language.
His return prompts his realization that he is living in two worlds at once. For
him, exilic identity constitutes a forever-segmented voice, as cultural
fragmentation becomes a *sine qua non* condition of such a life. The past, an
ever-present companion for any exiled writer, accompanies him in Romania
as he revisits not only his native country, but also his former identity.

Within the symbolic geographies of exile, Codrescu's expatriation from
Romania is not necessarily political, but also poetic.[9] Romania is the
homeland with less dissidents than most Central and Eastern European
countries.[10] A homeland where poets and writers co-habit in language
symbolic dissent uses creative powers of discourse to poeticize resistance. A

children's poem takes the form of a counter public's hymn of resistance; a passport to freedom for a writer means *persona non grata* status and with it, an invitation to dissent outside of totalitarian regime. For it is easier, it seems, for political life of totalitarian Romania to rid itself of "problem" voices that could pollute the communist discourse of the official arena.[11]

Codrescu's identity as a poet, a Romanian Jew, and an exile frames his voice as an outsider for communist Romania. When Codrescu revisits his country of birth as an established poet attempting cultural assimilation in the United States for a quarter of a century, his exilic experience bears questions of rhetorical reconstitution and re-articulation of voice in past and present vocabularies of expatriation.[12] Becoming "Romanian again," paying the debt to his childhood, Codrescu experiences his identity as a foreigner the second time around in his country of origin, for his reconstitution of exilic identity became evident only when he returned.[13] Ontologically first, his identity from the margins carries through discourse a constant reposition of his locus of speech. Always already at the crossroad between cultures, history, past and present salience of a homeland, Codrescu resorts to discourse to reposition his identity as a continuous liminality.[14]

Following his poetic exile identity from Romania to the United States and back to his former homeland, Codrescu engages in yet another chronotrope of exile, writing almost at the same time another book, *The Disappearance of the Outside: A Manifesto for Escape.*[15] Here the vox from the margins of cultures shifts loci, repositioning and invoking countries as geographical entities turned cultural and symbolic borderlands of discourse. Building rhetorical identity from intricate strategies of dislocation, invoking multiple contexts of language and history, Codrescu reconstitutes himself as a poetic exile, an always already voice of difference in the pre- and post-1989 public arena of Eastern Europe.

In exile, writing in response to his fragmentation, Codrescu locates his rhetorical identity at the intersection of different cultural borders: between past and present, between homeland and host land, and between poetic and political participation. Most important, his strategic reconstruction of poetic exile threatens his rhetorical powers. For, if he fails to connect with multiple cultures as a rhetor of exile, his rhetorical persona must again live the fragmented life of a rhetor without an audience.

What is Codrescu's significance as a poet in exile in terms of an identity of resistance? How is this reconstitution important for Eastern European democracy? And who is the audience for Codrescu's fragmented and

refragmented voice of difference? Pertaining to invoke an ethos of liminal difference, Codrescu rearticulates identity within multiple reconstitutions of contexts, revealing cultural history and ontological fragmentation of dissent as coexistent participants within his voice of exile. Accordingly, Codrescu's rhetorical redefinitions of voice reclaim the powers of language to revisit exile as a palimpsestic locus for critical resistance from the margins, enabling discourse to invoke and revoke politics as terminal vistas of freedom of expression. Revealing layers of contextualized language in his tensioned accounts to exile and back, de-fragmenting choice within past and current political and cultural lands, Codrescu's rhetoric of difference offers an intriguing redefinition of dissent from communist and post-communist world.

Codrescu: The Fragmented Author

Andrei Perlmutter, now Andrei Codrescu, is an expatriate author well known both in his native Romania and in the United States.[16] Where Romanians see a political exile writing about the West,[17] Americans know his intellectual essays against conformism or popular consumerism, about cultural dissent.[18] Codrescu has been writing about his exilic experience since 1965. Like other Romanian exiles--Mircea Eliade, Eugene Ionesco, Emile Cioran, or Tristan Tzara--Codrescu voices his experience of migration from the margins of Romanian and American culture. However, as a main theme of his works, exile comes to the forefront of his literary works during the Romanian revolution of 1989.

Born Andrei Perlmutter in 1946 in Sibiu, Romania, the writer had the conviction of his vocation as a poet from a very early age.[19] In his first volume of memoirs, the autobiographic novel *The Life and Times of an Involuntary Genius*, Codrescu described his early stages of definition as a "poet," as a literary voice ready to take up the world with his ideas about life and democracy.[20] An enfant terrible in his teens, Codrescu wrote and read his poems in literary circles both in Sibiu and in Bucharest. By 1963, Codrescu had already published poems and essays in Romanian literary magazines.[21]

The period of the 1960s promised to create social and cultural openings to a new era. By mid-1960s Romania had a new communist leader, Nicolae Ceauşescu . As Mungiu and Verdery mention in their accounts on Romanian intellectuals,[22] at the time the intelligentsia hoped for a more open sociocultural arena in which to express democratic opinions.[23] Yet to a

teenager who perceived life from an individualistic perspective, the signs of communist oppression remained evident. Chafing under a politically oppressive system and dreaming of dissent, Codrescu decided to leave communist Romania. Soon after his literary debut in Bucharest, Codrescu managed to escape to the United States, becoming a voluntary exile.[24] The year was 1965, he was only nineteen years old. Unable to speak English well, Codrescu was determined to learn it in order to achieve his poetic vocation.[25]

Once in the United States, the poet maintained his identity of difference. Eager to express his freedom, and moving from New York to Detroit, Codrescu joined John Sinclair, Allen van Newkirk, and other literary writers of dissent in the American literary world of the 1960s. "I found my country of exile not in the company of my literal fellow exiles but in the native youth of America. At that time, exile was the *status quo* (my emphasis). Generations were in exile from each other, thousands of young people roamed the continent in deliberate religious abandon. Exile was part of the popular culture," remembers Codrescu with nostalgia.[26] At the same time, exile was becoming the "very language that people spoke in communist Romania,"[27] turning into a language where "truth was forbidden," inviting civic discourse to disappear as the foreign tongue of totalitarianism was gaining more and more power.[28]

While he continued to write poetry in Romanian for a while, Codrescu soon found himself more and more at home in the culture of American dissent.[29] Both his Jewishness and his Romanian cultural heritage helped him redefine himself as *the Other*.[30] Codrescu remembers: "My sense of being different [has] accompanied me since the day I was born. I am a Jew, so I was 'different' in Romania before ever being different in the States."[31] Like Konrád and most dissidents of Jewish descent in Eastern and Central Europe, the simple acceptance of an identity of Jewishness within (any) discourse in reference to communist and post-communist arenas posits the speaker in the realm of otherness.[32]

In spite of his intensive acculturation, he maintained his Romanian identity, although not necessarily the language. By 1970, Codrescu had stopped writing in Romanian.[33] From then until 1989, his literary career focused more on American cultural settings of literary dissent. As an American, a poet of metaphoric exile immersed in the American counterculture, Codrescu became a frequent literary presence in magazines and newspapers in the United States. Defining himself as a "planetary

refugee" and a permanent exile, Codrescu explained his poetry and literary involvement in American culture to be "not the desire to melt in but the desire to embody an instructive difference."[34] Since 1983, his physical voice has become familiar to all listeners of National Public Radio, as Codrescu is a radio commentator on the popular program, "All Things Considered." Thus, long after his migration from Romania, Codrescu is well known on the American literary and cultural scene. Codrescu maintained his rebellious nature, and his literary identity is maintained by his multifold activities as an essayist, writer, poet, professor of creative writing at Louisiana State University, and editor of several literary journals.[35] In other words, whether his audiences hear him as a Romanian or an American voice, Codrescu is a well-known literary figure whose main interest is the cultural value of freedom in a democracy.

Had 1989 not brought the collapse of communism, Codrescu would have continued to write mainly on American literature and culture.[36] History decided otherwise. Twenty-five years after his exile, Codrescu revisited Romania right after the revolution of 1989. In that year, like the old metaphor of falling dominos, Poland, Hungary and East Germany (October), Czechoslovakia (November), Bulgaria, and Romania (December) became revolutionary democracies.[37] Fighting against communism, all these Eastern and Central European nations finally voiced their social, political, and nationalist claims against their governments, demanding the political and social changes needed to create civil and democratic societies.

Having witnessed, as he declared, from oceans away, how one after another of the communist regimes was forced by its population to open the "iron gates," Codrescu was about to revisit his exile.[38] Offered the opportunity to report on Romanian political events for the ABC television network, Codrescu found himself, at the very end of 1989, in the midst of the Romanian revolution. Romania was one of the last Eastern European countries daring to fight against dictatorship, finally freeing itself from the Ceauşescu regime in December 1989. As an American journalist, Codrescu was to relate the exciting Romanian story to an American audience. Romania, once closed to the writer, opened its borders again, allowing the poet to reflect and redefine his voice in light of his exilic experiences.[39]

Discourse of Exile: A Visit in the Wonderland of Dissent

Codrescu's first visit to Romania (1989-1990) becomes, then, a cultural threshold for his rhetorical redefinition of his exilic voice. Codrescu experiences *himself* in his journey, an expatriate writer from communist Romania and an American poet advocating dissent and exile. The Romanian trip makes Codrescu leave his American identity, re-experience his Romanian past, and with it, renew the fragmentation of his expatriate voice. Time, whether past or present, became a rhetorical and personal companion in his journey of redefinition. Similarly, place became a cultural and rhetorical locus from where Codrescu reflects on his cultural expatriation. His rhetorical actions capture his struggle within his exile together with his cultural fragmentation of voice. This re-visitation challenges him to redefine his different exilic identities in new textures of discourse, creating powerful appeals of dissent. How does he reconstruct his exilic identity after this powerful confrontation with the past, with his former culture, with the new social and political changes in his native country?

Codrescu relives his exile in the two books written right after his return: *The Disappearance of the Outside: A Manifesto for Escape* (1990) and *The Hole in the Flag: A Romanian Exile's Story of Return and Revolution* (1991).[40] In these works on an *almost* post-communist Romania, Codrescu revisits not only his country and his cultural experiences during and after communism, but also his existence as a writer in the borderlands of exile.[41] In *The Hole in the Flag*, his cultural fragmentation surfaces in dimensions of *time*. Memories of a Romanian childhood during the communist regime are rhetorically invoked as background for the present account. In *Disappearance*, his journey of redefinition parallels dimensions of contingent *place*. He travels to places of his past to find his exilic difference. Written almost at the same time, these accounts of exile capture the poet's fragmented identity through temporal and locative dimensions of his discourse. In both accounts, Codrescu the exile presents himself as a living-in-the-margins poet, always already interpellated by the counterculture. What, then, are his strategies as a rhetor, for redefining his voice in response to fragmented experience both as a voluntary exile and as a poet of the Outside? As such, can he create a coherent voice for his rhetorical appeals addressed to large audiences?

Fragments of Time and Fragments of Voice: A Voluntary Exit

Written as a log, *The Hole in the Flag* presents Codrescu's political and cultural account of the revolution within his memoir of return to Romania.[42] In his discursive travel to his native country, Codrescu chooses a literary form inviting his readers to meander through past and present Romania. Time becomes a rhetorical ally where fluid mementos, temporal sequences (past, present, future), and personal chronology intersect.[43] Personal stories of past life and fantasies of return find their way into the poet's invocations of a disrupted Romanian identity. Along with personal fragments of narratives, the writer presents prominent literary and political figures of the Romanian revolution of 1989 and visits relatives and friends in his native city, Sibiu. Excited by events at the time of his return, Codrescu writes his account both as a well-established American journalist, and as the long-absent "alien" or "prodigal" son of Romania, reclaiming his lost world.[44] Thus, Codrescu experiences his past and present identities when retelling the story of his voluntary exile from Romania. However, can Codrescu recreate a culturally coherent voice by clustering fragments of his past and present?

In *The Hole in the Flag,* the writer invokes cultural, personal, and political textures of his voice with a somewhat chronological narrative of the revolutionary transition. Although *Hole* is structured chronologically, Codrescu's identity in relation to time remains fluid. For, while the writer depicts the events relating to the Romanian revolution and its political and cultural aftermath more or less chronologically, he also journeys backwards in time to reminisce, compare, contrast, and face his identities, voices, and memories of his homeland.[45]

Accordingly, Codrescu leaves his once-settled identity as an expatriate poet to face the challenges of discontinuous identities coexisting by juxtaposing multiple time lines of narratives and rhetorical voices of the speaker, which I call *rhetorical refragmentation.*[46] Describing the events of the revolution within the memories of his Romanian past, he revisits his own discontinuous life. For example, Codrescu constructs his tribute to the victims of the Romanian revolution by juxtaposing memories of his youth: "[M]oments before the end of the decade, I stood in the cold, ice-covered center of University Square in Bucharest, Romania, and said a brief prayer of thanks."[47] Reflecting that the young victims "had also died so that he "could stand here for the first time, twenty-five years after leaving [his] homeland," Codrescu faces his fragmented life as a returning Romanian: "This magical

city of my youth, which I had once thought to conquer with my poetry, was both different and the same."[48] He proffers that time has "nothing in common with ordinary time. The past 25 years were a dream."[49] No longer chronological sequence, the rhetorical dimension of time becomes a linguistic mosaic on which Codrescu locates himself within past, present, and reflexive temporal fragments.

Poetry and Exile: A Textual Intervention

Repeatedly juxtaposing different times throughout the account, for Codrescu's voice political context of the Romanian revolution coexists with his past and with childhood memories in his exilic narrative. Since Codrescu's exilic redefinition is important to legitimate his salience as a rhetor of dissent, this might be the place where his speech needs contextualization, re-inscribing poetic expatriation within the 1989 events in Romania.

It would be easy to dismantle Codrescu's exilic identity as political existence, had it not been for the communist practices of banning poets and intellectuals during Ceausescu's regime. The less than "human face"[50] that communist discourse had in the Romanian official arena carried with it resistance in the form of public absences, hidden spheres of discourse, and most of all, exile. Romanian pre-1989 public discourse carries with it the pursuit of "multilateral development" for bringing national economy to the brink of collapse, "progress" for repressing artistic and literary creativity, "systematization" for demolishing thousands of villages as the list of words enriched by the glory of communism grew over the decades of the regime.[51] Even children literature becomes a censor-sensitive matter.[52]

As Romanian poets and writers attest, proscribed words entered the lexicon of prohibited vocabulary in the hands of censorship. Simply listed in different historical moments during communism, "red," "meat," "ghost," "cross," food lines," "dictator," "coffee," "homosexual," or "God" along with "democracy," "freedom," "angel," or "church" were all banned.[53] Meanwhile, words encouraged to emerge announced the triumph of a "Great Leader" (with capital letters), the ruling of "the Father of the Nation" leading the Romanians into an "era of light," into the "Golden Age of Socialism."[54] Romanian words as political contexts of expression become appropriated in Ceausescu's times by censorship, "the secret police of the word," transformed into powerful weapons of power.[55] Hence, Irina Grigorescu-Pana's claim that

in her native Romania, "writers were already in exile, translating their work into allegories"[56] permeates the context of political and poetical discourse during the days of Romanian fall from communism.[57]

Hence the discursive context within which Codrescu places his identity of expatriation represents a productive space where exiled words, former and future public arenas and political power juxtapose in the aftermath of Romanian revolution. As the poet mentions in one of the interviews at the time, Codrescu regains legitimacy as a poet of and in exile by becoming "Romanian again," by re-instantiating narratives of the past and present within the concurrent loci of his voice.[58]

A Foreigner in Romania: Time as a Narrative of Exile

Continuing his journey into homeland in retrospective mode, Codrescu recaptures the discursive lines of past and present, 'here' and 'there', repositioning again his Romanian identity, and with it, a lost exile. Experiencing convergent yet complex fragments of identity, the American poet journalist recounts his emotions as the visit posits him in back and forth motion, in different times, in different voices, in different realities :

> The most touching scene–one that I did not mind doing over and over–was a walk I took through the destroyed library building of the University of Bucharest. The books of all those literary lights gathered at Capşa once-upon-a-time were all here. So were the invaluable works of others–three hundred thousand books gone up in flames. There was something else here, too– namely, *a very young me*, writing poems at those long readers' tables, . . . I raised the collar of my coat and looked out through what used to be a grand window but now was only an archway open to the sky. Volunteers with spades and brooms below were beginning the slow and painful process of clearing the debris. It snowed over them, giving brilliance to the black-and-white world where they moved. . . . It seemed to me as I looked out the window of my bygone youth that everything had come to a standstill in a single frame. Time had stopped. I can't swear that a tear didn't streak hot and salty down my cheek. It broke my reverie and brought me back to the present.[59]

Torn between past and present, Codrescu articulates distinct temporal frames for his fragmented self. Stopping time, seeing multiple fragments of his identity almost cinematically, Codrescu observes the "touching scene" of "the destroyed library building" while revisiting memories of a "very young" author, "writing poems at those long readers' tables." His nostalgic reminiscence of his literary youth while observing the volunteers trying to

clear the "black-and-white world where they moved" allows him to experience his re-fragmentation and his own emotional journeys of voice, at the same time.[60]

Nothing in present-day Romania makes Codrescu experience his re-fragmentation more than his visit to his native Sibiu, and to his uncle and aunt, his only living relatives in Romania. Uncle Rihard barely remembers the past and with it, the writer. "I told him that I was a writer, that I worked for the radio, and that I was pretty much an American now," confesses Codrescu.[61] Framing his reconstruction of voice in memories of communism, the poet reintroduces his exile, as he relates the emotional family reunion:

> The revolution had come too late for him, too late certainly for my aunt, who, mercifully remembered very little. I pressed all the money I had on me into his hand. He took it with a kind of wounded hopelessness that broke my heart. I could barely imagine what they had suffered, what they were suffering. They lived, at their age, in an unheated apartment, slowly dying of hunger. Decades of this misery had passed, each year worse than the one before. . . . My last glimpse of him was a thin man with a messy pile of banknotes in his hand, looking bewilderedly after a car from another world that visited him briefly. He did not seem to know what the money was for or why having come back, I was leaving–again.[62]

Tracing different identities, as an American, an exile, and a returning nephew, Codrescu faces his presence in disparate worlds. Past and present carry discontinuous fragments of his identity. As he reconstructs himself, Codrescu sees this reunion through the emotional lens of childhood memories, while at the same time, aware of the communist period. As decades "of this misery had passed, each year worse than the one before," Codrescu reintroduces himself as an exile. "[L]eaving–again," the writer retrieves past and present time lines to reinforce fragmented voice.[63]

However, this fragmentation is unsettling. Codrescu attempts to overcome his exilic condition by rhetorically construing coherence to *redefine* and *reunify* his identity. His rhetorical strategy to do so is to collapse different times when defining his rhetorical and cultural voice. Attempting to recapture his rhetorical powers of speech within exilic time, where fluid memories and present events coexist in discourse, Codrescu recalls the rhetorical dimensions of his *now* and *then* discourse. Past and present function, then, as a complex cultural and rhetorical dimension where chronologies, personal reflections, and political situations entwine to reveal his voice in the margins. Preparing to visit Sibiu and his relatives, Codrescu

changes personae from an American journalist to his former Romanian self, full of emotion and anticipation. His voice becomes reflexive, revealing how different time lines continue to reposition his cultural understanding of the world.

> Next morning I was ready to leave Bucharest. The past three days had been remarkable. Even those things that under normal circumstances are banal and uninteresting, like watching television or having lunch, had been made sharply significant by the times. Time itself was stretched to accommodate the rapid unfolding of a thousand events. As in a fairy tale where the hero grows ten days in a year, a minute was a day, a day was a year. Three years had thus passed in three days, but my heart was still yearning for the real return, to the town of my birth, Sibiu, in the Transylvanian mountains. My childhood was there, and the friends of my childhood. I wanted also to see my uncle Rihard and my aunt Elena, my only living relatives still in my homeland. I'd heard that they had been moved from their house to an apartment building in the town of Alba Iulia near Sibiu. An address with several long, scribbled numbers had reached me via one of our old neighbors, who now lives in Canada. They had no telephone, and they were very old. I had written to them, but there had been no answer. I did not know if they were still living.[64]

As he relates the narrative of the revolution within his memoir, Codrescu uses three strategic moves to merge time in this passage and beyond: the political, the literary, and the cultural chronologies of his existence. First, managing political time to tell the story of the revolution, Codrescu merges history with current events while positioning his voice in discourse. The revolution, the last days of December 1989, the time of the infamous trial of the presidential family, Nicolae and Elena Ceauşescu, all merge into a kaleidoscope of events showing the political time for Romania is changing. As Codrescu points out, this defining moment in Romanian history *stretches* to incorporate the sudden avalanche of political events.[65] Thus, the times of the revolution create a chaotic rhetorical background against which the author sets his own emotional or reflexive temporal perspective.

Redefining himself along a second temporal line, "as in a fairy tale," Codrescu recalls the literary form of myth to collapse time within his narrative. Locating himself in between American and Romanian borders, the author alludes to his childhood, entwined with the cultural narrative of Romanian myths and folklore. And, after delineating the political events, the writer inserts a strategic retexturing, adding a cultural rhythm of Romanian fairy-tale narratives.[66] It seems Codrescu has already switched to a Romanian mode of discourse, as he recaptures his childhood patterns of story telling.

The magical time of his Romanian childhood colors the text with memories and old traditions of a child's cultural universe. Three years pass "in three days," letting his exilic voice remember his "*yearning* (my emphasis) for the real return."[67] By now, the rhetorical force of his narration lies in the tempo, as the author invokes the Romanian pattern of storytelling. Enhancing his voice with the rich tradition of folklore, he posits himself "in a fairy tale where the hero grows ten days in a year, a minute was a day, a day was a year."[68]

And yet, returning to his native city, Codrescu cannot forget a third dimension of his temporal framework: his cultural reflections on voluntary exile from communism. Merging images of the culture of the communist past with current events, Codrescu relives the cultural aspects of communist life from which he fled into exile, as he prepares to visit his old Uncle Rihard and Aunt Elena. Meeting the "only living relatives still in [his] homeland" reminds the writer of his own escape from the political regime under Ceauşescu, of the political implications of his action.[69] Embedding cultural references to communist times, Codrescu enriches the texture of his voice, adding cultural and political nuances to anyone's existence in this Eastern European country. Time becomes a cultural memory, an almost enthymematic invitation for his Romanian voice to take part in his rhetorical journey of redefinition. Aside from a Romanian cultural site for his voice, Codrescu entwines cultural and political implications to capture the communist story of expatriates: "I had written to them, but there had been no answer. I did not know if they were still living."[70] The rich texture of his rhetorical persona in cultural and complex time gives the writer the rhetorical substance for his voice as a voluntary exile from Romania, revisiting his homeland.

In the rhetorical attempts to redefine his fragmented voice in different times, Codrescu is more a *poet* in exile than a rhetor of expatriation. The strategies he invokes to merge time into a *coherent* story of identity are drawn more from his literary powers than his rhetorical ones. For, aside from the past or present conditions of his voluntary expatriation, the writer enters the realm of language to face his exile.

Due to his *poetic* life as an expatriate, Codrescu textures his discourse by introducing a *metaphorical* dimension of time to his fragmented identity. A Romanian poet turned (but not completely) American public rhetor, he links cultural fragments of voice in *metaphoric* relationships between time and identity. Thus, Codrescu exploits the power of metaphor to bend and collapse

time when addressing his exilic life, by recalling ideatic visions to concur with chronologies of past and present history. Observing Bucharest in January 1990, while comparing it with *his* city from 1965, Codrescu faces his fantasies of return:

> I felt as if I were at a crossroads. I was tempted to leave my suitcases and walk away. I imagined renting a room somewhere in Bucharest with a view of Cismigiu Lake. I could change my name once more and tell nosy neighbors that I was a provincial literature teacher from a remote Transylvania burg who had come to the capital for "culture.". . . I'd had this fantasy in many forms before–becoming a gas station attendant in a small town in Utah, for instance–but *here it nearly became real.*[71]

Present and past dimensions merge to shadow Codrescu, revealing the literary reality of his exile. Transcending all locations in the margins, Codrescu utilizes a metaphoric ethos of exile for the non-chronological dimension of his rhetorical account. Invoking multiple layers of his exilic life as a poetic and literary presence in different times, Codrescu acknowledges:

> I had the momentary illusion that all I had to do was to start talking, that my footsteps would find the shadow of my old footsteps, and that if I followed my old path, I would somehow cancel time and be nineteen years old again. Suppose that there is a moment in the midst of a revolution when it is possible to transcend time. There is something in the Romanian psyche that keeps searching for that moment. There is a man in a story by Mircea Eliade, the great Romanian religious scholar and novelist, who leaves an enchanted garden only to rediscover that thirty years have passed. Conversely, leaving the garden of my exile, I might discover that thirty years have *not* passed. Exiles--and Eliade was most consciously an exile--do not believe in chronological time. We hold the places of our youth unchanged in our minds and stay secretly young that way. On the other hand, what if age catches up with us when we return?[72]

Holding the rhetorical power to invoke and redefine identity, metaphoric time blurs the *now* and *then* of exilic discourse into an "as if" reality. Similarly, in response to expatriation, no writer or poet omits from his or her discourse the metaphoric powers of exilic action, as all emphasize their rhetorical relation between native and host languages, between literary and cultural perceptions of reality.[73] Defying "chronological time," the writer transforms his exile into *"places* of our youth,"[74] thus creating a metaphoric locus for his coexistent past and present identity.[75] In *Hole*, the rhetorical

strategy of collapsing past and present in discourse can be seen throughout, an example being an entire chapter entitled after his home town "Sibiu."

Codrescu finds himself back in his home town, and the visit triggers the story of his childhood.[76] Similarly, in the beginning of *Disappearance*, the writer makes usage of that very rhetorical strategy to emphasize his personal experiences of exile from Romania.[77] Having an almost tangible experience of exile and reconstitution, the writer reflects on his ability to transcend different time lines, re-entering the poetic identity as a nineteen-year-old literary voice.

Transcendence of time constitutes part of both exilic and Romanian quest, as "there is something in the Romanian psyche that keeps searching for that moment" (80). The reference Codrescu makes to Romanian psyche transforms time into cultural substance, the two meeting along the mental space of collective and individualistic cultures. Pulling past and present incidents up along the same level of text, Codrescu incorporates in his voice all dimensions, for "leaving the garden" of his exile he "might discover that thirty years have *not* passed."[78] Here, in this metaphoric world, time and identity impel each other along as coexistent cultural and rhetorical dimensions in Codrescu's discourse.

But, ultimately, Codrescu succeeds less in reunifying his identity than in *accepting his fragmentation* in different temporal frames of discourse. His strategies to align divergent time lines when redefining his voice do not collapse his disrupted experiences into a singular rhetorical persona of expatriation. Rather, Codrescu remains in the realm of difference, never forgetting his language of exile. His *linguistic* experience of exile reveals how fluid the powers of language are for his rhetorical voice, how the same language becomes both a cultural connection and, at the same time, a major obstacle in an exile's journey back. Finally, as a Romanian, a Jew, an American, and a poet, Codrescu reaffirms his identity as an outsider, living and writing a discourse of *difference*.[79]

He confronts his failure to unify his discontinuous voices of discourse when telling the story of his high-school reunion. Returning to Sibiu in the summer of 1990, language and culture make the poet face his outsider status in the event. In spite of his genuine exhilaration of return, Codrescu sees himself "suddenly remote in time and place, no more remote perhaps than I once felt in high school, where I was also in a minority: a poet, a Jew."[80]

A quarter of a century had passed. It sat between us like a dark, unconscious mask, lit only now and then by an odd remark. In addition to time, we were separated by languages, politics, a sea (the Black Sea) and an ocean (the Atlantic). My Romanian was still rusty. Having been practiced mostly on the phone with my mother (with whom I have an accent-maintenance contract for the purpose of keeping my R's rolling) or the formal interview situations in which translation can be as wooden as what is being proffered. My whole adult life had taken place in America in the American language. My Romanian was frozen in the eighteen-year-old curl of existential and sexual melancholy smoke at Marishka's café. I barely got their jokes, and I was no doubt missing all the subtleties, where the real story was. Here came another revelation, just as eerie as, if not eerier than, the rest: I was missing *the story*! The journalist in me slapped me soundly once across my unstudious cheek. But there was also hardly any way I could have made them see *my story*, the ecstatic madness of an American poet's life lived in several cities on the coasts of two different oceans, a life, I might add, in complete sympathy with rebellious students of all causes. So have another brandy, and another wine! And roll on, tape![81]

No longer able to understand Romanian culture after the collapse of communism, Codrescu experiences his difference in language. Turning his fragmented identity into a rhetorical and linguistic event of miscommunication, the writer sees his high-school reunion as a signifier of his life in the *Outside*, his existence as an exile. Positing a "quarter of a century," with its political implications, as the rhetorical and cultural obstacle between himself and his former high-school friends, Codrescu confronts his *linguistic and cultural* separation from his past life.[82] The "dark, unconscious mass" of time transforms his identity into a major cultural obstacle in his rhetorical attempt to find coherence in his expatriation.[83]

Unsure whether his identity represents a "steely-gazed observer-journalist or a sentimental friend eager to recapture the past," the poet in exile seems unable to unify his multiple cultural and rhetorical fragments.[84] Living within two different linguistic and cultural frames emphasizes Codrescu's inability to share a singular cultural identity and, therefore, he bears the rhetorical stigma of his identity of *difference*. Amazed at the cultural powers of language, invoking his rhetorical voice of difference, Codrescu exclaims, "I barely got their jokes, and I was no doubt missing all the subtleties, where the real story was."[85] As an invisible witness to Codrescu's "eerie" failure of communication with his former friends, language mirrors to the poet his fragmentation.

Forced by exile to face his inability to understand the cultural and political connotations of current Romanian, Codrescu cannot reconcile his

displaced voices, either. The Romanian language, "frozen" in its "eighteen-year-old curl" of existential melancholy, brings the poet face-to-face with the time of his childhood.[86] And yet, his childhood Romanian, is "rusty," representing a past long gone. His grown-up language is "the American" where his present "adult life had taken place."[87]

Using the metaphor of wine to signal his acceptance of displaced identities, Codrescu calls for "another brandy, and another wine," as a poet forgetting a painful attempt at reconciliation. At the end of this excerpt, Codrescu accepts his Romanian and American experiences as discrete, yet coexistent contexts within his discourse of exile. Invoking his difference, for there would be "hardly any way I could have made them see *my story*, the ecstatic madness of an *American* poet's life," Codrescu reaffirms his identity as an expatriate intellectual, always already dis-united in discourse.[88] Attributing his difference to exile and to his poetic life in another culture, Codrescu remains a voice of fragmentation, always already in the Outside.

Therefore, the author has to look elsewhere to find unity for his exilic and discontinuous identity. Finding the distances of time rhetorically insurmountable, he searches elsewhere for coherence. Transforming exile into a metaphoric place, Codrescu addresses his rhetorical and cultural dislocation as a speaker by occupying a rhetorical *locus* as a rhetor of the margins.

Exile as a Cultural Place: Another Realm for Fragments

Codrescu's visit to Romania after an absence of twenty-five years had reopened the question of locating his fragmented identity through discourse. Facing past, present, cultural, and metaphoric times when reflecting on his rhetorical and literary voice, Codrescu relives his exile. Aware of his inextricable links to both Romania and the United States, understanding as well that he is also defined as a Jew and a poet, Codrescu finds a cultural fragmentation unlike anything he had experienced.. In the face of his displaced voices, the search for a coherent identity becomes the crucial rhetorical problem for his discourse. His attempts to assemble disparate times to solve this rhetorical problem of fragmentation end in failure. So, how does he recapture his rhetorical powers of voice when facing adverse and multiple contexts for his discourse?

As a poet, his solution is to create *The Outside* as the rhetorical locus for his identity, a place where he, and all exiles, live. In *Disappearance* the

author posits the question of *cultural place* as essential for any exiled intellectual's identity. Kathleen Dana has commanded in a review that: "[I]n his fascinating analysis of twentieth-century writing and politics Andrei Codrescu contends that bona fide literature can only be written on the *periphery* of the system."[89] In *Disappearance*, the liminal identity of a literary exile constitutes the starting point of his account: *culture* becomes the *place* of Codrescu's expatriation, the context from and in relation to which his discourse of resistance can emerge.[90]

Using the same events of the Romanian revolution as the context for this second account of exile, I argue that Codrescu constructs a cultural place of resistance from which to position his identity as a literary expatriate.[91] Although his main emphasis is the reconstitution of cultural exile as *the* place for *his* voice of the counterculture, Codrescu also advocates the beneficial and necessary existence of poets in the "state of exile" inhabiting the Outside, where they become resistant to hegemonic culture.[92] Asking "where does the dreaming fit," Codrescu pictures a cultural realm of dissent for both Eastern and Western cultures, a territory where literature needs to fight consumerism in the contemporary world.[93] His solution against the hegemonic "Center" is simply the existence of expatriation as a homeland of the counterculture, for only "the imaginative memory of [literary] exiles" can challenge "the Center," giving back to the world its imagination, and hence, its creative powers.[94]

Thus, delineating his own position as a poetic exile, Codrescu reconstitutes himself *within* the margins of discourse as the cultural *place of resistance* against institutional culture, in Western, communist or post-communist societies. Reacting to the Idea-State as the hegemonic Center, the author offers *The Disappearance of the Outside* as an extensive essay on the fate of exiled writers in the world, starting with his own.[95]

As Codrescu attempts to capture his voice of fragmentation in relation to place, he moves from the geographical dimension of location into the ambiguous yet powerful cultural and rhetorical location of the Outside. The very title, *The Disappearance of the Outside: A Manifesto for Escape,* announces Codrescu's life in the Outside as well as his advocacy of cultural resistance through exile. Blurring geographical locations of expatriation, Codrescu transforms his experiences into a poetic *place* from which to address his fragmented voice.

Disappearance begins with Codrescu's invocation of his memories of childhood interrogations into place and identity, which help to reconstruct his voice as an outsider:[96]

> What was my place? Was my place not the place where I was? Was the place that my voice inadvertently trespassed upon not *my* place as well? Was I not always and naturally in place? What was this place that I belonged to that was different from the adults' place? Were there distinctly drawn borders between my place and theirs? And how was I to know what my place was? Negatively? By learning what *wasn't* my place? Perhaps what was really meant was that *my* place didn't in fact exist or that, if it did, it was confined to certain conventional ideas indulgently ceded by tradition to children.[97]

From an early age his voice occupies the discursive *Outside*. Not only is the poet showing that *dis*-placement inhabits his life, rhetorically he constitutes the inside and the outside as two essential frameworks for his future identity in discourse. In a sense, Codrescu appropriates historicity as cultural memory and cultural discourse in order to reconstruct a dynamic, dyadic voice of the fragmented outsider.[98] Codrescu presents his cultural fragmentation from the very beginning, becoming a voice of always already *difference* in relationship with "my place and theirs."[99] Even as a child, he is a rhetorical persona inhabiting an outside and an inside as two culturally fragmented locations. This strategic definition permits him to relocate himself in his rhetorical discourse as a Romanian, an American, a poet, a Jew, and a voice of literary dissent. From now on, Codrescu participates in rhetorical action from a fragmented position, caught between discursive frameworks of inside and outside.

This strategic re-location of his outsider persona allows Codrescu to transform his narrative from a chronological account of childhood into a metaphoric place for his exilic identity. Delineating the two discursive frameworks of the inside and outside early in the account permits Codrescu to gain rhetorical voice within the cultural margins of different realities:

> The cursed outside was our home, while our home in the approved inside was a place of exile. Our children's existence took place under the double sign of this paradox that divided the world into ours and not ours, with bad and good attached but reversed in allegory and reality. The utopia (no place) of home (inside) met the existence (being) of the outside, though both were a story, an allegory that made no sense other than assigning moral values to both, and confusing us forever.[100]

Setting the divided realities of *inside* and *outside*, Codrescu positions his voice within two coexistent places. The "double sign" from where he speaks pulls into the discourse a particular relationship between "allegory and reality," acquainting him with his existence in a possible and cultural outside. The inside and outside, initially a childhood experience, becomes the major cultural and allegoric context from which his rhetorical voice as an outsider creates literature, "confusing [him] forever."[101]

Thus, Codrescu recalls the rhetorical powers of *cultural outside as place* to address identity. Construing the cultural dimension of exile as a metaphoric homeland for his voice, the poet empowers his rhetorical persona to inhabit mostly a cultural and literary outside. Choosing to speak from the *Outside*, and aware that his leaving Romania, "or even expressing the desire to do so" makes him "an enemy of the State, a political exile," Codrescu refuses to identify himself with the concept of political expatriation. Rather, invoking Romanian exilic *literature* and *writers* as inherent to the Outside, Codrescu equates his identity with cultural expatriation. Literature and culture Romanian culture and later American culture all become the exilic place from which he articulates discourse, and thus for Codrescu "the idea of being a writer and the idea of being an exile were synonymous."[102]

The relocation of identity in the metaphorically empowered Outside, in the cultural *place* "that was not any one country," allows Codrescu to regain rhetorical powers as a fragmented poet. Uprooted, yet living in the realm of "Exile" as the place of "pure *Outside*" where books "were not forbidden," Codrescu pledges allegiance to the cultural myth of exile.[103] As such, he articulates his rhetorical and literary participation in the culture of dissent, starting with his Romanian literary confrèrie:

> Exile unified us, [the Romanian writers] and in my mind, it assumed proportions of *a place*. I wouldn't be just leaving my country–I would be going to a place called Exile. I imagined Exile as a substantial territory, a psychological place of vast dimensions, with distinct boundaries, its own customs, as well as its peculiar tourist attractions. Geographically, this may have been Paris, Roma, New York, Buenos Aires, or San Francisco, but spiritually it began at the borders of the Soviet Empire. This archipelago was inhabited mainly by creative citizens, resembling Plato's republic of Letters. It was an international Idea-State, the only anarchist system in working order.[104]

Here Codrescu reverses the earlier reduction of geography to culture. In this strategic move, culture assumes geographic reality. Along with other

Romanian writers in exile, Codrescu positions himself in the metaphoric *Outside*, in the "substantial territory"of the exilic discourse. *The Outside* becomes a strategic rhetorical nexus where geographies, cultural and literary fragments of his life collapse. It is within this co-opting country of Exile that the poet regains legitimacy and coherence in discourse. Texturing multiple cultural connotations in this excerpt, Codrescu articulates his opposition to "borders of the Soviet Empire" through his voice located in a cultural place of exile.[105] This new homeland of dissidence, although not political, is full of literary and cultural inferences to support his redefinition of voice. The use of "archipelago," for example, refers to Solzhenitsyn's manifesto of freedom, courage, and dissent written from within the Soviet empire. Codrescu's choice of geographic locations like Paris or San Francisco reminds his readers there still are cities where dissident intellectuals reside and create. Paris represents the place where Romanian literary figures such as Emil Cioran, Eugen Ionescu, Mircea Eliade, or Tristan Tzara expressed their views on exile and culture.[106]

The convergence of different realms through the metaphor of Exile as the Outside solves Codrescu's problem of fragmentation, allowing him to open his participation in the freedom of the mind:

> [F]reedom is a greedy appetite of the mind, and both "time" and "geography" conspire against it, undernourish and frustrate it. This hunger is at the core of poetic exile, its need to establish an atemporal, aspacial identity capable of taking on *all* temporalities and localities of its habitations.[107]

To the poet, the *place* of exile represents more than a rhetorical circumference for expatriates. Defining his life in the Outside as an articulation of convergent sites of culture, time, and geographies, Codrescu empowers himself as a participant in the literature of the world. Living in the literary Pantheon of "myth and the poet-artists who are part of it," he thus is able to partake of the discourse beyond "worlds of political exiles and those of refugees," rejoicing in "being Outside."[108] Advocating the liberating experience of merging and sublimating all cultural fragmentation into an identity in the Outside,[109] Codrescu settles into living by "abandonment of place" using exile as "an alternative human organization."[110]

Why is exile-as-a-cultural-place rhetorically important in Codrescu's redefinition of identity? Because, as a poetic exile located in *the Outside*, participating in the counterculture of the world, Codrescu reconstitutes his

rhetorical persona in language along a *metaphoric resistance*. Positing his rhetorical presence in the literary world collapsing "West" and "East," the "Outside" of literature and the "Center," Codrescu relocates his identity within the discourse of dissent.[111] Reiterating that he is *not* a *political* expatriate, Codrescu declines that identity in relation to the historical context of Eastern Europe. And yet, as an a-political outsider, his difference re-instantiates marginalization for the Romanian public arena, as well as metaphoric dissent for all hegemonic discourse. Thus, as a poetic exile, Codrescu redefines himself in terms of a cultural resistance that is inherent in his rhetorical identity. The dissident and metaphoric *Outside* gives his rhetorical persona access to "the world of myths and of the poet-artists,"[112] placing him within the cultural "cluster of paradoxes" that marks him a legitimate voice of resistance.[113] From this locus of cultural resistance, Codrescu legitimizes his critique of the American culture of consumerism, recreating rhetorical ethos and with it, re-fragmenting oppression in global discourse.

Aware that such cultural fragmentation makes him reside in the "dreadful limbo between statelessness and naturalization," seeing "the distorted faces of the monsters of solitude, loss, and despair," Codrescu claims his rhetorical powers through a poetic life in exilic discourse.[114]

Why does Codrescu first recreate exile as a place of the *Outside*, then redefine his exilic existence in discourse as poetic? And why does he, in his reconstitutions, collapse geographies and cultures to define exile, and poetic and political identities to invoke his literary powers in discourse? Can he, then, as a "free" poetic exile, create his [S]elf in discourse from an *apolitical* standpoint? Not exactly.

Although Codrescu's poetic identity intends to liberate him from the confinement of any single political border, his reconstitution of voice involves a mission to participate in the counterculture. Thus, politically, Codrescu does not manage to free himself of his dissident identity in discourse, for even as a poetic writer of expatriation, he articulates his position as a rhetor of resistance. His reconstitution of voice in the cultural locus of exile converges political and poetical contexts of fragmented identity. Accessing myth, culture, and historicity, as a cluster of loci for legitimacy in discourse, the author articulates his existence as a Romanian, a literary outsider with a mission to defy history. Thus, Codrescu speaks from a locus of literary *resistance*, in itself a political stand:

The myth of exile was imbedded archetypally in our (Romanian) culture. I belong to a country whose main export is geniuses. The most famous exile of antiquity, Ovid, was exiled among the ancient Romanians and founded their literature. Since then, in misguided reciprocity, Romanians have been exiling their poets with a single-minded devotion to their beginnings. . . . We are powerfully afflicted with a tragic sense of history. To paraphrase Emil Cioran, we have survived by sabotaging history. History belonged, usually, to powerful outsiders whose coming meant only trouble.[115]

Creating a narrative of exilic roots in Romanian literature, the author sets himself as a "young poet educated by the new regime," fascinated by the writings of Romanian expatriate literati, advocates of freedom through culture.[116] Having survived communism by a missionary-like "sabotaging" of history, Codrescu feels empowered to defy not only Romanian, but general mainstream culture.[117] At one point, Codrescu confesses trying "to be neither an 'ethnic' nor a 'minority,' rather an aristocrat, a poet," who invokes rhetorical voice in relation to the *Outside* of counterculture, taking a political stand. While his invocation can be interpreted as fairly preposterous within the American public discourse, the identity of aristocracy bears again a political vein for Romanian re-gained literary language. His defiance and use of grand language contrast with the populist grandomania that Romanian official discourse articulated and encouraged during Ceauşescu's regime. Once again, the poet's liminal ethos is legitimized by continuous cultural fragmentation of contexts, intertwining Romanian and American countercultures in contrapuntal constructions of his voice of dissent.

Consequently, leaving his Romanian identity aside at times, during the communist era in order to glorify exile as a place and to settle, rhetorically, into a poetic voice, the author blurs cultural and political borderlands. An outsider and a spokesman of the counterculture, Codrescu's strategic reconstitution of identity captures the tensioned relationships between symbolic and metaphoric locations of voice *against* political ones. Erasing borders between geographical and imaginary lands, or between poetical and political discourse, Codrescu becomes an advocate of cultural dissidence.

Exile as a cultural place becomes rhetorically salient for his identity, so it is through a language of resistance that Codrescu regains legitimacy. Freeing language from any single political system, Codrescu participates in linguistic and cultural resistance:

A new map of the world is in the making. Countries of memory that were once real
countries again make their appearance: once erased from the map, they first
reappear as ghost images, quickly draw substance to themselves, and soon are
undeniably here. Czeslaw Milosz's long-gone Lithuania appeared from the fog of
his "Issa Valley" and is now part of our world.[118]

Because words have liberating powers, Codrescu's poetic exile and his
rhetorical location in *the Outside* pave a rhetorical venue of action against
political oppression. For him, "the geography of the victims of history"
returns via imagination in order to possess present time pointing to the
needed language (and culture) of resistance.[119]

Sensitized to language, to the literary (and rhetorical) force that texts
bring to the fore, Codrescu argues that exilic discourse represents the
solution to political oppression. Exilic place, then, presents a cultural map of
the Other, a cartography where the palimpsest of homeland and its cultural
borderlands helps any expatriate writer to take action through discourse:

The world, they said, (referring to Barthes) is a text... The library is the repository
of the official text. The rest of the text, the hard-to-read part, has not really
disappeared. It has merely been relegated to an Outside. This Outside is vast,
expansive, changeable, paradoxical, perverse, traversed by all the escape routes. It is
filled with tension, movement, instability, and force. Its pressure causes authors and
authorized texts to shift, to sink, to crack, and to explode. What has been repressed
returns through these cracks and destroys the order of the status quo. The erased
Outside text sometimes reappears quietly, like an erased file on a computer disk, but
it often surges cataclysmically,... The exilic text is likewise liable to irrupt within
approved literature.[120]

For Codrescu, language fulfills one of the most important functions for an
expatriate voice as a resistant '*Other*' in the metaphoric locus of *the Outside*.
"What has been repressed returns through these cracks and destroys the order
of the status quo," warns the poet.[121] His exilic discourse a part of the
counter-text, the writer reiterates his political mission of dissent. Language
then counters oppression, giving Codrescu rhetorical legitimacy to rebut
consumerism, cultural atrophy, and political subjugation.

In addition, through his strategic articulation of identity in relation to the
linguistic powers of exile as *the Outside*, Codrescu achieves two rhetorical
tasks. First, due to the fluidity of his cultural and political fragmentations in
language, Codrescu reconstitutes his identity by merging exile as voice and
expatriation as rhetor's location in discourse. Second, he regains coherence,

relocating himself within the "vast, expansive, changeable, paradoxical, perverse, traversed by all the escape routes" place "filled with tension, movement, instability, and force."[122] In closing, Codrescu observes:

> Yesterday's dissidents are today's heroes in the East, but are they equipped to understand the devious oppressive power of the image-based media? Until the recent revolutions in the East, the distinctions were clear: the Censor ruled the world, TV ruled ours. The Censor and TV were the neat Couple in whose suffocating embrace the human slowly gave up the ghost. It now appears that the old Censorship has dissolved into the illusionary liberty of our image-making machinery. What happens from here on out is no longer a question of ideological oppositions, but a struggle for global reality. There are two global realities, resembling in a nonrepresentational way the of programmatic realities of the East and West: the imaginary electronic globe, and the poetic-specific-eco-community.[123]

In the final statement that "[T]he poet's job is to short-circuit the imaginary globe," and intending to "short-circuit" any hegemonic discourse, Codrescu speaks from multiple locations in his expatriation, arguing against any singular culture, or any singular vision of democracy.[124] *The Disappearance of the Outside* constitutes his rhetorical appeal against conformity, hegemonic culture or politics; an attempt to put the powers of imagination back on the map of human existence.

Rhetorical Relations and Exilic Discourse: Changing Text and Context to Voice

Complex fragmentation as an exile stimulates Codrescu to reconstitute his rhetorical persona along cultural dimensions of time and place, while articulating a dissident position. From a critical standpoint, McGee's theoretical perspective on cultural fragmentation and its relationship with text and context are illustrated and continued by Codrescu's articulation of exile.

Rhetorically, cultural fragmentation challenges the inherent function of the text-context relationship in contemporary rhetoric, according to McGee.[125] Differentiating his critical perspective from close textual approaches to rhetorical analysis, McGee states that: "[C]ritical rhetoric does not *begin* with a finished text in need of interpretation." Rather, "texts are understood to be larger than apparently finished discourse." McGee believes that different cultural fragments form a discursive map, that is, text and context collapse when creating meaning. Taking "rhetoric as a master term,"

McGee emphasizes that "rhetors *make* discourses from scraps and pieces of evidence," creating meaning by moving between different cultural fragments that are both textual and contextual, when it comes to creating rhetorical action. Discourse, then, is seen by McGee in its *cultural* interconnectedness, as "structures of fragments, finished texts" and contexts account for the complex rhetorical action at hand.[126]

Implicating culture "in every instance of discourse," McGee focuses mainly on the relationships between text and context within the rhetorical framework of cultural fragmentation. Calling attention to the "fundamental interconnectedness of all discourse," McGee challenges the traditional notion that text is a finite rhetorical product and separate from its historical (and cultural) context. Consequently, McGee collapses the two, in order to visit cultural fragmentation.[127] Suggesting that "such conceptual separation" created confusion "about the root nature of discourse," he contends that rhetoric needs to see discourse within a collapsed text-and-context relationship in culture.[128] For him, rhetorical criticism no longer deals with *a* finished text in need of interpretation, rather it deals with *apparently* finished discourse that presents itself as transparent, where "all of culture is implicated in every instance of discourse."[129] As a result of his approach, McGee argues that by modifying the relationship between text and context, critics and rhetors operate with "*discursive fragments of context,*" with an invisible text "never quite finished but constantly in front of us" and with a text construction "*done more by the consumers than the producers of discourse.*"[130] Thus, offering the collapse between text and context as the strategic solution to give voice to inherent cultural fragments contained in "apparently finished" texts, McGee celebrates rhetoric as a map of incomplete structures where text disappears into a rhetorical construction of the fragmentation of culture.

McGee posits a pertinent question regarding the contemporary treatment of text and context in rhetorical studies. Fundamentally, I agree with McGee and therefore I take his assumptions as important premises for my rhetorical study.[131] However, when applied to exilic discourse, McGee's position emphasizes mostly *one* specific culture, namely American, and with it, the fragmentation of discourse in a singular cultural mode. As Codrescu points out in both volumes studied here, due to exile, his fragmented identity posits a question of the *rhetor* located in multiple cultures to which and from which he/she creates discourse. He also reinforces that the locus of consistency for a rhetorical account lies within the rhetor's power to recreate his or her voice

of coherence. Accordingly, my study enforces the relation between rhetor and culture, rather than adopting McGee's approach on text and context in culture.[132] Codrescu's reinvention of voice illustrates that a rhetor can remain fragmented due to multiple cultures invoked in his discourse, leaving at least temporal fragments of his identity separate, and uncollapsable, to use McGee's vocabulary.

To demonstrate the rhetor's continuous fragmented identity in multiple cultures, let's look one of the previous discursive excerpts presented from *Hole*. As the poet-exile announces his intention to visit his uncle, the last five sentences of the excerpt pull into the text cultural readings most Romanian audiences can interpret. Codrescu utilizes subtle, penumbra-like allusions to his relatives' life during Ceaușescu's regime. Mentioning briefly that his Uncle Rihard and his Aunt Elena "had been moved from their house to an apartment building," Codrescu invokes his Romanian readership in the *cultural* and *political* reading of the text.[133] For this statement translates culturally into a narrative where the elder couple's house was taken by the state. Anyone reading from within the culture knows that Codrescu's relatives lost their house in Sibiu because either some political apparatchik wanted to use it, or because some officials harbored anti-Semitic sentiments.[134]

Two more cultural references to Romanian policies reinforced during Ceaușescu's regime stand out. Writing that an address with "scribbled numbers had reached me via one of our old neighbors," he alludes to a routine political measure to forbid people in Romania to correspond with their relatives abroad. Consequently, in communist times, Romanians, and for that matter, Eastern Europeans used the underground technique of circulating documents and information via other Eastern European people lucky enough to travel abroad.[135] During the communist regime in Romania, it was a common practice to persecute people whose police files were stained by their "relatives abroad" by moving them from their homes into whatever housing the state's officers allotted them.[136] In addition, a conglomerate of residual images of anti-Semitic sentiments and re-inscribing of ethnic difference concur to reiterate Codrescu's constitution of expatriate identity within pre- and post-1989 Romania.[137]

Codrescu's identity as a rhetor pulls different cultural fragments into the text as he retells the story of difficulties in communicating in Eastern and Central Europe during the communist regimes, in the 1980s.[138] For anyone who has lived behind the Iron Curtain, and especially in the last decade of

the communist era in Romania, his visit to his uncle's house provides a *palimpsest* of the unspoken political pressures of those times.[139] For a Romanian and Eastern or Central European readership, Codrescu embeds different cultural contexts of time, creating a richer reading of his rhetorical text. In addition, his re-contextualization of political tensions for Romanian citizens of Jewish origin brings additional rhetorical legitimacy to his voice of difference.

Returning to McGee, his rhetorical proposition appears to omit questions relevant to my inquiry. In response to multiple *and divergent* cultural contexts, how does a rhetor negotiate his/her discursive fragmentation? Or, what strategies does a culturally fragmented rhetor use to reveal dissimilar cultural contexts as they enter his or her text? Or, can an exiled author reconfigure coherence in his rhetorical account of disrupted existence by merely collapsing text and context?

I argue that Codrescu's redefinition of identity in discourse expands the rhetorical relation established by McGee. Exiled rhetors are fragmented by definition, and more important for rhetorical analysis, they are fragmented in *different* and *multiple* cultures at the same time. Thus, what happens when a rhetor of expatriation, due to *simultaneous yet different processes of cultural fragmentation,* creates a rhetorical action? While McGee advocates the necessity of understanding the "invisible text" that culture creates in the discourse, I consider contemporary studies should also reveal the *divergent tensions* culture creates in a rhetor's voice in discourse. Hence, culture becomes a major factor in the discursive relationships a rhetor constructs when attempting an effective and coherent rhetorical action. Codrescu's rhetorical powers of voice pull into the text tensions from both his cultural worlds, creating a *complex* rhetorical relationship between rhetor and coexistent cultural fragments of discourse.

Adding to McGee's argument, coherence of exilic identity stems precisely from invoking disparate cultural fragments coexistent within Codrescu's voice. Being in exile and writing in response to expatriate conditions, the rhetor creates from a fragmented position, from the intersection of various cultural borders, from distinct relationships between past and present, freedom and oppression, homeland and host land, and from the struggle between poetic or political experiences in expatriation. All these sites coincide and transform each other within the rhetor's voice between text and context in expatriate discourse, challenging each other, creating conflictual tensions between multiple identities in dissent.

Consequently, Codrescu's fragmentation in culture directs rhetorical analyses towards the divergent tensions a rhetor encounters through exilic discourse. Whether poetic or political exile, Codrescu brings to the forefront multiple loci for a *rhetor's voice of expatriation* along with cultural dimensions of time and place as coexistent in discourse, in order to articulate a most necessary rhetorical coherence.

Notes

[1] An earlier version of this chapter was published as a book chapter in *Realms of Exile,* edited by Domnica Radulescu. See Noemi Marin, " The Rhetoric of Andrei Codrescu: A Reading in Exilic Fragmentation," *Realms of Exile: Nomadism, Diasporas ans Eastern European Voices,* Domnica Radulescu, ed., Rowman and Littlefield Press-Lexington Series, (Lanham, MD: 2002) 87-107.

[2] Joseph Brodsky, Stanislaw Baranczak, Czeslaw Milosz, or Eva Hoffman are some of the previously mentioned Eastern and Central European writers emphasizing the cultural challenges of exile throughout their works. Two collections of writers' perspective on exile reflect the salience of the topic, Robinson, Marc, ed., *Altogether Elsewhere: Writers on Exile* (San Diego: Harcourt Brace, 1994); and Aciman, André, ed. *Letters of Transit: Reflections on Exile, Identity, Language, and Loss* (New York: The New Press, 1999).

[3] Edward W. Said, "Reflections on Exile," *Altogether Elsewhere: Writers on Exile* ed. Marc Robinson (San Diego: Harcourt Brace, 1994) 140-41.

[5] Hoffman, Eva, "Obsessed with Words," *Altogether Elsewhere: Writers on Exile,* ed. Marc Robinson (San Diego: Harcourt, 1994) 229.

[4] Living in past and present linguistic and cultural worlds, Brodsky reveals that: "a writer in exile is by and large a retrospective and retroactive being. In other words, retrospection plays an excessive role--compared with other people's lives--in his existence, overshadowing his reality and dimming the future into something ticker that its usual pea soup," see Joseph Brodsky, "The Condition We Call Exile," *Altogether Elsewhere: Writers on Exile,* ed. Marc Robinson (San Diego: Harcourt, 1994) 6; and Noemi Marin, "Eastern European Exile and its Contemporary Condition," *Migration: A European Journal of International Migration and Ethnic Relations,* 33/34/35 (2002): 155-71.

[6] Baranczak discusses language as a barrier of different experiences: the audience in the exiled writer's adopted country, even if not entirely indifferent, is often unable to understand not merely his interpretation of reality but simply what he is speaking about. And quite naturally so, since neither the material of the readers' own experiences nor their inherited way of viewing reality has prepared them to accept this sort of literary world." Stanislaw Baranczak, "Tongue-Tied Eloquence," *Breathing Under Water and Other East European Essays* (Cambridge: Harvard UP, 1990) 234-35.

[7] Aciman, André, "Introduction." In *Letters of Transit: Reflections on Exile, Identity, Language, and Loss.* Aciman, André, ed. (New York: The New Press, 1999)10.

[8] Andrei Codrescu, *The Hole in the Flag: A Romanian Exile's Story of Return and Revolution* (New York: Avon, 1991).

[9] I am borrowing Sorin Antohi's term. See Antohi, Sorin, "Habits of the Mind: Europe's Post-1989 Symbolic Geographies." In Antohi, Sorin and Vladimir Tismaneanu, eds. *Between Past and Future The Revolutions of 1989 and their Aftermath.* (Budapest: Central European UP, 2000): 61-81.

[10] See Alina Mungiu, "Romanian Political Intellectuals before and after the Revolution."*Intellectuals and Politics in Central Europe.* Ed. András Bozóki. (Budapest: Central European UP, 1999): 82. Also Ivan T. Berend. *Central and Eastern Europe, 1944-1993: Detour from the Periphery to the Periphery.* (Cambridge: Cambridge UP, 1996): 289-90. Mungiu, Berend, Tismaneanu, Brown, Pacepa, and many others explain the political venues pertinent to Romania that prevented dissidents from becoming a powerful resource for social and political change in the country during Ceausescu's regime.

[11] Norman Manea explicates in detail the irony and tragedy of existence as a writer in *On Clowns: The Dictator and the Artist.* The essay "The History of an Interview" reinforces specifically the diffused existence of resistance in Romania of the 1980s (125-178). See Norman Manea, *On Clowns: The Dictator and the Artist.*(New York: Grove P, 1992).

[12] Andrei Codrescu, in an Interview with Molly McQuade in the aftermath of the Romanian Revolution, discusses his return. See McQuade, Molly. "Andrei Codrescu: A Not-So-Prodigal Son Returned to Revolution in Romania, and Wrote a Book about It." *Publishers Weekly,* 238.23 (May 24, 1991): 39-41.

[13] Codrescu in McQuade's interview, 39.

[14] In terms of his voice as an essays, writer, or exile, Codrescu identifies mostly with his existence as a poet throughout his works.

[15] Andrei Codrescu, *The Disappearance of the Outside: A Manifesto for Escape* (Reading, MA: Addison-Wesley, 1990).

[16] Codrescu, *Hole* 164-65.

[17] In spite of Codrescu's perception of himself as a "poetical exile" in most of his interviews and in his discursive accounts, in Romania he is perceived as a cultural and/or political exile. In his last return to Romania in 1998, Codrescu was celebrated for his books in a cultural event sponsored by the government. As he is "no causal visitor" received with great honors both in the cultural world and in the political one, Codrescu writes that: "Despite their cynicism, poverty, and politics, Romanians love art and literature. It may be impossible (and unnecessary) to separate art from politics in a country where national consciousness has been forged by poets for the last three centuries" (10). Andrei Codrescu, "Return to Romania: Notes of a Prodigal Son," *Washington Quarterly*, 21(1998): 3-21.

[18] On the jacket of one recent books, *The Dog with the Chip in His Neck* Codrescu is described as follows: "[T]renchant, occasionally splenetic, and always brutally funny, Romanian-born Codrescu confronts the convulsions of our post-ideological world at a time when "the advent of cyberspace and the caffeinating of America has occurred simultaneously." With these newest essays from 1994 and 1995--some that are straight off the NPR airwaves and some that have served magazine pieces or speeches--Codrescu takes us on a roller-coaster tour through our own dramatically changing country." See Andrei Codrescu, *The Dog with the Chip in His Neck* (New York: St. Martin's P, 1996).

[19] One of his first pen names is Andrei Steiu. He also signed with a feminine name, Maria Parfenie. He starting using Andrei Codrescu as his pen name in Italy in 1965. However, he continued to take other pen names like: Julio Hernandez, Peter Boone, Alice-Henderson Codrescu and "Tristan Tzara." Andrei Codrescu, interview with Constantin Pricop, " Sensul diferentei a fost cu mine de cind m-am nascut," *Romania Literara*, 45, 12 Nov. 1997, 5 Apr.1998 <http://romlit.sfos.ro/www/html/rl745.htm>. In addition, in *Hole*, Codrescu offers a paragraph on his reasons to use a pen name, the major one being Romanian anti-Semitism. See Codrescu, *Hole* 164-65.

[20] Andrei Codrescu, *The Life and Times of an Involuntary Genius* (New York: George Braziller, 1973).

[21] Codrescu states in the same interview that his first publications were poems in literary magazines like *Steaua* in Cluj, and *Luceafarul* and *Gazeta Literara* in Bucharest.

[22] Alina Mungiu, "Romanian Political Intellectuals before and after the Revolution."*Intellectuals and Politics in Central Europe.* Ed. András Bozóki. (Budapest: Central European UP, 1999):73-101; and Katherine Verdery, *National Ideology Under*

Socialism: Identity and Cultural Politics in Ceaușescu's Romania (Berkeley: U of California P, 1991) 98-137.

[23] While not as numerous as studies on the rest of Central Europe, a number of works on communist Romania reveal the scarcity of political dissidents and the difficulties of existence especially after 1971 during Ceaușescu's regime. See Daniel B. Nelson, "Romania." *The Legacies of Communism in Eastern Europe.* Zoltan Baranyi and Ivan Volgyes, eds. (Baltimore: The John Hopkins UP, 1995): 198-227. In addition, an excellent study by Harsanyi and Harsanyi explains how by cultivating a rhetoric of double-talk the communist regime in Romania coopted intellectual writers. See Harsanyi Doina and Nicolae Harsanyi, "Romania: Democracy and the Intellectuals,"*East European Quarterly*, 27.2 (June 1993): 243-261.

[24] In the previously mentioned interview, Codrescu acknowledges that after leaving Romania, the writer passes through the Italian immigrant camp, where he changes his name before coming to the United States.

[25] "Poetry is my religion" states the author in the beginning of *The Hole in the Flag.* Codrescu, *Hole* 7.

[26] Codrescu, *Disappearance* 42.

[27] In a study on another emblematic poetic exile from Romania, Maria-Sabina Draga-Alexandru reaffirms the political and cultural marginality of civic discourse in communism, adding the dimension of gender as one additional locus of resistance. See Maria-Sabina Draga-Alexandru, "Exiles from Power: Marginality and the Female Self in Post-communist and Postcolonial Spaces." *The European Journal of Women's Studies.* 7 (2000): 355-66.

[28] Irina Grigorescu-Pana. *The Tomis Complex: Exile and Eros in Australian Literature.* (Berne: Peter Lang, 1996): 10.

[29] About that time, the writer states that: "[S]o open was American culture at the time of my arrival that I was almost instantaneously absorbed by it. Its values, at the time, seemed to be my own. Or rather, my values seemed to be highly regarded by my American contemporaries. I had no way of knowing, as I have said elsewhere, that 'America was an uninterrupted anthology of fads changing each other faster and faster across shorter and shorter time spans," see Codrescu, *Disappearance* 45.

[30] Codrescu explicitly offers accounts of his identity as "different" throughout his writings. In addition to the texts studied in this chapter, where he defines himself as the Other, Codrescu emphasizes the same identity in his recent accounts of visiting Romania, like his article "Return to Romania: Notes of a Prodigal Son."

[31] My translation from the interview in Romanian.

[32] Speaking about anti-Semitism in contemporary Poland, Michnik attempts to dislocate his place of otherness, invoking his identity as a Pole and a Jew. Adam Michnik, "Poland and the Jews," *Letters form Freedom: Post-Cold War Realities and Perspectives*, Irena Grudzinska Gross, ed. (Berkeley: U of California P, 1998): 169-175. However, the case for anti-Semitism in post-communist times continues to be made, and needs to be raised due to the rampid discourse of nationalist insurgence incurring in most of the countries of the area.

[33] He makes this statement in his previously mentioned interview in Romania.

[34] Andrei Codrescu, "Notes of An Alien Son" *The Nation* 12 Dec. 1994: 722.

[35] Codrescu is also well known as an editor of anthologies and of an independent avant-garde literary journal, *Exquisite Corpse*. See Andrei Codrescu, "Literature at the End of the Century: An Editorial Perspective" *Literary Review* 33.2 (1990): 157-62.

[36] His essays after 1989 demonstrate Codrescu's assiduous participation in the American public discourse. However, his four visits to Romania and his Romanian cultural "recall," as I name it, appear in large number in his latest collections of essays. In *The Muse Is Always Half-Dressed in New Orleans and Other Essays*, Codrescu has an entire section (five essays) related to Romania and his exile. Similar case for his later collection, *The Dog with the Chip in His Neck*. Andrei Codrescu, *The Muse Is Always Half-Dressed in New Orleans and Other Essays* (New York: St. Martin's P, 1993) 85-127; and Andrei *Codrescu, The Dog with the Chip in His Neck: Essays from NPR and Elsewhere* (New York: St. Martin's P, 1996) 121-95.

[37] A great account of the Central and Eastern European revolutions of 1989 can be found in Tismaneanu's chapter entitled "The Triumph of the Powerless: Origins and Dynamics of the East European Upheaval." See Vladimir Tismaneanu, *Reinventing Politics: Eastern Europe from Stalin to Havel*, (New York: Free P, 1992) 175-241.

[38] Codrescu, in the chapter "The Long Road Back," describes his emotional journey back after twenty-five years, offering also an endearing account of an exile's fantasies of return. See Codrescu, *Hole* 51-65.

[39] In *The Hole in the Flag*, Codrescu articulates his excitement, writing that: "suddenly there, under the cold moon, there it was, the Romanian flag with the socialist emblem cut right out of the middle. It fluttered over a square brick building marking the frontier. *It's through that hole*, I thought, *that I am returning to my birthplace.*" Codrescu, *Hole* 67.

[40]Although the chronological dates of publication for these two accounts are listed above, I contend they are written within the same period of time. Codrescu's "Foreword" in

Disappearance is dated "Sibiu, Romania, December 31, 1989," the same time period for his account of the Romanian revolution in *Hole*. See Codrescu, *Disappearance* viii.

[41] Due to my personal cultural connection to Romania, Codrescu's discourse constitutes a powerful challenge. In reading them, I find my critical voice dubbed by an emotional understanding of his exile due to my own personal experiences in this communist country. Watching Codrescu return to his native country, and mine, I find myself following, like a personal hologram, Codrescu's experiences. For, along with his journey, I recognize my own, as I seem to revisit with Codrescu page by page. Since I left Romania at the very beginning of February, 1990, a time between Codrescu's two visits portrayed in *The Hole in the Flag*, this particular account makes it even more personal for me. And yet, Codrescu's visit bears throughout the nostalgia of a poetic exile's return, while my last memories of Romania carry with them the distinct bitterness of a political action.

[42] Tismaneanu, reviewing the book, writes that: "Codrescu insists that his account is not journalism, leaving the reader puzzled as to what exactly it is. A memoir, a travelogue, a journal? No matter. It is a primary source on today's Romania." Vladimir Tismaneanu, "Hole in the Flag," rev. of *The Hole in the Flag: A Romanian Exile's Story of Return and Revolution*, by Andrei Codrescu, *Orbis*, 35 (1991): 623.

[43] For the purpose of this study, I use the phrases "cultural context" and "cultural borderland(s)" interchangeably.

[44] I am referring to the titles of two articles mentioned previously. Both articles follow the book: "Notes of An Alien Son"is written in 1994, and "Return to Romania: Notes of the Prodigal Son" is written after his recent trip back to Romania, in 1998.

[45] In *The Hole in the Flag*, the chapters " New Year's 1990 in Bucharest"(15-25), "Death of a Dictator" (25-51), "Bucharest" (77-95), "The Revolution is Televised: Seize the Means of Projection!"(95-113), "Someone's Shooting at Me" (113-27), or "Adrian: Writers Improvise the Revolution"(127-41) provide detailed narratives of the events during and right after the Romanian revolution of 1989.

[46] What I mean by "refragmentation" in response to exile is the concept that rhetorically discontinuous identities coexist by juxtaposing multiple time lines of narratives and rhetorical voices of the speaker.

[47] Codrescu, *Hole* 15.

[48] Codrescu, *Hole* 15.

[49] Codrescu, *Hole* 17. In addition, similar perception is to be found in Brodsky's address on exile in Vienna, 1987, as he states there that an exiled author is "a retrospective being." See Brodsky, "Condition" 7.

[50] Grzegorz Ekiert, "The End of Socialism with a Human Face," *The State against Society: Political Crises and their Aftermath in East Central Europe.* (Princeton, NJ: Princeton UP, 1996);162-198.

[51] Nelson's exemplifications are some of the many in relation to the wood language of communism and in particular in relation to official discourse during Ceauşescu's regime. See Daniel B. Nelson, "Romania." *The Legacies of Communism in Eastern Europe.* Zoltan Baranyi and Ivan Volgyes, eds. (Baltimore: The John Hopkins UP, 1995): 198-227

[52] A famous case is the poet Ana Blandiana, and the banning of her children book *Memories from My Garden* (translation from Romanian by the author). While the case is well known among Romanian dissent, I could find almost no bibliographic information on the specific work. See <http://www. geocities.com/sky_ralu/carte.html> . Blandiana's poem, "Children's Crusade" remains the most (in)famous affront to Ceausescu's regime. The poem runs as follows: "An entire people/unborn yet/but yet sentenced to be born/already in line, before being born/foetus next to foetus/an entire people/who do not see, who do not hear, who do not understand/but who marches forward/ among bodies of women struggling/among streams from mothers/ever asked (to be)." Translation from Romanian by author. Poem posted by Romanian Voice at <http://www.romanianvoice.com/poezii/poezii/cruciada.html>

[53] Sorkin, Adam J., "The Paradox of the Fortunate Fall: Censorship and Poetry in Communist Romania." *The Literary Review*, 45.14 (Summer 2002): 886-912.

[54] Even editorials in *The Economist* use in 1989 some of the official idioms and words reflective of the (in)famous Romanian official vocabulary. See *The Economist (US).* 311.7599 (April 22, 1989): 16.

[55] Norman Manea's account of censorship is not only illuminating but also explicating its horrific powers of censorship on words in a dictatorship. See Norman Manea, "Censor's Report: With Explanatory Notes by the Censored Author," *On Clowns: The Dictator and the Artist* (New York: Grove, 1992): 63-91.

[56] Grigorescu-Pana, *The Tomis Complex* 10.

[57] A Romanian literary critic living in Paris makes the argument for the resilience of Romanian literature surviving the horrid times of totalitarianism. See Mircea Iorgulescu, "The Resilience of Poetry," *Times Literary Supplement,* 4529 (January 19, 1990): 61-64.

[58] Codrescu in the interview with Molly McQuade, *Publishers Weekly,* 238.23 (May 24, 1991): 39.

[59] Codrescu, *Hole* 117-18.

[60] Codrescu, *Hole* 118.

[61] Codrescu, *Hole* 173.

[62] Codrescu, *Hole* 174.

[63] Codrescu, *Hole* 174.

[64] Codrescu, *Hole* 143.

[65] Codrescu, *Hole* 143.

[66] Romanian oral tradition has remained, to this day, a salient part of its national culture. Consequently, the rhythm of time Codrescu alludes to its identifiable style typical to Romanian fairy tale narratives. The number *three* is a major device to measure time in Romanian tales for passage of events. In addition, the word "yearning" has etymologically been considered having a specific and singular Romanian meaning, hard to translate in any other language. Zamfir in his Foreword discusses such particular references in Romanian tales. See Mihai Zamfir, Foreword, *History and Legend in Romanian Short Stories and Tales,* trans. Ana Cartianu (Bucharest: Minerva, 1983) I-xix.

[67] This particular word, which for American readership does not necessarily carry cultural and national connotations, does so for Romanians, as "dor." In Wales, interestingly, a similar cultural identification is to be found in the usage of the word that denotes similar nostalgic and longing attributes nationally accepted. The word is "hiraeth" and a n insightful cultural explanation is offered by Robertson Davies in his collection of essays on music and literature. See Robertson Davis, *The Happy Alchemy: On the Pleasures of Music and the Theatre,* eds. Jennifer Surridge and Brenda Davies (New York: Penguin, 1999) 318.

[68] Codrescu, *Hole* 143.

[69] Codrescu, *Hole* 143.

[70] Codrescu, *Hole* 143.

[71] Codrescu, *Hole* 80.

[72] Codrescu, *Hole* 80.

[73] As mentioned previously, Brodsky, Milosz, or Baranczak, to remain in the company of authors quoted, represent important literary voices recalling the metaphorical transpositions of time due to linguistic powers of exile.

[74] Codrescu, *Hole* 155-169.

[75] Codrescu, *Hole* 80.

[76] Codrescu, *Hole* 155-169.

[77] Codrescu, *Disappearance* 1-37.

[78] Codrescu, *Hole* 80.

[79] Codrescu's identity as an outsider will be developed much more in his following section analyzing his strategies of redefinition in *Disappearance.*

[80] Codrescu, *Hole* 230.

[81] Codrescu, *Hole* 232.

[82] In a sense, the same linguistic separation can be interpreted rhetorically as an absence and presence dimension of discourse. However, in McKerrow's critical rhetoric where this dichotomy appears, it is located within the discourse of power and freedom. See Raymie E. McKerrow, "Critical Rhetoric: Theory and Praxis," *Communication Monographs*, 56 (1989): 91-111.

[83] Codrescu, *Hole* 232.

[84] Codrescu, *Hole* 226.

[85] Codrescu, *Hole* 232.

[86] Brodsky reveals a similar view, stating that exile for authors represents "first of all, a linguistic event: an exiled writer is thrust, or retreats, into his mother tongue." Brodsky, "Condition" 10.

[87] Codrescu, *Hole* 232.

[88] Codrescu, *Hole* 232.

[89] Kathleen Osgood Dana, "Perspectives on World Literature," rev. of *The Disappearance of the Outside: A Manifesto for Escape*, by Andrei Codrescu, *World Literature Today*, 65.1 (1991): 197-99.

[90] I use the term "culture" in its double rhetorical and literary connotation salient for this account. On one hand, Codrescu refers to "culture" as ethnic, political, and social contexts related to exile, and on the other, he refers to culture as the educational and literary context from where his poetic voice can produce a language of resistance. See "Culture," *Webster's New Collegiate Dictionary*, ed. 1977.

[91] A phenomenological construction of space as a locus for poetic imagination is provided by Gaston Bachelard in his intriguing work, *The Poetics of Space*. However, Bachelard offers a perspective bridging philosophy and poetry, as he leaves out the rhetorical dimension of spatiality. See Gaston Bachelard, *The Poetics of Space*, trans. Maria Jolas (Boston: Beacon P, 1964).

[92] Dana writes in her review of the book that: "Andrei Codrescu contends that bona fide literature can only be written on the periphery of the system, on the "Outside"; that is imagination and truth do not function within the establishment. . . . Codrescu himself exalts the status of the political or literary exile, since the very existence of a state of exile denotes an existence on the periphery, on the active edge of the Outside, where a moral stance has credibility and writing is real." See Dana, "Perspectives"197-98.

[93] Codrescu, *Disappearance* 206.

[94] Codrescu, *Disappearance* 123, 107.

[95] Although his book is a free-form literary essay on exile, its first part retells Codrescu's personal story of exilic existence. Most of this analysis of voice in relation to place refers mainly to this first part of the book, as it captures most of Codrescu's strategic redefinition of identity in exile. I refer particularly to the first chapters, namely, "Time Before Time" (1-37), "Exile, A Place" (37-57), and "Living with Amnesia"(91-115).

[96] I want to emphasize that "cultural" carries ambiguous and multiple meanings, specifically for this second account. On one hand, Codrescu invokes culture in its educational and literary connotation, and on the other, he refers to culture within ethnic or sociopolitical dimension of the term. I consider this ambiguity to be a part of Codrescu's strategic invocation of exile for his redefinition of voice.

[97] Codrescu, *Disappearance* 6.

[98] It is within the rhetorical action of appropriation of historicity that rhetors select and emphasize self-understanding providing the resources to invent publicness (Hauser, 113). While Hauser discusses "historicity" in relation to publics and counterpublics, I find the same concept useful for exilic ethos. See Hauser, *Vernacular Voices*, 111-161.

[99] Codrescu, *Disappearance* 6.

[100] Codrescu, *Disappearance* 11.

[101] Codrescu, *Disappearance* 11.

[102] Codrescu, *Disappearance* 37.

[103] Codrescu, *Disappearance* 37.

[104] Codrescu, *Disappearance* 40.

[105] Codrescu, *Disappearance* 40.

[106] All these Romanian writers in exile have a large influence on Codrescu's cultural upbringing, for he makes numerous references to their names throughout his essays.

[107] Codrescu, *Disappearance* 54-55.

[108] Codrescu, *Disappearance* 55-56.

[109] Although declaring himself a *political* exile, Edward W. Said advocates similar liberation as an expatriate. For him, exile becomes the political and cultural instrument of cooperation in the world, a unifying tonality of communication. See Edward W. Said, "Reflections on Exile," *Altogether Elsewhere: Writers on Exile*, ed. Marc Robinson (San Diego: Harcourt Brace, 1994)140-41.

[110] Codrescu, *Disappearance* 54. In addition, comfortable in his cultural fragmentation, the writer confesses that "the reality of my exile has, so far, been less important to me than the myth." Codrescu, *Disappearance* 58. In addition, by 1994, in "Notes of an Alien Son," Codrescu reiterates similar identity as a poetic and literary exile, stating that he is a "planetary refugee, a professional refugee, a permanent exile," never feeling "like a refugee, either political, or economic. What I felt was that it was incumbent upon me to manufacture difference, to make myself as distinct and inassimilable as possible. To increase my foreignness, if you will. That was my contribution to America." See Codrescu, "Notes" 718.

[111] Interestingly, Foucault conceptualizes history along similar discontinuous and fluid rhetorical interactions. In the "Introduction" to *The Archaeology of Knowledge*, Foucault states that "a history... would not be division, but development; not an interplay of relations, but an internal dynamic; not a system, but the hard work of freedom; not form, but the unceasing effort of a consciousness turned upon itself... a history that would be both and act of long, uninterrupted patience and the vivacity of a movement, which, in the end, breaks all bounds;" see Michel Foucault, *The Archaeology of Knowledge and The Discourse on Language,* trans. A. M. Sheridan Smith (New York: Pantheon, 1972) 13.

[112] Codrescu, *Disappearance* 55.

[113] Codrescu, *Disappearance* 42.

[114] Codrescu, *Disappearance* 45.

[115] Codrescu, *Disappearance* 38.

[116] Codrescu, *Disappearance* 40.

[117] Codrescu, *Disappearance* 38. His action of sabotaging history seems to me to be a political action in Codrescu's discourse.

[118] Codrescu, *Disappearance* 57.

[119] Codrescu, *Disappearance* 58.

[120] Codrescu, *Disappearance* 107-108.

[121] Codrescu, *Disappearance* 108.

[122] Codrescu, *Disappearance* 107.

[123] Codrescu, *Disappearance* 206-207. Throughout this excerpt and others in *Disappearance* Codrescu invokes P. B. Shelley's claim that the poet is the "unacknowledged legislator of the world" in his famous "Ode to the West Wind." Again, I am grateful to the reviewer's comment for revealing this layer of rhetorical meaning. See Percy Byshe Shelley, *The Complete Poetry of Percy Byshe Shelley*, Donald H. Reiman and Neil Fraistat, eds. (Baltimore: John Hopkins UP, 2000).

[124] Codrescu, *Disappearance* 207.

[125] Michael McGee, "Text, Context, and the Fragmentation of Contemporary Culture," *Western Journal of Speech Communication*, 54 (1990): 274-90.

[126] McGee, "Text" 279.

[127] McGee, "Text" 281.

[128] McGee, "Text" 283. Positing himself in contrast with the close textual analysis of rhetorical texts, McGee writes that: "[B]y contrast, with rhetoric as a master term, we begin by noticing that rhetors *make* discourses from scraps and pieces of evidence. Critical rhetoric does not *begin* with a finished text in need of interpretation; rather, texts are understood to be larger than the apparently finished discourse that presents itself as transparent. The apparently finished discourse is in fact a dense reconstruction of all the bits of other discourses from which it was made" (279). Later on, describing how fragments reshape the relationship between text and context in contemporary rhetoric, McGee adds that: "My way of stating the case (using the concept "fragments" to collapse "context" into "text") emphasizes an important truth about discourse: *Discourse ceases to be what it is whenever parts of it are taken "out of context."* McGee, "Text" 283.

[129] McGee, "Text" 281.

[130] McGee, "Text" 287-88.

[131] Further on, McGee explicates that text construes inherent relationships with *con-text* (my emphasis) in so that two consequences occur: (a) context invokes phronesis (cultural) in understanding text, and (b) context and text collapse into each other, as no finished single text can be interpreted. See McGee, "Text" 288.

[132] In personal correspondence, McGee was gracious in relation to the rhetorical work submitted, to reinforce my point as an extension to his theoretical position. McGee, email 2002.

[133] Codrescu, *Hole* 143.

[134] Makine refers to similar strategies of communication in Russia. See Andrei Makine, *Dreams of My Russian Summers,* trans. Geoffrey Strachan (New York: Simon and Schuster, 1995) 223-26. In addition, part of the same political policies during Ceaușescu's regime in Romania, a common practice for political apparatchiks was to abuse their power in order to live in better houses. Consequently, all the people who were on a black list of sort were transferred, legally, in a smaller apartment, in accordance with the apparatchiks' decision on their fate. Pacepa describes some of the political abuses of the black-listed population. See Ion

Mihai Pacepa, *Red Horizons: The True Story of Nicolae and Elena Ceaușescu's Crimes, Lifestyles, and Corruption*, (Washington, D.C.: Regnery Gateway, 1987).

[135] Codrescu, *Hole* 143.

[136] Although not referring to housing, but to communist politics of intimidation, Konrád makes similar references in *The Melancholy of Rebirth*, especially in the beginning of his collection, "Thoughts on the Border"(1-7), "Letter from Budapest" (7-15) and "Being Hungarian in Europe" (15-21). See George Konrád, *The Melancholy of Rebirth: Essays from Post-Communist Central Europe, 1989-1994*, trans. Michael Henry Heim (San Diego: Harcourt Brace, 1995).

[137] The anti-Semitic sentiments in Eastern Europe continue to remain a problematic of current times. See Timothy Garton Ash, "Apres Le Deluge, Nous." *Writings on the East: Selected Essays on Eastern Europe from the New York Review of Books*. (New York: The New Work Review of Books, 1990): 29.

[138] Codrescu, *Hole* 143.

[139] The idea of exile as palimpsest has been circulating in the body of literature on exile. An example is David Bethea's usage of the palimpsest when analyzing Joseph Brodsky's creation of exilic condition. See David M. Bethea, "Brodsky's Triangular Vision: Exile as Palimpsest," *Joseph Brodsky and the Creation of Exile* (Princeton: Princeton UP, 1994) 48-74.

CHAPTER IV

Drakulić: Rejecting Exile from the Balkans

With communism "defeated," must exile remain a reality for critical intellectuals of Eastern and Central Europe? What has happened to Eastern European discourse, as nationalistic myths of independence and rationales for war seemed to take over after 1989? Where do advocates of civil society posit themselves in the public sphere of nationalism? Slavenka Drakulić is a writer from the Balkans, one of the critical intellectuals whose life in the margins posits significant rhetorical and political problems. Drakulić is a Croat and a former Yugoslav, a European who lives part of her time in Eastern Europe and the rest on the Western side of the continent, a civic voice with two homes and no land, an advocate of democracy, bringing to the rhetoric of exile a unique and intriguing perspective on the relationship between marginalization and discourse. For Drakulić the chaos of the Balkans starts in 1990 and from then to now, her search for rhetorical voice in a democracy never stops.

Unlike its formerly communist neighbors, Yugoslavia, as a federal republic, became gradually nonexistent after 1989. With nationalism emerging more and more vigorously in the public arenas of the different republics--Croatia, Serbia, and Slovenia, to name the first three involved in

the Balkan conflict-- Drakulić lost a homeland and a culture.[1] A refugee in a war zone, then publicly banned in her homeland, witnessing drastic political changes in all the former Yugoslav republics, and challenging nationalist ideology in her newly independent country of Croatia, Drakulić presented a fragmented voice of democracy in Eastern Europe.

Due to the nationalistically shaped public sphere of the 1990s in the former Yugoslavia, the dissidence of critical intellectuals became a discursive and a political problem. Democracy yielded pride of place in the post-communist states of the Balkans as, instead, an ethnically driven discourse of independence and cleansing *from* the *other* populations once in the Yugoslav federation took priority.[2] As a critical intellectual, with no homeland after the dissolution of Yugoslavia, with no right to participate in the public arena of her new country of Croatia, and with no cultural and democratic discourse to share after the fall of communism, Drakulić struggled to maintain rhetorical voice.

Resisting political life in her homeland, Drakulić also found herself in discursive and (later) political expatriation. Living in tension with new linguistic cultural dimensions of what democracy, ethnic appeals, and civic responsibilities might mean in the new public arena of the Balkans, the ex-Yugoslav turned Croat was caught between cultural languages. The new Croatian politics and nationalist discourse declared communism dead. As Drakulić's critical intellectual discourse articulated an opposition perspective, fighting against a nonsensical war, against nationalism, and against continuing communist practices, she become marginalized. Experiencing a chaotic and tragic life in the post-communist Balkans, Drakulić refused to settle and remain silent on the political problems she experienced. Her discourse continued to mirror unrest in the Balkans, expatriation, and communist and neo-communist oppression. And yet, could she participate along with her fellow citizens in the public arena of her recently independent Croatia if she did not share cultural readings of communist dissidence or the long tradition of Croat nationalist appeals? And as an exile resisting her condition, could she articulate dissent in her new country with its new discourse in place? If so, how could she regain rhetorical voice while living in exile?

But Drakulić does articulate a resistance to exile. Denying the expatriation she is experiencing, the writer regains her coherence as a rhetorical identity of dissent through strategic reconstructions of place and time in language. From a rhetorical perspective, Slavenka Drakulić presents

an interesting and atypical expatriate case in her writings. Unlike other exiled critical intellectuals coming to terms with their existence in limbo for a long time, her identity as an expatriate is relatively new (only six years) and not even total.[3] And unlike fellow Croatian feminist, Dubravka Ugrešić, who accepts herself as a voluntary exile, Drakulić refuses to acknowledge such an identity in her writings.[4] Relatively *new* in experiencing exile, Drakulić *refuses* to consider exile either a definitional or a definitive experience. However, like all critical intellectuals from Eastern and Central Europe, she refuses to remain silent when facing post-1989 neo-communist practices. How does she reconcile her voice with the exilic experiences and the cultural conflicts she faces in her discourse?

Unsettled in her expatriation, Drakulić reconstructs her dissident identity in two accounts, *The Balkan Express* and *Café Europa*, published outside of her country.[5] More than anything, Slavenka Drakulić's essays on post-communist Eastern Europe reveal her voice in conflict with her forced displacement. Her discourse from the margins always attempts to engage the *other* discourse (pun intended), the one inside the Croatian public sphere, the one offering a coherent explanation for the casualties of an absurd war, or providing a rationale for authoritarian politics or nationalistic "fantasies of salvation."[6]

Drakulić's shifts of voice through language in relation to place and communist and post-communist times suggest a complex rhetorical action, and at the same time, a complex rhetor. Her multiple and different relationships with her audiences can either *fail* or *relocate* continuously her identity in relation to audiences in discourse. By positing her dis-placed voice in resistance against intricate cultural and rhetorical situations, such as the war in the Balkans, new and old Croatia, and a new Europe opened to civil discourse, Drakulić modifies the rhetorical relations between her identi*ties* in discourse. Thus, I argue, this rhetor's intricate and complex life in exile brings validation to new venues of investigating the rhetorical processes of the contemporary world.

Slavenka Drakulić: How Many Lives in the Margins?

Slavenka Drakulić writes from a position of an exile in denial. The Balkan war made her a refugee. The Croatian, Serbian, and Bosnian conflicts forced her to question her beliefs in democracy and her views on national identity. The public arena of Croatia excluded her participation. Thus, soon

after the fall of communism, Drakulić faced the challenges of a double exilic identity in her homeland: a refugee during the war, and a dissident under the new regime. However Drakulić refused to embrace her status as an exile. Experiencing the disintegration of Yugoslavia as a disintegration of her own identity, Drakulić's discourse becomes a search to regain rhetorical powers as a critical intellectual caught in between the cultural and political implications of nationalist and non-democratic contexts.

Before 1989, Drakulić was settled as a critical intellectual and journalist in the former Yugoslavia, publishing in one of the most important newspapers in Zagreb, *Danas*.[7] During the last years of the 1980s, unlike most critical intellectuals exiled from Eastern Europe, Drakulić's life in the margins of political opposition remained without political consequences.[8] Able to publish actively in magazines and newspapers in the West,[9] Drakulić, passport in hand, had the freedom to travel in both Western and Eastern Europe, enjoying, as she acknowledges, a "much higher standard of living and greater freedom . . . than did [those people in] the rest of the communist states." Continuing her explanation, Drakulić expands on the benefits a passport could bring to the Yugoslav population, stating that:

> We had refrigerators and washing machines when others did not, and could travel abroad, see American movies, buy a graduation dress in Milan or spend our summer holidays in Greece or Spain. Yes, essentially is it a comparison between prison cells, but the comfort of your cell makes a lot of difference when you are imprisoned (149). [10]

As a journalist, Drakulić knew her "official" political rights for publishing in communist countries. Censorship in those times, she notes, lay in "its subtler, deeper variations--autocensorship, internalized in each of us, so that we don't need to chat with our censors too often, so that we make their job easier."[11] She is a successful journalist and novelist. Publishing *Holograms of Fear* and *The Marble Skin* in Serbo-Croatian, and then in several other languages, Drakulić earned acclaim inside and outside Yugoslavia and even in Croatia.[12] Her most recent novel, *S.: A Novel About the Balkans*,[13] revisits the "already half-forgotten horror: the Bosnian war of 1992-95, in which the Serbian minority laid siege to Sarajevo and began rounding up and massacring Bosnia's Muslim population.[14]

After the 1989 revolutions, expecting a civil democracy to follow the demise of communism, Drakulić was bewildered. History, it seemed, had a different political experience in store. The demise of the communist regime

brought the disintegration of the six federal republics, called, once upon a time, Yugoslavia.[15] All of a sudden, the war in the Balkans between Serbia and Croatia and later between Serbia and Bosnia-Herzegovina presented a different reality, a reality of battles, nationalist claims, and civil unrest.[16] Slavenka Drakulić has always lived in a land of contrasts, in the land where cultural and political borders have been debated throughout the history of the region. Tanner, in his introduction to the history of Croatia, locates the country in a geographic and metaphoric borderland:

> Croatia is border land. It lies on the geographical border between Central Europe and the Balkans, and between the Mediterranean world and continental Europe. It lies also on a cultural and religious border, between Eastern, Byzantine Christendom and the Latin West. The very shape of the country reinforces the impression of a frontier. Nothing compact, square, or secure. Instead the country curves round Bosnia in a narrow arc, in the shape of a crescent moon, or a boomerang. At no point is Croatia more than a few hundred miles wide; at most points it is much less. In the far south, both north and south of Dubrovnik it is only a few miles wide, hemmed in between the Adriatic Sea on one side and the mountains of Bosnia on the other.

> The fate of border land is always to be precarious and frequently to *move*, shrinking and expanding across the generations to an astonishing degree. The fate of borderland is also to be buffeted in one direction or the other, to be trampled on, crossed over, colonized, defended and abandoned in turn by stronger neighboring powers. (x)[17]

By 1991, Drakulić had begun to realize that her beliefs and values might not be shared by a large number of Croatians, Serbians, Bosnians, or Herzegovinians. But she refused to believe in this disintegration of the cultural and political promised arena of democracy, as she continued to "believe in the words, in the power of communication," unable to remain quiet.[18] Her discourse became one of dissidence as she published more and more in the West, resisting the (re)newed language of nationalism and the war in the Balkans.[19]

By late 1991, the war between Serbia and Croatia forced Drakulić into even greater displacement. Already living amid nationalist chaos, witnessing casualties of war she had thought could never happen again after the crimes of the Second World War, Drakulić became a refugee. She fled to Slovenia. There, as a Croat refugee struggling to survive an incomprehensible history,

Drakulić experienced living without a home, while resisting war and nationalism.

As for her homeland, Croatia proclaimed its independence in January 1992. A new state, Croatia posed for numerous critical voices a political and cultural question, since from then on, "no one is allowed *not* to be a Croat."[20] Drakulić, Ugresić, and other critical intellectuals charged that Croat independence and Tudjman's nationalist and authoritarian regime did not promote a civil society and freedom in the country.[21] Therefore, unwilling to buy into the political discourse of the new government, and searching for a civil society and a democratic public arena, a large number of critical voices remained skeptical of the political transformation of the country, seeing no guarantees for a democracy.[22] Watching President Tudjman drinking coffee during a protest of people from Vukovar in the same square, Slavenka Drakulić witnessed how "the police authorities had cut off power to the [people's] microphones," just like "in the days of the communist regime."[23]

At a time of national homogenization, Drakulić expressed her opinions in print about the social, political and nationalistic changes around her. As a consequence, she was attacked as "a public enemy and a traitor."[24] Thus, refusing to align herself with the nationalistic claims of independence, feeling deceived in her expectations for a post-communist civil society, Drakulić experienced loss of identity, loss of rhetorical powers, loss of legitimacy.[25] In her collection of essays, *The Balkan Express: Fragments from the Other Side of War*, she responds to her circumstances as an angry citizen forced to experience expatriation, refugee status, and dissidence. In the "Introduction," Drakulić writes that:

> The myth of Europe, of our belonging to the European family and culture, even as poor relations, is gone. We have been left alone with our newly-won independence, our new states, new symbols, new autocratic leaders, but with no democracy. We are left standing on a soil slippery with blood, engulfed in a war that will go on for God knows how long.[26]

Writing detailed narratives defining the conflict in Croatia, Yugoslavia, and Eastern Europe, Drakulić brings readers from all over the world into a discourse about losing voice and access to a democratic life in the Balkans. Whether writing about an interview with a nineteen-year-old soldier who asks, "Will you come to my funeral?" or a letter to her daughter, whether she reflects on the Croatian peoples' support of the authoritarian regime or on her

personal experiences, the author continuously emphasizes the drama in the post-communist Balkans.[27]

Struggling to address the newly created identity she never sought, Drakulić resists the nationalist discourse that makes her only a Croat born in Rijeka, depriving her of other cultural heritages she pertained to, as a Yugoslav. Confessing in "Overcome by Nationhood" that for her, "as for many of my friends born after World War II, being Croat has no special meaning,"[28] Drakulić resists living in a country that "has had six bloody months of war," where her new, post-Yugoslav identity as a Croat. becomes her "destiny." Ugresić, who shares with Drakulić the public execution as "witches of Croatia" writes along similar lines about her own identity as a Croat in *The Culture of Lies,* "My passport has not made me a Croat. On the contrary, I am far less that today than I was before. I am no one. And everyone. In Croatia I shall be a Serb, in Serbia a Croat, in Bulgaria a Turk, in Turkey a Greek."[29] If so, how can Drakulić be defined by her nationality "and by it alone?"[30]

A Croat refugee in Slovenia, left with no other cultural identity than that of an expatriate, Drakulić reconstitutes her voice using the place called "home" as her major rhetorical and cultural signpost of discourse. Uneasy with her status and with the cultural schism produced, the Croat writer remembers that: "[O]f course, Slovenians and Croats understand each other, so it was not a problem of understanding but of something else, of a particular context. I was disturbed by the look people gave me when I started to speak in Croatian." For, she is transformed, after 1989, turning into "not only a foreigner now–but a *very special kind of foreigner,*" a refugee, reduced to the speechless collective group of homeless people.[31]

When the war ended, Drakulić returned to Zagreb, where her life in the new Croatian state took a dissident turn. Under the new regime, the right of critical intellectuals to speak up against the government was denied in the Croatian media in the name of nationalist cleansing of the public arena.

> The new government were soon determined to control the media almost as much as the old Communists, and much more so than the Racan-era Communists had been. The new HDZ bosses were strong nationalists with an intolerant streak. Milovan Sibl, director of the new Croatian news agency Hina, was typical of the group. 'Many of these journalists are of mixed origins,' he scoffed, referring to the anti-HDZ press, 'one Croat parent, one Serb. How can such people provide an objective picture of Croatia? . . . The only place you can read the truth about President Tudjman is in Hina news. (230)[32]

The year 1993 marked a turning point for Slavenka Drakulić. Her questioning of the regime in news commentary inside and outside the country rankle the authorities.[33] If Croatia is a democratic regime, asked Drakulić, why is the discourse of political resistance and dissidence not permitted in the new public arena? And why are the media controlled by the nationalist frenzy of Tudjman's rhetoric? Can it be that communist practices are back with a vengeance, only under a different name in this new state?[34]

The response to her critique was dramatic. Branded a "witch" in an article entitled "Croatian Feminists Rape Croatia," she was expelled from the press. Martha Halpert, reporting on the fifty-ninth International PEN Congress held in Zagreb in 1993, writes in *Partisan Review* about this incident, identifying two "of the brutally attacked women, Slavenka Drakulić and Dubravka Ugresić as members of PEN," whose guilty action is the fight against the official press of the times.[35] Hunted together with four other women writers for her "anti-war, anti-nationalistic, and individual standpoint,"[36] Drakulić again crossed the *cultural* borders of exile, becoming *persona non grata* in Tudjman's Croatia.[37] Called a "traitor of the Croatian people," Drakulić was forced to enter life in the margins of discourse, this time, as a feminist.[38] One could say, then, that Drakulić entered yet another realm of marginalization, that of a woman in a male-oriented culture.[39] Her public voice silenced, she was harassed in the media, unable to present her opinions in the new public arena.[40]

Technically, Drakulić became a political exile. Publicly banned, she lost her public and professional identity in Croatia, as her collaboration with the newspaper *Danas* ceased.[41] As a witch, a feminist, and a critical intellectual, her main professional offense was her overt criticism of "nationalist homogenization and the non-democratic new regime."[42] Refusing to acknowledge her exile, continuing to write on democracy and civil society in her homeland, Drakulić's public voice remains suppressed to this day to remain in the Croatian media. Oblivion is her punishment.[43] The only way Drakulić is present in the Croat press is as the subject of well-articulated attacks.[44] Drakulić explains that: "*they* publish only criticism towards my writings."[45] And yet, Drakulić resists even this self-characterization. She published a novel in Croatia in 1995 and some articles in the *Feral Tribune*, one of the very few opposition newspapers.[46] For the most part, however, Drakulić remains with no readership in her homeland, no opportunity to be present in the media, expatriated, and yet refusing to accept her new political

status. What happens, then, to her rhetorical redefinition of identity in response to exile?

In response to this situation, Slavenka Drakulić begins to posit herself as a critical intellectual in search of civil societies throughout Eastern Europe. In her collection of essays, published in 1996, *Café Europa: Life After Communism*, Drakulić moves away from the scene of the war, fighting old enemies like communism and authoritarian regimes, relentlessly promoting individual responsibilities in the creation of worldwide democracy. A critical intellectual with a mission to reveal the horrid traces of communism, Drakulić travels Central and Eastern Europe seeking answers for her own vocabulary of democracy. Contrasting her identity with that of her Swedish husband, she discusses her marked life as an Eastern European in the essay "Invisible Walls Between Us."[47] Drakulić reminds her readers that: "I know, they know, and the police officers know that barriers exist and that citizens from Eastern Europe are going to be second-class citizens still for a long time to come, regardless of the downfall of communism or the latest political proclamations. Between us and them there is an invisible wall."[48] Depicting in "To Have and To Have Not," "The Trouble with Sales," or "Invisible Walls Between Us" how communist borders remain *within* cultural identities in Eastern Europe and in the still discriminating westernized world, Drakulić presents the grammatical and cultural difference between "us and them" throughout her account.

Despite her cultural travelogue of the Eastern European world, Drakulić refuses to leave Croatia out of her experiences and her discourse, altogether. Whether traveling in Bulgaria, Romania, Austria, or Israel, this critical journalist brings her readership her experiences as a Croat, an Eastern European, an ex-Yugo, a feminist, and a public intellectual. And while only once does she refer to her expatriation overtly, throughout these essays Drakulić creates powerful narratives of dissidence against communist practices. Resisting with passion the public destitution in her homeland, she rearticulates her dissident voice while denying, at the same time, her actual exile. Speaking throughout the essays of *Café Europa* in the fragmented voice of dissidence, "not yet" a European, still an *Eastern* European, even a Yugoslav and a Croat, Drakulić fights her condition of expatriation in relation to communist or neo-communist *times* and all their cultural dictionary, visible or invisible.[49]

How, through all of this, does she reclaim rhetorical voice? "Introduction: First-Person Singular," the very first essay of this second

collection on post-communism, sets up Drakulić's re-constitutive identity in dissidence through the cultural powers of language. Locating her refusal of exilic voice as a flexible and tensioned linguistic and rhetorical presence between lands ands borders, or between past and present Eastern Europe, Drakulić reiterates her dissidence.[50] How, then, does she respond to multiple locations of her voice, to her displacement in discourse?

I contend that, as Drakulić rejects exilic experiences in her accounts, her strategic reconstitution of identity calls for repositioning of voice in complex relations to place and time through language. In response to being a refugee from the Balkan war, the writer reconstitutes herself in relation to the *cultural discourse* of Croatia and the Balkans.[51] It is within the intersection of nationalism and mythology that Croat discourse of nationalism arises, attracted, like other nationalist discourse, "by consolation, the bliss of community, a simple way to overcome feelings of humiliations and inferiority, and a response to real or imaginary threats."[52]

Thus, her rhetorical repositioning of voice creates a double cultural *location* resisted by her expatriation. In response to being a dissident journalist away from her readership and from the public arena of her homeland, Drakulić invokes her identity in relation to the linguistic and cultural dimensions of the communist *past* and the post-communist *present*. Thus, time and grammar become her counterpart context in which she recreates her voice of resistance against nationalism and the authoritarian regime in Croatia.

Drakulić is a rhetor without a country, without an audience, without a future civil society, resisting her identity in these conflicting rhetorical contexts. Her *dis-location* as a refugee marks her discourse, as she resents its rhetorical, political, and cultural consequences for her loss of voice. How can Drakulić redefine herself as a critical intellectual when she lacks a homeland and a rhetorical context to address? What rhetorical strategies can she use to recapture her identity, as her fragmentation continues?

Losing the Word "Home": The Voice of A Refugee

Soon after the fall of communism and due to the outbreak of war in her homeland, Drakulić became a refugee in Slovenia. The political irony is, of course, that Ljubljana, the capital of Slovenia, was not a foreign land prior to 1990, rather one of the major cities in former Yugoslavia. Due to war, however, territories once part of 'home,' turn into adversary lands. The

writer describes this new and almost surreal situation in her essay "On Becoming a Refugee" in *The Balkan Express*.[54]

Attempting to redefine herself as a refugee in Ljubljana, she poses relevant questions regarding the rationale of war and the cultural discourse in the former Yugoslavia. Her rhetorical response to the absurd situation of expatriation from one former Yugoslav region, Croatia, to another, Slovenia, entails a difficult political, cultural, and rhetorical redefinition. Resisting her status, Drakulić reconstitutes herself in relation to a place that carries double cultural dimensions: homeland as Croatia, and homeland as the Balkans.

"I know perfectly well that I might never go back. The country was at war and I wouldn't be the first one to leave home for a few days only to lose it all and have nothing to go back to."[55] Drakulić reconstructs her voice in relation to Croatia. Homeless due to war, the writer confesses that her identity has changed forever. Living now as a foreigner, "a special kind of foreigner,"[56] exile means "seeing the content of your life slowly leaking out, as if from a broken vessel."[57] And yet, how can she adopt a new and resented cultural and rhetorical identity? How can she reinvent herself when everything around her reminds her of a place she once called "home"?

Being in Ljubljana as a refugee, in a city that was a part of her former Yugoslavia, speaking the same language, Drakulić enters into the no man's land of expatriation As she calls herself more often "an exile" than a "refugee, her identity appears to be in consent with Said's distinctions between the two cultural categories, as he writes that:

> Exile originated in the age-old practice of banishment. Once banished, the exile lives an anomalous and miserable life, with the stigma of being an outsider. Refugees, on the other hand, are a creation of the twentieth-century state. The word "refugee" has become a political one, suggesting large herds of innocent and bewildered people requiring urgent international assistance, while "exile" carries with it, I think, a touch of solitude and spirituality. (144)[58]

Life in post-communist Ljubljana does not allow the author to forget she is "not only a foreigner now– but a very special kind of foreigner" where place and language seem to have lost their known meanings.[59] The writer was acquainted with Slovenia as a former Yugoslav republic, having a social and cultural normalcy, even if that normalcy was communist. Ljubljana used to be part of her country. The war and Croatians' and Serbians' dreams of independence changed the known reality. Thus, caught between past and

present personae, confused by a place with a new cultural meaning, namely that of a foreign land, Drakulić writes:

> It was on Sunday morning when I finally understood what it would mean to become an exile. I was not yet fully awake when the smell of coffee entered the apartment and gently stirred my nostrils. It was the smell of freshly brewed coffee made in an espresso machine, strong and short, the Italian way. This was just as I used to make it on lazy Sunday mornings, drinking it wrapped in an old pullover over pyjamas while tufts of a milky smog still hung on the hortensias in the garden. . . . I looked around 'my' apartment: except there was not one thing that was mine. Only a suitcase not yet emptied and my winter coat hanging in the closet with my friend's summer clothes. . . . This was not my home, there were no pictures and posters on the walls which I had put there, no books I had bought.[60]

Rejecting again her identity as exile, Drakulić builds the conflictual relationship between her rhetorical voice and this exilic place. By setting distance between her identity and her position in exile, the author "finally" realizes "what it *would* mean" to be expatriated. The use of the optative mode (*it would mean*) implies Drakulić's refusal to accept her condition. The strategic contrast between her past routine of a cup of coffee in the morning in her own apartment as against her days in a borrowed and foreign house create an effective rhetorical action. Drakulić cannot forget or accept her status, her present identity, her foreignness.

Being *out of place*, the rhetor becomes an unsettled exilic voice, while she continues to refuse her status through the cultural meanings of her discourse. Using quotation marks when referring to her new apartment ('my apartment'), the author emphasizes the tensioned relationships between identity and the cultural meaning of *place*.[61] "This was *not* my home, there were *no* pictures and posters on the walls which I had put there, *no* books I had bought."[62] These three negative statements in one sentence emphasize her non-identity in Slovenia, her refusal to accept life in a place that is not her home. The peaceful, accommodating, yet alien house in Ljubljana is compared to a more personalized place that Drakulić accepts as her *own*. Thus, by locating herself in two different places, she becomes even more unsettled, rejecting her present while she reinforces her previous existence in the more stable life of the past. If so, then which past identity does the author reenact in her rhetorical action: Balkan, Yugoslav, or Croatian?

Interestingly, by resisting the refugee status, Drakulić reconstructs her former Yugoslav voice, filling her text with yet another rhetorical tension.

Her lost home is not only today's Croatia, but also yesterday's Yugoslavia. Her strategic response is to redefine herself in relation to *both* locations.

> That first Sunday in Ljubljana was empty and white like a sheet of paper waiting for me to write something on it: new words, new beginning. But I couldn't. My hands were shaking and I didn't know what to write. Living in uncertainty, in constant expectancy of what would come next, I knew I had been deprived of the future, but I could bear it. But until that moment I wasn't aware that I had been deprived of the *past* too. Of my past I had only memories and I knew they would acquire the sepia color of a distant, undistinguished event, then slowly dissolve, disappear in the soft forgetfulness that time would bring as a relief, leading me to doubt that I had ever lived that part of my life.[63]

Again, Drakulić rejects her state of in-between. Deprived of both future and past, she is at a loss for the "new words" of her exile. Her past lacks any cultural, geographical, or political signpost of coherence. While her house is in Zagreb, Croatia, her past voice is in the former Yugoslavia. Contrasting her different identities yet again, the author resists Ljubljana and everything it stand for, in her refugee time. Though doubting all previous lives as a journalist, novelist, and more important, a settled, non-refugee, Drakulić is still reluctant to settle into the discourse of a refugee. In response to the new realities, however, just who is she, anymore? Facing the conflicting realities of the Balkans, her attempt to reconstruct a coherent voice in her essay encounters more rhetorical tensions.

Rejecting displacement, the author plays these torn identities against each other. She chooses the language of a disillusioned citizen from the former Yugoslavia. Continuing her story, Drakulić meets an unfriendly Slovenian neighbor, who identifies her as a refugee from Croatia. Consequently, accused by this "university professor from Ljubljana" of getting "more money per month from the state" (due to her refugee status) than does a retired Slovenian, Drakulić finds herself defined as a Croat, an *other* because she lives in another place.[64] But even if to this Slovenian her identity is Croat, she articulates herself differently, as a civil voice, an individual trying to live in a democratic world. In the following excerpt, the author constructs her *otherness* in relation to the cultural dimensions of language and all these homelands:

> I felt an almost physical need to explain my position to him, that I am not "we" and that "we" are not getting money anyway. I think I have never experienced such a terrible urge to distinguish myself from others, to show this man that I was an

individual with a name and not an anonymous exile stealing his money. I started to explain to him that I was not what he thought I was, but then I stopped mid-sentence, my anger hanging in the air for the moment. . . . I walked away. But his two sentences were enough to strip me of my individuality, the most precious property I had accumulated during the forty years of my life. I--no longer me--went to 'my home' that was not mine.[65]

Drakulić starts to use, more overtly, the cultural conventions of language to mark her displacement. The "we" of the refugee group emphasizes her resistance to being categorized in linguistic, cultural, and nationalistic terms. Fighting the cultural and prejudicial profile hurled by the Slovenian professor, Drakulić alternates several locations of her voice. Her choice of words invokes dislocation and resistance to the exilic identity forced upon her.

As Drakulić repeats "I am *not*" throughout the excerpt, she refuses the social category offered by the host culture.[66] "I am *not* 'we,'" she insists, stubbornly affirming she is "an individual with a name and *not* an anonymous exile," "*not* what he thought."[67] Her strategic use of negation throughout the excerpt, and the essay for that matter, forms Drakulić's rhetorical response to a denial of "individuality" and voice in the Balkans.[68] Her denial seems futile, however, for she stops in the middle of her explanation, realizing that war does strip her of her individuality. Drakulić's presence in Slovenia affirms that she *is* indeed a refugee living in a war between two regions once part of the same country. Her identity as a "writer from Zagreb" appears obsolete since her "most precious property," her individuality, turns into a "no longer me."[69] "I–no longer me," and "'my home' that was not mine" create brief, yet evocative relationships between her conflicting identities, between tensioned locations of her critical voice.[70] Her rhetorical strategy of negation in discourse reaffirms her loss of identity and also her past in a settled Eastern European country once called Yugoslavia.

Unsettled in Slovenia, Drakulić reconstructs her rhetorical persona in constant conflict with political and cultural locations of her discourse. By now, as past and present time lines and cultures collapse, Drakulić presents herself in the *neither-nor* condition of alienation, living and speaking in "a no man's land: not in Croatia any more, not yet in Slovenia."[71] Due to her traumatic experience as a refugee, Drakulić takes turns in reinventing herself as a Croat, a Yugoslav, or a citizen with individual aspirations for a democratic post-communist Eastern Europe country.

And yet, the very last sentence of her essay settles her identity in relation to just one location: the land of the foreigners. "[A]t the thought of becoming an exile, I understood that it would take me another lifetime to find my place in a foreign world and that I simply didn't have one to spare."[72]

In this last paragraph, the author reinforces her resistance to exile, articulating a *non*-foreign position, at all costs. Thus, her denial of exile takes central place against any of the conflicted locations of her voice in discourse. Exile makes Drakulić "shiver" physically, emotionally, and rhetorically in her actions. Unable to solve her problems of voice in relation to place, the writer refuses throughout her discourse to exist physically and rhetorically in a "foreign land," in a cultural place where no home is home.[73]

Although her time as a refugee is brief, as Drakulić returns to Zagreb, and to her Croatian homeland, the author continues to revisit her expatriate condition. More important, Drakulić reconsiders the refugee status, only from a different angle, and in a different rhetorical voice. Back in Zagreb, soon after Croatian independence, Drakulić writes "High-Heeled Shoes," a complementary essay, in my opinion, to "On Becoming a Refugee." In this later essay, Drakulić responds to alienation from a different position, as a hostess reflecting on the cultural and political inconvenience refugees create in Zagreb.[74] By now, empowered by her own repositioning of voice in a "safe" place, Drakulić constructs herself rhetorically as a non-exile in her homeland, in Croatia.

Telling of her encounter with a journalist friend, a refugee from Sarajevo, Drakulić captures in "High-Heeled Shoes," one more time, the conflict between refugees and the host population, their cultural and rhetorical tensions. As a refugee, carrying a "yellow piece of paper," "the certificate that she was a refugee," this Slovenian journalist friend, Dražena, intends to make the Croatian capital her new home.[75] Full of good intentions, Drakulić is, however, surprised when her daughter offers Dražena a pair of high-heeled shoes. Seeing no use for such an offer, Drakulić considers the proposition a misplaced gesture. Later, realizing her stereotypic reaction, she confesses, thinking that, for a refugee, high-heeled shoes would be impractical and too fancy to use when in exile.[76]

What has happened to Drakulić's identity of expatriate? Has she already forgotten her own life as a refugee? By now, back in Zagreb, Drakulić revisits in discourse the same relationship between the refugee condition and the cultural dimension of place, only from a different rhetorical viewpoint. In "High-Heeled Shoes," she reverts in her rhetorical voice from a host

intellectual located in Croatia to a dissident reacting against the entire Balkans as a place of conflict.

In spite of an honest exploration of the rhetorical implications of a refugee identity, the writer does not refer at all to her own experience. And yet, her rhetorical strategy to refuse displacement remains consistent throughout both writings. Drakulić again contrasts two cultural identities (refugee/foreign and host resident) in order to articulate her critical position of the anomalies of the Balkan war.

Thus, evoking first the unsettled neither-nor voice of a refugee from and in the Balkan area, Drakulić wonders:

> Who are these people, I asked myself, realizing at the same time what a strange question it was, a question poised between the cliche established for us by the media and the fact that they are not different from us, only less lucky. *These are people who escaped slaughter by the Serbians*, I could hear my tiny inner voice answering. But I could also hear the other voice, the voice of suspicion, of fear, even anger: *They are just sitting smoking, doing nothing. Waiting. Waiting for what? For us to feed them. They could work, there are plenty of jobs around, houses to be repaired or working the land.*[77]

Contrasting the "we" who have to feed the "them," the author charges these two cultural group names with different meanings, as she changes her relationship between exilic voice and place.[78] By now beyond her own refugee status, Drakulić no longer belongs to the "them" of no man's land, having moved into the "we" of Zagreb.[79] The foreigners, cohorts of refugees, "they," disturb the coherence of the city, bringing suspicion and other negative reactions into Croatian ethnocultural discourse.[80] It seems, then, expatriates are waiting to be fed by the "us" that by now the author.[81] Using "us" versus "them"as two linguistic and cultural dimensions of the conflictual location of homeland, the author reveals the discursive tensions of exclusion at work, moving her location of voice outside exile.[82]

And yet, Drakulić does not maintain her *out of exile* identity for long. From her identity in discourse as a hostess in Zagreb, full of cultural prejudice against refugees, behaving rather like the Slovenian professor she had encountered seven months before. However, Drakulić changes her mode of discourse, and her rhetorical identity, as she transforms her rhetorical voice into a critical intellectual one, advocating resistance to nationalistic claims. Using the same strategic relation between identity and cultural alienation from a place in the conflict of the Balkans, Drakulić repositions

her voice on the outside of dissidence, in the antiwar discourse against nationalism. Leaving her Croat identity aside, she responds to the unsettled place of the Balkans as her rhetorical context:

> What I am starting to do is reduce a real, physical individual to an abstract 'they'--that is, to a common denominator of refugees, owners of the yellow certificate. From there to second-class citizen--or rather, non-citizen--who owns nothing, has no rights, is only a thin blue line. I can also see how easy it is to slip into this prejudice as into a familiar pair of warm slippers, ready and waiting for me at home. And even if I don't like to recognize it to myself, I obviously believe that there is a line dividing us, a real difference--never mind if it is not me who is defining the line, setting the rules, excluding them. Or is it? Once excluded, they become aliens. Not-me. Not-us. . . . With this exclusion the feeling of human solidarity turns into an issue of my personal ethics. That is, once people are reduced to the category of the 'other'--or 'otherness'--you are no longer obliged to do something for their sake, but for yourself only, for the benefit of your own soul.[83]

Shifting her locus of voice from Croatian to critical intellectual, Drakulić readjusts her identity, changing her cultural mode of discourse, in the last part of the essay. Recalling in text the cultural participation of "me," or "we" versus "they" in the context of the Balkan war, she advocates an *inclusive and resistant* identity in her rhetorical action.[84]

As a critical intellectual, warning of the powers of language in a nationalist environment, Drakulić reminds herself and her readership that *naming* is a strategy of exclusion. "They" represent the excluded, the group of "otherness," the "aliens."[85] Sensitized by communist discourse where the same "we" and "they" invoked culturally and politically different groups of people, Drakulić invokes the same dyad to emphasize her resistance to the sociopolitical practices in her homeland.

Especially for Eastern European writers, pronouns represent strategic choices to invoke cultural walls of exclusion that words create in circumstances of dissent.[86] Revealing the cultural and political dimensions that alienation (and exile) carries in discourse, Drakulić acknowledges that expatriation brings in "a line dividing us, a real difference." Realizing she actually might identify herself with the non-exiled population, Drakulić uses the negatives, "not-me," "not-us," to remind herself and her readers of the dangers of thinking along "the category of 'other,'" or "the non-citizen." Thus, by warning against the nationalist discourse of exclusion, the author reveals the existent attitudes in the former Yugoslavia where residents and the "second-class citizens" with no property, no rights, remained in

continuous ethnic and political non-communication.[87] Invoking the cultural and political double discourse used by different groups in her homeland, Drakulić is also able to emphasize the political complicity of discourse in a non-democratic society.

How does the author, then, solve this tension between "us" and "them"? As a critical intellectual, Drakulić responds to "otherness" through her rhetorical and political appeals to reject the war and neo-communist practices in the Balkans, repositioning her identity once again. According to Drakulić, the powers of language, the strategy of "naming them, by reducing them to the other" in discourse lead to horrors like the killings of Jews in World War II or the ethnic cleansing in the Balkans. By remaining between the discursive walls of "us" and "them," residents of a host culture co-opt language into re-inscribing similar discriminatory constructs of identity. "[W]e are becoming collaborators or accomplices in the perpetuation of war. For by closing our eyes,... by pretending nothing is happening, by thinking it is not our problem, we are betraying those 'others'--and I don't know if there is a way out of it" admits Drakulić. The author reacts precisely against the refusal of [Croatian] audiences to reflect on their cultural and political discourse, when naming 'the other.' For, continuing to use such vocabulary places audiences as complacent participants in the discourse of war [88]

Her strategic shift of rhetorical voice from a Croat into a critical intellectual from the Balkans calls for a discourse of political dissidence, for the discourse of the critical Other. By the end of the essay, Drakulić has constituted a dual critical voice both from Croatia and from the Balkans, hoping her example will influence by her readers. Drakulić no longer excludes herself and others from the circumstances in the Balkans, rather, she *includes* all former Yugoslavs, and even all readers, as co-participants in the war. After all, by creating an inclusive identity of "only us" when revisiting exile, the dissident journalist calls for responsibility, both individual and collective, in the name of human and democratic societies in the world, reminding herself and her readers that:

> [W]e are at war; we carry in us the possibility of mortal illness that is slowly reducing us to what we never thought possible and I am afraid there is no one else to blame. . . . There are no them and us, there are no grand categories . . . There is only us--and yes, we are responsible for each other. [89]

And yet, although her refusal to use rhetorical barriers between "us" and "them" offers a powerful readjustment of position in discourse, Drakulić remains an unsettled rhetorical voice in relation to her exile. Refusing to align herself within the rhetorical and cultural parameters prescribed by the nationalist discourse of Croatia, she remains a critical voice in tension with her political context. Therefore, when she reconstitutes herself as a public intellectual advocating democracy in Eastern and Central Europe, what happens to the rhetorical tensions she confronts in her cultural discourse of dissidence addressing exile and displacement?

Voiceless in Croatia, Voiceless in the Balkans: Resisting Old Times

Since the war between Croatia and Serbia was over by 1992, one would think Drakulić would have concluded her discourse of alienation. However, in between *The Balkan Express* (1993) and *Café Europa* (1996), Drakulić had shifted her rhetorical identity, turning from a refugee from the war into another kind of outsider, an expatriate journalist excluded from the Croatian political arena.[90] Fervently advocating the moral responsibilities of citizens in a civil society, and responding to new adverse circumstances during Tudjman's regime, Drakulić offers new accounts of resistance from a rhetorical locus of exile. However, she does that without at all acknowledging her expatriate condition. Nonetheless, though, rejecting her expatriation and her forced silence, she configures a new relationship for her exilic discursive persona.

By 1993, because of her public opinions against the new Croat politics, Drakulić had become, technically, a voluntary exile.[91] And yet, *Café Europa* is not meant as a collection of works on exile. Rather, it is a volume on the writer's cultural and political experiences when visiting Eastern and Western Europe with a Croat passport.[92] Presenting a journalist's log, Drakulić continually posits herself in relationships with her cultural contexts encountered: an Eastern European, a former Yugoslav, a Croat, or a critical intellectual, a citizen promoting individualism for a democratic and less-prejudiced world. How can she, then, reply rhetorically to the all-too-familiar political dissidence?

In response to her banning in Croatia, away from her national readership and from the public arena of her homeland, Drakulić changed her strategy of redefinition by shifting the cultural dimension of an identity-place relationship into an identity speaking against the past and (still) communist

homeland. Rather, she invoked her identity in relation to the linguistic and cultural dimensions of the communist *past* and the post-communist *present*. For, how else could she urge resistance against nationalism and the authoritarian regime in Croatia if not by reminding her audiences and herself of old practices still current? After 1993, exile *per se* lost relevance, and the author's emphasis on *discursive resistance* against communist practices in Eastern Europe reaffirms her ostracized voice. Her discursive resistance becomes a rhetorical oppositional strategy against and from the host culture, in this case, communism and its haunting ghosts.

Beginning with this rhetorical strategy of discursive resistance, in the first essay of *Café Europa*, "Introduction: First-Person Singular," Drakulić offers a rhetorical account of her political resistance to the still-communist Croatia.[93] The writer recaptures rhetorical force as a speaker of dissent in relation to the cultural and political metaphor of "we" and "I." This simple contrast locates her voice along discursive counterparts in communist and neo-communist times in Croatia and the Balkans.[94]

Rhetorically, her strategic relation between "we" and "I" becomes a cultural and political move to differentiate two conceptual and cultural identities: communist versus dissident. In spite of her exile, objecting strongly through language to any communist and neo-communist practices, Drakulić provides a powerful account of political ostracism before and after the so-called fall of the Iron Curtain in the Balkans. And more important, Drakulić reinvents her discourse as a grammar of dissidence, to paraphrase Burke. How does the first-person pronoun constitute a rhetorical gauge to expose the cultural and political barriers between the author and communist or neo-communist times in Croatia? Drakulić juxtaposes a second discursive, and rhetorically effective, resistance: saying "no:"

> How does a person who is a product of a totalitarian society learn responsibility, individuality, initiative? By saying "no." But this begins with saying "I," thinking "I" and doing "I"-- and in public as well as in private. Individuality, the first-person singular, always existed under communism, it was just exiled from public and political life and exercised in private.[95]

The *no* that marks her position in dissent becomes the rhetorical impetus for her definition of difference, her *rejective* terra firma, her own Outside. The negation implies more than a rhetorical tension between the grammatical distinction between first-person pronouns in singular and plural forms; rather, Drakulić affirms her own dissidence and resistance against the "safe,

anonymous 'us'"of the collective that communism brings about.[96] Empowering her voice as the grammatical voice of the singular "I," Drakulić asserts her dissident identity as a threat for any communist and neo-communist public sphere.[97] For, both in past and in present political contexts in Croatia as her homeland, "the first-person singular" is "exiled from public and political life," becoming a voice of dissidence.[98]

This grammatical distinction transforms Drakulić into an exile, a critical intellectual isolated from life as part of "we," part of a non-democratic mass mentality. Thus defining her outsider position as a speaker within a simple, yet evocative grammatical category, the relationship the writer constructs between "I" and "we" becomes a rhetorical and political locus of conflict, the nexus of her exilic identity in dissent. Her hatred of communist times elicits powerful, almost visceral reactions:

> I hate the first-person plural. But it is only now, seeing it in my own writing, that I realize how much I hate it. My resistance to it is almost physical, because more than anything else, to me it represents a physical experience. I can smell the scent of bodies pressed against me in a 1 May parade, . . . I can feel the crowd pushing me forward, all of us moving as one, a single body--a sort of automatic puppet-like motion because no one is capable of anything else.[99]

For Drakulić, the first-person plural is her enemy, personifying communism. Her criticism of a group mentality becomes almost physical, as she considers its discursive and cultural powers transforming everybody living in Eastern and Central Europe. Memories triggered by the plural pronoun "we" remind her of the ideology and propaganda imposed on the populations.[100] Remembering mandatory participation in popular and populist events of communist times, Drakulić describes how people became, throughout the years, "a single body--a sort of automatic puppet--like motion."[101] As the "first-person plural" gets personified and rhetorically transformed into communist cultural discourse, Drakulić vehemently rejects the public sphere of the collective, responding as a promoter of individualism (equating, culturally, in this part of the world, democratic freedom of speech), and thus, dissident voice. After all, this writer is exiled because she continues to say "I," remaining excluded and in disagreement with the popular and more collective government of present-day Croatia.

To bring this criticism home to today's Croatia, however, requires an additional strategy–a temporal comparison of past and present, a reminder of the political and social role of 1989 in the area. Delineating through this

grammatical and rhetorical distinction the meaning of communist versus democratic societies, Drakulić posits her voice within different times to emphasize her political opposition in her rhetorical discourse. She uses the past tense as a grammatical and rhetorical strategy to reject the communist ideology of Eastern or Central Europe. Remembering the past, Drakulić recalls that she "grew up with 'we' and 'us' in the kindergarten, at school, in the pioneer and youth organizations, in the community, at work."[102] In addition, as a journalist and a critical intellectual, the author reminisces on the political dangers of using that first-person singular, on the problems a speaker like herself faces in and through the language of individuality.[103]

> Writing meant testing out the borders of both language and genres, pushing them away from editorials and first-person plural and towards first-person singular. The consequences of using the first-person singular were often unpleasant. You stuck out; you risked being labeled an 'anarchic' element (not even a person), perhaps even a dissident. For that you would be sacked, so you used it sparingly, and at your own risk. This was called self-censorship.[104]

Depicting the life dictated by the "we" of communist times, Drakulić delineates clearly the fluid (insider/outsider) position of any professional in the communist media before (and after) 1989.[105] In the past, once a person attempted to speak out, the political consequences became clear, and one became an outsider, "an 'anarchic' element," or "even a dissident."[106]

Of course, the fall of communism in 1989 should have changed all that. Drakulić sets to mark denying that it did in Croatia. With this strategic move, her indictment of the neo-communist regime takes shape. Blaming the war on the collective mentality of nationalism, Drakulić incisively criticizes the political, cultural, and rhetorical consequences of such a continuing mentality. For, she argues, "that hideous first-person plural" which infects a "20 million-bodied mass swinging back and forth," makes its members follow "their leaders into mass hysteria."[107] Thus, the rhetorical relationship she posits between time and identity permits her to reconstitute herself against both past and present communist *times* in Croatia.

Drakulić transforms her rhetorical voice from critical intellectual of past communism into present dissident living in the outside. As an exile, her individual voice can no longer be heard in the new Croatia. Much later, reminiscing about her "witch" identity in another essay, Drakulić revisits her "public execution," and the "lack of solidarity" around her, leaving a void around her, exposed, alone, without readership or friends.[108]

Left without readership in her homeland, Drakulić explains how the communist past and neo-communist present call forth in discourse exilic identities like hers. As in communist times, the individual citizen "had no chance to voice his protest or his opinion, not even his fear" in the post-communist Balkans:

> He could only leave the country–and so people did. Those who used "I" instead of "we" in their language *had to escape*. It was this fatal difference in grammar that divided them from the rest of their compatriots. As a consequence of this "us," no civic society developed. . . . As under communism, individualism was punished–individuals speaking out against the war, or against nationalism, were singled out as "traitors."[109]

Accordingly, exile, particularly her own unacknowledged expatriation, is connected with the dissident voice, with the user of "I," with the person saying "no." Drakulić has not so much distanced herself from her Balkan homeland, as she has from pre-1989 communism. In the view of Drakulić and others, the Croat regime has not shed its communist past; therefore, those who dissent remain caught between their democratic dreams and the realities of 1989 and beyond. Thus, shifting her account to present-day neo-communist and nationalist practices, the writer emphasizes that, like her own, critical voices of antinationalism become singled out, ostracized as traitors, and forced to leave their homeland.[110]

In other words, although Drakulić does not explicate her own status in the essay, she acknowledges that after 1989, people who use the first-person singular continue to become exiles, expatriates, and dissidents in countries like hers. Linking her political agenda to her freedom of speech, Drakulić sees the "fatal difference in grammar" as a conflicting relationship between her identity and the present regime in Croatia. A "traitor" in and through her rhetorical action, Drakulić experiences exile, while articulating her position as public intellectual from beyond Croatian borders.[111] The relationship Drakulić constructs between identity and past-present communism begins in language, continues with its rhetorical and socio-cultural implications, transforming her into a political exile. "Introduction: First-Person Singular" becomes her grammatical, rhetorical, and cultural discourse of exile, redefining an unsettled identity determined to fight (again) against neo-communist practices in Eastern and Central Europe.

Returning to Place: A Cultural Possibility for Voice

Establishing herself as a dissident writer from Croatia, Drakulić offers critical accounts of Eastern Europe in post-communist times in *Café Europa*. Her journalist's perspective reveals the continuing cultural and political struggle between communism and democratic arenas. Most interesting however, is that rhetorically, Drakulić does not overtly reconstitute herself as an exile in her discourse written outside of Croatia. Neither does she resolve the tensions raised by her relational definitions of dissent, never writing from a settled position of either expatriation or European identity. Does she, at any point, settle her expatriate status in her writings? Does she remain a dissident in relation to place or time?

Her solution to exile can be considered, in a sense, a return to the previous relationship between identity and place through language, as she finds herself constructing a rhetorical place that becomes her vision for democratic existence. In "People From the Three Borders," Drakulić reaffirms that language, place, and cultures can coexist in culturally fluid relationships.[112] Functioning as a possible rhetorical vision, "People from the Three Borders" offers *the* coherent rhetorical solution to displaced identity in the Balkans.[113] Here Drakulić features Istria, a peninsula in the northern Adriatic and the writer's birthplace. She describes a borderless civil society, with no prevailing ethnicity and a population lacking single identities. Thus, the locals see "no contradiction in claiming three different nationalities," Croatian, Istrian, and Italian.[114]

Using nationality and language to reconstruct an inclusive rhetorical and cultural national identity grounded in place, Drakulić explains her conceptual and cultural solution:

> But Istrians today are apparently trying to establish their region as their "nationality," because they want to avoid defining themselves, or being defined by others as "pure" Croats, or Italians, or Serbs. Zagreb is, of course, right to suspect them of not being nationalistic enough, as are Ljubljana or Rome. Sitting there ruling from hundreds of kilometers away, how can these authorities understand the meaning of Istrianism—the enlarging concept of identity, as oppose to the reducing concept of nationality? To Istrians, identity is broader and deeper than nationality, and they cannot choose a single "pure" nationality as their identity.[115]

Negating a single nationality, living in the *neither-nor*, with an identity "broader and deeper than nationality," the Istrians exemplify the regional and the cultural solution to nationalist conflicts in the Balkans.[116] Promulgating

"identity" as an enhanced cluster of cultural, rhetorical, and political dimensions for one's voice in the region, Drakulić leaves the nationalist turf of all the countries around Istria, emerging with an inclusive rhetorical appeal for tolerance and peaceful coexistence. Seeing no contradiction in this cultural grouping of multiple identities, Drakulić hyphenates names, people, and areas, to reject one single nation and embrace multiplicity as a rhetorical and political concept of coexistence in a democratic Eastern Europe. Karlo, her neighbor in Istria (or is it Carletto?), carries "two names for the same sixty-seven-year-old man with thick glasses and a bad leg," she tells her readers.[117]

In the Balkans, after living the political life of communism as Yugoslavia, languages and identities should be inclusive, without building visible or invisible walls around-between each other, seems to be Drakulić's rhetorical appeal here. Looking at Istrian history over the centuries, she sees its strength: "[T]he Istrians of today have learned to tolerate different languages and nations, to live together irrespective of political borders and to put their region above nation or ideology. The Istrian model has demonstrated that tolerance is possible and that it works."[118] And, since Drakulić has a house in Istria, and was born close by, her familiarity with the Istrian possibility of coexistence becomes also a personal solution.[119]

Istria, then, becomes both a rhetorical vision and a metaphoric solution for Eastern Europe and the Balkans, enabling Drakulić to find a stable location of voice for her future discourse, free from communism, or any other nationalistic practices. If so, she can transform her cultural, rhetorical, and political resistance to exile, for once, into a discourse of European unified identity. However, for the time being, Istria as a metaphoric construct of a coherent rhetorical identity remains a fantasy. Despite all the residents' political and legal efforts, the peninsula remains, for now, a part of Croatia, "forced to live not in the present, but in the past, for yet some time to come."[120] Aware of the political realities at hand, Drakulić too remains, for now, a discursive voice of dissidence and an unsettled exile in and from Eastern Europe.

Rhetorical Implications: Negation, Identities, and Identification

Due to her fragmentation in discourse, Drakulić's strategic reconstruction of rhetorical voice recalls Codrescu's rhetorical strategies to redefine his identity in exile. The Croat dissident also redefines herself in relation to time

and place. Similarly, Drakulić's fragmented voice in exile reveals different relationships that a rhetor creates between text and context in rhetorical action. McGee's operative perspective then seems the appropriate critical view for Codrescu's redefinition of fragmented voice when in exile, and possibly effective for Drakulić's strategic response to expatriation.[121]

However, there is an important difference, rhetorically. Cultural fragmentation is rhetorically salient for Codrescu, because he invokes text and context in his permeable redefinition of identity as a poetic exile. In contrast, Drakulić's articulation of rhetorical voice and her cultural fragmentation are strategies of the speaker's powers played *against* text and context, hence emphasizing, I argue, *other* (pun intended) rhetorical consequences for such discourse. For, the rhetorical consequences of Drakulić's reconstitution of dissident voice lie in her continuous *resistance* to exile. As an unsettled rhetor, resisting multiple fragments of identity in text and context, Drakulić's strategic redefinition of voice carries two *other* rhetorical implications. First, since Drakulić continuously refuses to accept exile as an inherent part of her identity, the rhetor transforms the rejective mode of discourse into a constitutive dimension of rhetorical action. Second, due to her different reinventions of identity, Drakulić challenges yet another rhetorical relation important for rhetorical criticism, the relationship between identity and identification, as she remains an unsettled speaker throughout her discourse.

Resisting Exile: A Rejective Frame of Discourse

Drakulić's continued resistance to exile as part of her rhetorical voice emphasizes the rejective frame of discourse in her rhetorical action. This frame, presented by Burke in *Attitudes Toward History*, involves a "shift in the allegiance to symbols of authority."[122] Stemming from the acceptance framework of discourse, which means for Burke, a "more or less organized system of meanings by which a thinking man gauges the historical situation and adopts a role with relation to it,"[123] the rejective frame is simply a matter of emphasis, a by-product of acceptance.[124] In other words, what Burke implies in his perspective on human motives transformed in language is the relation a writer or a rhetor creates with his or her context when creating discourse. Although Burke does not favor the rejective mode, for "[T]his problem of dissociation always arises to make trouble when conditions require a shift in our patterns of allegiance,"[125] he reinforces its role as an

against position needed for an unsettled rhetor.[126] From this point of view, Drakulić reinforces Burke's perspective on the rejective frame, as a non-settled mode of discourse. Through this discursive framework, Drakulić creates a relationship of resistance between her historical, political, and cultural context and her displaced identity, in my view. Because of her dual exile, both in terms of place and time, her emphasis on redefining voice lies *within* the rhetorical process of exile, within the unsettled and potential reinvention of identity in discourse.

In addition, since Drakulić continuously rejects exile, this conflictual relationship transforms her discourse, engaging her rhetorical voice in a rejective process of re-articulation against the political and cultural environment or context, in rhetorical tradition. Having the rhetorical option either of accepting her status of exile, thus creating a frame that accepts her condition, or remaining in the neither-nor position of a Croat, or an Eastern European voice, thus articulating a rejective rhetorical voice, Drakulić chooses the latter. Unwilling to choose any single identity of the outside, Drakulić does not settle for any singular rhetorical persona: she is neither just a refugee in "On Becoming a Refugee" in *Balkan Express*, nor a mere exiled critical intellectual in "Introduction: First-Person Singular" in *Café Europa*. In response to all these exilic tensions of her identity in discourse, the rhetor's plural identities as an outsider are always already clustered in a tensioned rhetorical locus of dissidence. Her identity is "outcast," whose discourse remains in the plural rejective voices, continuing to create rhetorical attacks against communism and post-communism.

Drakulić's use of the rejective frame reveals two novel implications for the rhetoric of exile, in my view. First, it appears that this rhetorical action permitting her to reject her displaced positions enables Drakulić to shift identities while remaining in cultural tension with an accepting strategy of redefinition. Resisting her own condition, Drakulić maintains her tensioned position as a rhetorical voice, opening more cultural and political margins in her action. Thus, the rejective frame of her discourse calls for conflictual relationship between the rhetor's identity and her/his place of speech, adding *instability* and *potentiality* as rhetorical qualities of her texts of dissent.

The rhetorically unstable quality of her voice, the transformative relation that Drakulić negotiates constantly from the margins of discourse, all add rich and significant rhetorical texture in her writings. Rhetorically, her neither-nor relationship established in discourse, her reluctance to "give in" and align her voice with the discourse of power might be why she shifts

marginalized positions so often, from insider to outsider, from no- man's-land refugee, to a Croat hoping one day to re-enter the public sphere of her country or to emerge as a borderless European.

And yet, the potential co-opting of rejection into acceptance is always present in Drakulić's essays. There is always a lingering, a nostalgia for the adverse context (turned unfriendly) to transform itself into the welcoming place where displacement is removed from her identity. Her brush with vision occurs in her affirming a nostalgic and almost utopic Istrian existence. The condition of such transformation is, of course, that participants in the discourse of the power (authoritarian) culture are willing to modify their discourse so that it becomes culturally tolerant and encompassing, allowing outsiders inside the rhetorical con-text, and consequently, creating an inclusive rhetoric.

The other rhetorical consequence of the rejective frame relates to the rhetorical potentiality of exilic identity.[127] While she refuses to be an exile, Drakulić's rhetorical action contains an always already interpellated acceptance, a possibility of transforming her expatriate identity into that of a resident. Her strategies of shifting marginalizations, always delineating the voice on the border in confrontation, bringing into discourse an empowered position, reveal a flexible existence in the outside. Drakulić appears to develop a consistent voice of the Outside. If achieved, the author's constant relocation of marginality creates a rhetorical tension with her refusal to accept a single rhetorical voice. Accordingly, this rhetorical settled voice of *the other* denies her rejection of exilic identity.

Significant for narratives of displacement, Drakulić's identity is always transformed in relation to place in discourse. Her homeland of Croatia, the "no man's land" for a refugee, and/or Europe as a cultural cluster of democratic values represent(s) rhetorical loci *against* which she can re-position her voice. In a sense, the potentiality, the choice of marginalized identity might give her as speaker the needed flexibility to create a dynamic and effective rhetorical discourse, and a viable rhetorical identity, altogether. Or, because the rhetor perceives so many differences in relation to multiple rhetorical situations, her rhetorical action of redefinition effectively invokes the restlessness or fluidity that exilic identity entails.

Identities and Identification: Another View

In explicating the rhetorical relationship between identity and identification, Burke leaves that relationship mysterious, concentrating mostly on the identification part of the dichotomy.[128] In fairness to Burke, the reason he treats identification extensively in *A Rhetoric of Motives* is because his intention is to treat "identity" in *Symbolic of Motives*, the unfinished last volume of his trilogy. Burke himself states this intention: "[A]nd our third volume, *Symbolic of Motives*, should be built about *identity* as titular or ancestral term, the 'first' to which all other terms could be reduced and from which they could then be derived or generates, as from a common spirit. The thing's *identity* would here be its uniqueness as an entity in itself and by itself, a demarcated unit having its own particular structure."[129] On explaining and expanding the dialectic processes in relation to the audiences involved in discourse, Burke's emphasis lies mostly on the relationship between identity and identification. As identification is an assumption for the rhetorical process, that other part of the relationship seems of interest from an exilic perspective.

What Drakulić challenges with her strategic use of language and cultural contexts in multiple redefinitions of her voice governed by time and place is Burke's rhetorical and conceptual definition of the speaker's "identity" in discourse.[130] Intriguing, from my viewpoint, are the two rhetorical consequences of this challenge. First, what is the rhetorical identity of a speaker located in multiple voices and in multiple cultural contexts at the same time? And second, how does such a speaker, projecting such fluid identities in discourse, establish relationships of identification with her or his audience? Leaving identity as a "titular term," Burke falls short of addressing these questions, fundamental for exilic and displaced speakers and their rhetorical action.[131]

While I believe identity needs to remain an inherent part of the rhetorical relationship with identification, I also think Drakulić's multiple locations of voice, her transformative identities as a Croat, an ex-Yugoslav, an Eastern European, and a critical intellectual present a challenge for the contemporary definitions of rhetorical identity in discourse. Her cluster of identities modifies not only the relationship with identification, but also how critics interpret the rhetorical actions of a rhetor.

Her shifts of voice through language in relation to place and communist and post-communist times suggest a complex rhetorical action, and at the

same time, a complex rhetor. Her entailing multiple relationships with her audiences can either *fail* or continuously *relocate* her identity in relation to audiences in discourse. By positing her dis-placed voice in resistance to intricate cultural and rhetorical situations, speaking from a plural nexus of discursive locations, Drakulić modifies the rhetorical relations between her identit*ies* and the identification with different audiences. In my view, such a rhetor's intricate and complex life in exile validates new venues of investigating the rhetorical processes of the contemporary world.

Second, challenging Burke along the same relationship between identity and identification Drakulić's use of *conflicting* identities in her appeals lead to yet another problem of the same rhetorical relationship. Her identities in divergent locations create a *chiasmatic* tension between the writer and her readership.[132] By invoking multiple identities in conflict with the sociopolitical and cultural contexts of her discourse, Drakulić seems to invoke different audiences at different times, in crisscross relationships. As Drakulić responds to her marginalization as a Croat, an ex-Yugoslav, a dissident, or an Eastern European in search of a democratic Europe, her identification with her audience crosses multiple and tensioned locations of voice in cultural and rhetorical discourse of resistance.

Therefore, Drakulić resists her expatriation even as she reinvents herself in a complex rhetorical action against the cultural locations and times of communist Eastern Europe. The rejective frame of her discourse enables her to take an active part as an audience and as a speaker, responding to and reconstructing voice at the same time in complex and conflicting cultural and rhetorical relationships. In addition, Drakulić's strategic shifts of identity, her continuous repositioning in her writings, and her dissident arguments offer her the rhetorical opportunity to challenge settled rhetorical positions of speech in discourse. Drakulić's rhetorical powers stem precisely from this continuous rhetorical action and reaction against cultural contexts, from the tensioned relationships she creates as a fragmented and unsettling voice of dissent.

Notes

[1] From 1990 on, the six former Yugoslav republics undergo major political changes. Croatia is independent from January 1992, Slovenia, since 1991 But the political unrest related to independence starts with the year 1986, when Slobodan Milosevic comes to power in former Yugoslavia, and remains the president of present Yugoslavia to this day. Marcus Turner and Vladimir Tismaneanu provide extensive political and historical discussions on the nationalist politics in practice nowadays in the region. See Marcus Tanner, *Croatia: A Nation Forged in War* (New Haven: Yale UP, 1997) 203-221; and Vladimir Tismaneanu, *Reinventing Politics: Eastern Europe from Stalin to Havel*, (New York: Free P, 1992) 236-38.

[2] Arguing from a political perspective of myth construction in Eastern Europe, in his recent book, Tismaneanu features important differences between civic and ethnic *nationalism* as two major umbrella ideological myths continuing to emerge in Eastern and Central Europe. Along the latter categorization, *ethnocentric populism* appears to become the predominant rhetoric for Serbian and Croatian public sphere. I treat them under the comprehensive term of *nationalism* due to the purpose of my rhetorical study. See Vladimir Tismaneanu, "Vindictive and Messianic Mythologies: Post-Communist Nationalism and Populism," *Fantasies of Salvation: Democracy, Nationalism, and Myth in Post-Communist Europe* (Princeton: Princeton UP, 1998) 65-88.

[3] Konrád and Codrescu had been experiencing alienation for sixteen or twenty-five years. See George Konrád, "A Self-Introduction," *The Melancholy of Rebirth: Essays from Post-Communist Central Europe, 1989-1994* (San Diego: Harcourt Brace, 1995) ix; and Andrei Codrescu, *The Hole in the Flag: A Romanian Exile's Story of Return and Revolution* (New York: Avon, 1991) 11-77.

[4] Dubravka Ugresić, one other part of the women intellectuals exiled, acknowledges her political fate in *The Culture of Lies*. Leaving Croatia, Ugresić comments that: "soon I shall be *voluntarily* joining that ocean of (willing and unwilling) refugees who are knocking at the doors of other countries in the world"(85). See Dubravka Ugresić, *The Culture of Lies: Antipolitical Essays*, trans. Celia Hawkesworth (University Park: Pennsylvania State UP, 1998).

[5] Slavenka Drakulić, *The Balkan Express: Fragments from the Other Side of War* (New York: Harper 1993); and Slavenka Drakulić, *Café Europa: Life After Communism* (New York: Penguin, 1996).

[6] Vladimir Tismaneanu, *Fantasies of Salvation: Democracy, Nationalism, and Myth in Post-Communist Europe* (Princeton: Princeton UP, 1998).

[7] Robert Kaplan, in his account of Eastern Europe around the revolutions of 1989, retells of his encounter with Slavenka Drakulić in Zagreb. He writes about her as she appears to be settled as a journalist of opposition, identified as "a Zagreb journalist who writes in Croatian for *Danas (Today)*, a local magazine, and in English for *The New Republic* and *The Nation*" (6). See Robert Kaplan, "Croatia: "Just So They Could Go to Heaven," *Balkan Ghosts: A Journey Through History* (New York: Vintage, 1994) 3-29.

[8] According to her own description in "A Chat with my Censor" Drakulić writes articles on cultural politics or on Albanians in the province of Kosovo prior to the fall of communism, in 1988 (78). See Slavenka Drakulić, "A Chat with my Censor," *How We Survived Communism And Even Laughed* (New York: Norton, 1991) 77-82.

[9] Drakulić is a contributing editor at *The Nation* since 1986. She also publishes often in *The New Republic* and other periodicals such as *Los Angeles Times, New York Times, The New York Review of Books* in the United States. For example, see Slavenka Drakulić. "Voting Their Fears in Croatia," *New York Times* 21 Jun 1997, A21.

[10] Drakulić " My Father's Guilt," *Café Europa* 143-160. In addition, Drakulić repeatedly acknowledges her different status in comparison with the rest of Eastern and Central Europeans in the 1980s. In "Why I Never Visited Moscow" she explains that "[H]aving a Yugoslav passport meant that you could travel both to the West, and to the East, and the USSR was the only country in the communist bloc that I did not visit" (28). See Drakulić, "Why I Never,"*Café Europa* 22-32.

[11] Drakulić, "A Chat" 80-81.

[12] Slavenka Drakulić, *Holograms of Fear* (New York: Norton, 1992); and Slavenka Drakulić, *Marble Skin*, trans. Greg Mosse (New York: Norton, 1994).

[13] Slavenka Drakulić, *S.: A Novel about the Balkans*, trans. Marko Ivic (New York, Viking, 2000).

[14] Brigitte Frase, Books Review, rev. of *S.: A Novel about the Balkans*, trans. Marko Ivic (New York, Viking, 2000). http>//archive.salon.com/books/review/2000/02/08/drakulic> 1/19/2003.

[15] Marcus Tanner, "'Comrade Tito Is Dead,'" *Croatia: A Nation Forged in War* (New Haven: Yale UP, 1997) 203-11; and Tismaneanu, "Vindictive and Messianic Mythologies: Post-Communist Nationalism and Populism," *Fantasies* 65-88.

[16] While her most recent book published is fiction, the political context of the realities of a horrific war in the Balkans fuels Drakulić's *S.: A Novel About the Balkans*.

[17] Tanner offers a symptomatic cultural description of Croatia in terms of its history, along with informed cultural and political explanations of the tumultuous history both in contemporary and past times. See Marcus Tanner, "Preface" *Croatia: A Nation Forged in War* (New Haven: Yale UP, 1997) ix-xiii.

[18] Drakulić, "Introduction: The Other Side of War," *Balkan* 4.

[19] A large number of her essays published in the collection *The Balkan Express* and *How We Survived Communism and Even Laughed* had been previously published in *The Nation* or *The New Republic* in the United States.

[20] Drakulić, "Overcome by Nationhood," *Balkan* 52.

[21] In the last part of Tanner's book on Croatia, the author points toward post-communist authoritarian practices similar to communist ones, from not long before. Mixing nationalist vision with the legacy of communist politics, Tudjman's regime raises many questions in the international arena regarding freedom of speech and freedom of speech. In addition, the 1996 "free" elections constitute yet one more remainder of the above mentioned practices in the public arena. Tanner states in the postscript of the volume that: "[A]longside the disturbing new habit of judging everyone in Croatia's history on the simple basis of whether they were *državnotvorni* (state-building) or not, there were other signs that Tudjman and the HDZ had a *decidedly skewed view on democracy* (my emphasis"(303). See Tanner, "Postscript: Freedom Train," *Croatia* 299-305.

[22] Both Ugresić and Drakulić present doubts in terms of the political future of the new Croatian state. See Ugresić, *Culture* 49-55; and Drakulić, "The Smell of Independence," *Balkan* 53-60.

[23] Drakulić, "And The President Is Drinking Coffee on Jelačić Square," *Balkan* 108.

[24] Slavenka Drakulić, "How I Became a Witch: Nationalism, Sexism, and Post-communist Journalism in Croatia."*Media Studies Journal* 13.3 (Fall 1999): 135.

[25] Drakulić writes in several essays overt attacks against President Tudjman. See Drakulić, "And the President Is Drinking Coffee on Jelačić Square,"*Balkan* 106-114; and Drakulić, "An Unforgettable Meeting," *Café Europa* 186-95.

[26] Drakulić, "Introduction" 3.

[27] A powerful essay is "A Letter to My Daughter" where Drakulić writes to her daughter Rujana as a mother happy to see her child away from the war scene. See Drakulić, " A Letter to My Daughter,"*Balkan* 125-37.

[28] Drakulić, "Overcome" 50.

[29] Ugresić, *Culture* 260-70.

[30] Drakulić, "Overcome" 50.

[31] Drakulić, "On Becoming A Refugee," *Balkan* 29.

[32] Tanner, *Croatia* 221-41.

[33] The 1996 elections in Croatia appear, according to the Western press, to have been tainted by nationalist politics. See Chris Hedges, "In Croatia's Capital, Politics, and Democracy Don't Mix Well," *New York Times* 2 May 1996, A10.

[34] Tanner, *Croatia* 299-305.

[35] Martha Halpert, "The Fifty-ninth International PEN Congress," *Partisan Review*, 3 (1993): 450-52.

[36] Halpert, "The Fifty-ninth International PEN" 452.

[37] Dubravka Ugresić writes about the same incident, quoting, in her account, excerpt from the same article. In addition, Dubravka Ugresić, partner in "crime" with Drakulić and others, presents the Croat political discrimination on feminist basis, as she offers more quotes from the same article and from Croatian press. The accusations are mostly warranted by these women's feminist actions. Here is how, these women are portrayed: "In 'democratic' Croatia, those women have been proclaimed 'traitors,' 'women who conspire against Croatia,' 'a serious danger,' 'women who sell their homeland for their own gain,' 'amoral beings,''a group of unhappy, frustrated women' . . . and finally 'witches,'" see Ugresić, *Culture* 124.

[38] Drakulić, e-mail with the author, 18 Feb. 1999.

[39] Rada Ivekovic is another of the 'witches' that suffered discrimination and had to become a voluntary exile. See Rada Ivekovic, "Women, Nationalism, and War: 'Make Love Not War'" *Hypatia*, vol. 8.4 (1993): 113-127.

[40] Drakulić writes that: "the new political leaders used democracy to establish their authoritarian system, much alike one-party system during communism. If you write this, however, *you become an enemy of the system, i.e. a dissident* (my emphasis). You cannot get a job, you are harassed in the media, etc. which all happened to me. So you have to go abroad in order to survive!" Drakulić even calls herself an "enemy of the state;" see Drakulić, e-mail to the author, 1 Feb. 1999.

[41] The liberated media becomes a problem for the Tudjman's political arena. Determined to control it, the new government returns to the old practices of communist censorship. In addition, press releases with information about the abusive and authoritarian measures taken against journalists continue to be reported. See the following articles: "CPJ Protests Journalist Trial in Croatia" *Editor and Publisher*, 12 Oct. 1996: 25; and "Jail Time for Croat Journalists" *Editor and Publisher* 2 May 1998: 48.

[42] Drakulić, e-mail with the author, 18 Feb. 1999.

[43] From 1993 on, the writer admits it becomes "impossible to publish anything in Croatia," Drakulić, e-mail with the author, 18 Feb. 1999.

[44] A sample of such attack is published by C. Michael McAdams, "C. Michael McAdams Responds to Michiko Kakutani's New York Review of Slavenka Drakulić's *Ghost of Communist Past*" *The Zajednicar*, 9 Apr. 1997. A reprint of a position signed by C. Michael McAdams, University of San Francisco, this attack is just one of his vehement responses sponsored by The Croatian Information Services. His recent book, *Croatia Myth and Reality: The Final Chapter* intends precisely to bring rectifications to all cultural and political misconceptions related to Croatia. See C. Michael McAdams, *Croatia, Myth and Reality: The Final Chapter* (Arcadia, CA: CIS Monographs, 1997).

[45] Drakulić, e-mail with the author, 18 Feb. 1999.

[46] Drakulić publishes *The Taste of a Man* in Croatia in 1995. Drakulić, e-mail with the author, 18 Feb. 1999.

[47] Married to a Swedish journalist, Richard Swartz, this Croat dissident can travel freely. Her life in Western Europe could satisfy her needs of democracy and lead her into a comfortable life outside Croatia, if she decides to acculturate. She mentions in one of her recent essays, the life in an intercultural marriage, where the barriers between Eastern and Western European contexts surface in marital communication. See Drakulić, "Buying a Vacuum Cleaner," *Café* 109-118.

[48] Drakulić, "Invisible Walls Between Us," *Café* 21.

[49] In the essay "To Have and To Have Not" Drakulić ends the piece with a simple statement inferring her expatriate life outside Croatian borders. Telling the story of any Eastern European who, by living abroad, becomes guilty for his or her abundant life in the West, Drakulić states that: "I do not like living abroad that much." See Drakulić, "To Have," *Café* 45.

[50] Dated from 1993 on, all her essays in *Café Europa* are written after Drakulić is expelled from Croatian media.

[51] I refer again to "culture" in its political, nationalistic and mythical dimensions, pertaining to Eastern and Central European discourse, aside from any of the other dimensions discussed previously. Referring specifically at political myths and their power in communism and post-communism, Tismaneanu reiterates that "political myths are not systems of thought but rather sets of beliefs whose foundations transcend logic; no empirical evidence can shatter their pseudo-cognitive immunity"(*Fantasies* 9).

[52] Tismaneanu, *Fantasies* 83.

[54] Drakulić, "On Becoming A Refugee," *Balkan* 28-35.

[55] Drakulić, "On Becoming" 28.

[56] Drakulić, "On Becoming" 29.

[57] Drakulić, "On Becoming" 33.

[58] Throughout the essay, Drakulić uses "exile" and "refugee" as synonymous words, resonating with Said's own explanation of the terms. See Edward Said, "Reflections on Exile," *Altogether Elsewhere: Writers on Exile*, ed. Marc Robinson (San Diego: Harcourt Brace, 1994) 137-49.

[59] Drakulić, "On Becoming" 29. Edward Said reiterates the connection between exile and nationalism through language, only in somewhat different cultural dimensions: "[W]e come to nationalism and its essential association with exile. Nationalism is an assertion of belonging to and in a place, a people, a heritage. It affirms the home created by a *community of language* (my emphasis), culture and customs; and by so doing, it fends off exile, fights to prevent its ravages"(139). See Said, "Reflections" 139.

[60] Drakulić, "On Becoming" 31.

[61] Here again, one can see how culture functions as an active rhetorical con-text for any displaced identity in discourse.

[62] Drakulić, "On Becoming" 31.

[63] Drakulić, "On Becoming" 32.

[64] Drakulić, "On Becoming" 33.

[65] Drakulić, "On Becoming" 33.

[66] Drakulić, "On Becoming" 33.

[67] Drakulić, "On Becoming" 32.

[68] Drakulić, "On Becoming" 33.

[69] Drakulić, "On Becoming" 32.

[70] Drakulić, "On Becoming" 33.

[71] Drakulić, "On Becoming" 33.

[72] Drakulić, "On Becoming" 33-34.

[73] Drakulić, "On Becoming" 34.

[74] Drakulić, "High-Heeled Shoes," *Balkan* 137-47.

[75] Drakulić, "High-Heeled" 137.

[76] Drakulić, "High-Heeled" 140.

[77] Drakulić, "High-Heeled" 141.

[78] Drakulić, "High-Heeled" 141.

[79] Drakulić, "High-Heeled" 142.

[80] Julia Kristeva writes about similar xenophobic attitudes against the "foreigner" in Western Europe. In her extensive and impressive cultural definition of "the foreigner" in "Toccata and Fuge for the Foreigner," Kristeva states that outsiders are: "[C]onstantly feeling the hatred of others, knowing no other environment than that of hatred" (13). Julia Kristeva, "Toccata and Fuge For the Foreigner," *Strangers to Ourselves*, trans. Leon S. Roudiez (New York: Columbia UP, 1991) 1-41.

[81] Tanner refers to the Croat-Muslim conflict in Croatia and how the Muslim refugees are constructed as the "Croats' public enemy." See Tanner, *Croatia* 291-92.

[82] The same "we" versus "them" strategy is realigned one more time in Drakulić recent essays as an observer in the Milosovic trial in the Netherlands in 2002. Her essays, "The

Consensus of Lies," and "Why Should Anyone Care?" are part of a collection in progress. Drakulić, email with the author, January 19, 2002.

[83] Drakulić, "High-Heeled" 142.

[84] Drakulić, "High-Heeled" 142.

[85] Drakulić, "High-Heeled" 142.

[86] Most Eastern and Central European dissident writers refer in their writings to the cultural difference between "we" and "they," implying the political and sociocultural dichotomy between official and underground discourse in communist times. Baranczak, when analyzing dissidence, refers to this important rhetorical strategy in yet another dissident's discourse, Miklós Haraszti; see Stanislaw Baranczak, "The State Artist," *Breathing Under Water: And Other East European Essays* (Cambridge: Harvard UP, 1990) 87. George Konrád makes use of the same strategy in "15 March: A Colorful Day," *Melancholy of Rebirth* 130-6. In a similar way, playing against each other the cultural with the political connotations of pronouns in Eastern Europe, Codrescu writes in "Time Before Time" that: "[I]n the story, by the fire, we knew why we existed, why we were 'us' and not 'they' ('us' being those who knew the story, and 'they' the uninitiated outside the circle), why the world was the way it was."(5). See "Time Before Time," *The Disappearance of the Outside: A Manifesto for Escape* (Reading, MA: Addison-Wesley, 1990) 1-37.

[87] Drakulić, "High-Heeled" 142.

[88] Drakulić, "High-Heeled" 144-145.

[89] Drakulić, "High-Heeled" 146.

[90] Most of the essays in *Café Europa* do not treat her expatriation, rather her public intellectual position, advocating moral responsibilities in a civil society, as she travels throughout Eastern Europe: "He Sleeps Like a Baby" (170-182); "Still Stuck in the Mud" (195-204); "A Premeditated Murder" (93-100); or "My Father's Guilt" (143-160).

[91] Tanner in *Croatia* notes that after the war:"Pressure increased on independent voices in the media, such as Zagreb-based magazine *Danas* and the Split-based satirical paper *Feral Tribune*"(284). Drakulić contributed to both. In addition, talking about the control of the media in Tudjman's regime, Turner writes that: "In 1996 what was left of Croatia's independence media, especially the Split-based *Feral Tribune* and *Novi List* of Rijeka, faced strong pressure from a combination of politically motivated tax demands and new laws which were framed to make insults against members of the government a criminal offence"(302). See Tanner, *Croatia* 299-305.

⁹² Throughout *Café Europa*, Drakulić reinvents herself as a traditional critical intellectual, invoking the cultural and political discourse and values of communist Eastern Europe in order to reaffirm her social and political beliefs in a democratic Europe.

⁹³ Drakulić, "Introduction: First-Person Singular," *Café* 1-6.

⁹⁴ In my personal correspondence with Drakulić, the author expresses directly her belief that "communism is not gone" in Croatia. This is the reason I refer to *neo*-communist and *post-communist* times as synonymous terms for the Croat political situation after 1989. See Drakulić, e-mail with the author, 1 Feb. 1999.

⁹⁵ Drakulić, "Introduction" 3-4

⁹⁶ Drakulić, "Introduction" 4.

⁹⁷ Drakulić, "Introduction" 3.

⁹⁸ Konrád, in "More Than Nothing" writes about identical cultural and political delineations in grammatical form between official and underground arenas in communist Hungary. The political dissident writes that: "Looking backward, we must keep in mind that communist censorship did more than prohibit; it affirmed, affirmed all manner of things. Moreover, it did so in exalted tones and as often as not in the *first-person plural* (my emphasis)"(90). See Konrád, *Melancholy* 90.

⁹⁹ Drakulić, "Introduction" 1-2.

¹⁰⁰ Reading Drakulić's excerpt I had a similar physical reaction, for I remembered precisely similar events in Romania, where crowds were forced to participate in order to "honor" the cause of communism, and/or its leaders. Ceaușescu had turned these events into unbearable experiences, for his need for adulation and praise was infinite. Pacepa, in his account of Ceaușescu's dictatorship, offers extensive descriptions of the mass manifestations organized in praise of the communist leader. See Ion Mihai Pacepa, *Red Horizons: The True Story of Nicolae and Elena Ceaușescu's Crimes, Lifestyles, and Corruption* (Washington, D.C.: Regnery Gateway, 1987).

¹⁰¹ Drakulić, "Introduction" 2.

¹⁰² Drakulić, "Introduction" 2.

¹⁰³ Drakulić was never a member of the Communist Party. See Drakulić, "My Father's Guilt," *Café* 143-60.

[104] Drakulić, "Introduction" 2-3.

[105] Baranczak presents precisely the communist rules of censorship in Polish press during communism. See Stanislaw Baranczak, *Breathing Under Water* 61-67.

[106] Drakulić, "Introduction" 3.

[107] Drakulić, "Introduction" 3.

[108] Drakulić continues:"The most difficult thing for me was the lack of solidarity. Very few people defended us[the five women journalists against Tudjman's regime]. No professional association ... took up our case. I will always remember that terrible feeling of loneliness–that feeling of being all alone, exposed, and that no one was lifting a finger. . . . The door to my home was spit on every single morning; my car was damaged; I got threatening telephone calls and hate mail; my daughter was harassed and so was my aged mother."See Drakulić, "How I Became a Witch" 137.

[109] Drakulić, "Introduction" 3.

[110] Drakulić, "Introduction" 3.

[111] Drakulić, "Introduction" 3.

[112] Drakulić, "People From the Three Borders" *Café* 160-70.

[113] "Rhetorical vision" is utilized here in the same sense Bormann intends it. "Rhetorical vision" is defined as" constructed from fantasy themes that chain out in face-to-face interacting groups, in speaker-audience transactions. . . . Once such rhetorical vision emerges it contains dramatis personae and typical plot lines that can be alluded to in communication contexts and spark a response reminiscent of the original emotional chain" (398). Chaining this political and cultural solution from a possible "fantasy theme," Drakulić seems to be in consensus in this vision with the inhabitants of the Istria peninsula. See Ernest G. Bormann, "Fantasy and Rhetorical Vision: The Rhetorical Criticism of Social Reality," *Quarterly Journal of Speech* 58 (1972): 396-407.

[114] Drakulić, "People" 163.

[115] Drakulić, "People" 164.

[116] Drakulić, "People" 164.

[117] Drakulić, "People" 165.

[118] Drakulić, "People" 169.

[119] Drakulić is born in Rijeka, close to Istria. See Drakulić, e-mail to the author, 18 Feb. 1999.

[120] Drakulić, "People" 169.

[121] I refer specifically to McGee's "Text, Context, and The Fragmentation of Contemporary Culture" article. See Michael Calvin McGee, "Text, Context, and the Fragmentation of Contemporary Culture," *Western Journal of Speech Communication* 54 (1990): 274-90.

[122] Kenneth Burke, *Attitudes Toward History*, 3rd ed. (1937; Berkeley: U of California P, 1984) 3-34; 92-111.

[123] Burke, *Attitudes* 5.

[124] Burke, *Attitudes* 21.

[125] Burke, *Attitudes* 99.

[126] Burke, *Attitudes* 4.

[127] I mean "rhetorical potentiality" in the sense of both powerful and possible rhetorical voice when in exile.

[128] Burke in *A Rhetoric of Motives* develops large sections to explain "identification" as consubstantial process, compensatory to division, functioning rhetorically to establish a rapport between the speaker and his or her audience. For "identity," he develops a short section as a "titular or ancestral term, the 'first' to which all other terms could be reduced and from which they could then be derived and generates, as from a common spirit," "an individual locus of motives"(21). See Kenneth Burke, *A Rhetoric of Motives* (1950; Berkeley: U of California P, 1969) 21.

[129] Burke, *Rhetoric* 21. As mentioned, Burke's concept of identity is presented as a *first* term, and therefore, in a sense, final.

[130] In Burke's view, identity is a unique "entity in itself and by itself, a demarcated unit having its own particular structure," a point terminus "to which all other terms could be reduced" and "from which they could then be derived," see Burke, *Rhetoric* 21. It is against this finite and singular dimension of identity that I argue, when it comes to exilic voice in rhetorical discourse.

[131] Burke, *Rhetoric* 20-22.

[132] I owe the term to Dr. Robert N. Gaines. "Chiasmatic" means an inverted relationship, a crossing over action, according to Webster Dictionary. See "Chiasma," *Webster: New Collegiate Dictionary*, 1977 ed.

CHAPTER V

Toward a Rhetoric of Exile and Dissent: The Return of the Rhetor

In examining dissident discourse created by public intellectuals from Eastern and Central Europe, the study locates their rhetorical voices in the discursive and cultural nexus where identity, identification, and context transform each other in rhetorical action. The rhetorical problem that Konrád, Codrescu, and Drakulić must overcome is their *reconstructing voice* in response to exile and dissent, and consequently, *re-legitimizing* their rhetorical powers. As speakers of dissidence and democracy in Eastern and Central Europe, as critical intellectuals, Konrád, Codrescu, and Drakulić are well established within the public arenas of their respective cultures. They forfeit these powers, and lose their identities through the powerful experience of expatriation. Thus, their rhetorical task after exile and dissidence is to recapture their rhetorical voices and reenter participation in the national and international public spheres. In the process, Konrád, Codrescu, and Drakulić recreate a salient relationship between *culture and rhetoric*, opening novel venues for critical investigations in contemporary discourse.

Central to this critical endeavor is the concept of *identity reconstitution and a rhetorical action of resistance*. Identity, or voice, reveals the ethos these rhetors bring to their actions through positioning themselves in relation

to their context and to their audiences. As all three critical rhetors address a rhetorical crisis of losing voice, their discourse attempts to re-legitimize their rhetorical power in the public arenas of Eastern and Central Europe. Their *legitimacy* lies precisely in the rhetorical relationships they construct between identity and cultural and political power, grounding their rhetorical appeals in multiple cultural contexts. Consequently, as Konrád, Codrescu, and Drakulić respond to past and present events, to geographic or cultural dislocations, they also address their powers of persuasion.

Challenging publics and public memory by reconstituting their ethos, Konrád, Codrescu, and Drakulić use the contextualized language of resistance to create public discourse and with it, to re-inscribe themselves within the Eastern and Central European public sphere.[1] Yet, due to their relationship with exile, dissent and politics, they reconstruct identity and context as they legitimize rhetorical personae along cultural tensions of discourse.

Since each and every rhetor of dissidence offers specific discursive accounts grounded in different political and cultural contexts, a rhetoric of exilic reconstitution and resistance must develop through the study of multiple cases. As I examined in this book mainly the exilic discourse of Konrád, Codrescu, and Drakulić, I view such case studies as necessary to revisit dimensions of a rhetoric of exile: a rhetor's reinvention of voice, the political or cultural contexts of redefinition, and the rhetorical resources a speaker has in expatriate or dissident situations to resist and recreate discourse.

The critical intellectuals' discourse of dissent illustrate reinvention of voice in the face of expatriation and/or marginalization. Konrád, Codrescu, and Drakulić lose their rhetorical power and identity. Although from distinct political and cultural contexts, yet sharing similar rhetorical exigence Konrád, Codrescu, and Drakulić create identity to challenge the cultural narratives of communist and nationalist insurgence in post-communist times. Creators of public identities of resistance, their efficacy is contingent to their ethos of civic or cultural engagement. The cultural narratives within shared worlds of communist and post-communist revolutions infer the rhetors' reposition of ethos inside the liminal space for civil and rhetorical action. Concomitant positions of speech and contexts of resistance legitimize their discourse and with it, their identity.

These dissidents engage in constituting voice as their discourse challenges politics, publics and history. Konrád, famous as a dissident writer

throughout the world, finds himself needing to reassert his rhetorical powers in post-communist Hungary. At the very moment of triumph, when the demise of communism legitimizes his past resistance as a democratic voice in the Hungarian public arena, he is rejected by a group of his previous audience, newly turned nationalist. His juxtaposition of identities in the two squares, Petöfi and Freedom, in "Holiday" and "15 March," demonstrates his need to respond to public situations of marginalization with a strategic redefinition of voice. His defense of democratic powers articulated for the benefit of a civil society leaves him embracing yet a new marginalization, in response to nationalism and anti-Semitism.

Using language as his ontological site for discourse, and after twenty-five years of life in America, Codrescu re-immerses himself in his Romanian past, thus raising the problem of identity and the need to reconstitute his persona of and with exile. Drakulić's cultural and political realities shift importance in her newly independent country, Croatia, forcing her to raise her voice as an expatriate intellectual against political situations turned incomprehensible or unacceptable.

Tracing the second dimension relevant for a rhetoric of exilic reconstitution, these writers respond to dissidence by rebuilding identity from *political or cultural contexts of resistance.* Exile and dissidence become the vantage point that ultimately transforms rhetors' legitimacy and rhetorical power in discourse. Speaking about Poland and Eastern European counter-publics created pre-1989, Hauser points out:

> The official public sphere may have been the domain of apparatchiks and party members, but that fact did not stop the active members of society from locating alternative sites, such as samizdat literature, for open discussion. The resisters' unity of interests and consensus, their trust and spirit of reciprocity, in short, their community, rested on the rhetorical experience of sharing a public relationship of words and deeds.[2]

Konrád, Codrescu, and Drakulić' re-inscription of ethos within their discourse of resistance carries undeniable traces of history. More so, these writers' strategies to redefine themselves through and in discursive dissent capture contexts of political and cultural narratives within a language of resistance in the first person singular. Speaking from the vantage point of exile or the margins of discourse, such rhetors infer their own cultural and political narratives to reframe the realities of post-communist Eastern and

Central Europe. Hoffman identifies location of exile within the margins of existence, as she writes that:

> Being deframed, so to speak, from everything familiar, makes for a certain fertile detachment and gives one new ways of observing and seeing. It brings you up against certain questions that otherwise could easily remain unasked and quiescent, and brings to the fore fundamental problems that might otherwise simmer inaudibly in the background. This perhaps is the great advantage, for a writer, of exile, the compensation for the loss and the formal bonus–that it gives you a perspective, a *vantage point.*"(my emphasis)[3]

Konrád provides a good example of the rhetor of the outside addressing multiple political and cultural contexts as part of his reconstituted ethos. For not only is Konrád forced to respond to the political situation of the present, but he must also address the Freedom Square incident through an articulation of the political context against which he can recapture his rhetorical powers. In essays like "Melancholy of Rebirth," for instance, Konrád positions his voice within liminal and fluid contexts of an emergent civil society.. Konrád is and remains within the realm of inner exile, a rhetorical position recognized by audiences and rhetor alike, merging public and private personae. Political past is revisited only to reinforce the political future for Hungary, its political alternatives to communist history. Adding to and from this public arena of democracy in Hungary, the rhetor empowers himself to speak, to make appeals, to change the political into an antipolitical, more citizen-geared rhetoric necessary for a new democracy in his country

Codrescu offers probably the best example of the interaction of voice and *cultural* context necessary for a rhetor's articulation of exilic identity in discourse. Less directed towards political dissidence, yet empowered by the cultural conditions of expatriation, Codrescu reinvents himself as a rhetor by taking the cultural dimensions of time and place as his contextual partners in exilic language. Carrying with him an accent that a trace of other language and discursive otherness, Codrescu, like other exiles, still leaves "traces of an accent" in his prose, "call it a particular cadence in a language that is never quite just English."[4] Like Aciman and other writers of exile, even after moving into the familiar locus of marginalized existence, Codrescu would also become haunted by the cultural narratives of "compulsive retrospection."[5] His legitimacy as a rhetor stems from his poetic articulations of voice, from his metaphoric constructions of culture as the exilic place of *the Outside*. It is at this intersection of culture and language that Codrescu

posits his identity as an exile, living in two worlds, separated by different cultural traditions, yet reunited by his cultural aspirations in both.

The third dimension of the rhetoric of exilic reconstitution reveals *resistance, language,* and the *position of speaker* in the discursive action as three internal rhetorical resources that enable rhetors to reconstruct the relationship between voice and legitimacy.[6] These inherent constraints assist the rhetors' redefinition of voice in response to exile, reiterating how contextualized relations and events modify rhetorical discourse. *Resistance* appears to be an always already embedded assumption in the rhetoric of exilic reconstitution and dissidence. By definition, any exile or critical voice is resistant to the political or socio-cultural situation of his or her native country; otherwise there would be no expatriation.[7] Resistance becomes then *the* rhetorical trigger, the impetus with which a rhetor reacts in order to reconstruct a powerful voice in discourse. At the same time, resistance is also a rhetorical resource that lets the rhetor create and recreate identity in discourse.

As a rhetorical resource, resistance functions as the framework on which exilic rhetors declare their voice in their discursive actions. Konrád exemplifies how resistance may become the main framework of rhetorical action for exilic and marginalized voices. His strategies to claim identity as a public and private enemy call upon resistance as the main rhetorical resource when articulating voice. For how else can an internal exile, a former underground writer, act upon a political context still adverse to voices of democracy? Resistance and its dynamic resources of discourse provide Konrád the public and private strategies to rearticulate voice, capturing his past identity as a dissident in order to address the present context of confusing times.

While these writers' role as exiles and dissidents can be always challenged by historical perspectives on Eastern and Central Europe, their rhetorical strategies to reconstitute themselves through discourse provides an important venue to understand the rhetoric of exile. As rhetors of exile and dissent create discursive accounts of voice resisting political or cultural contexts in Eastern and Central Europe, they also bring to the fore of their rhetoric the power of words and language. For people like Codrescu, for example, language becomes the cultural adversary that needs to be conquered in order to create a coherent identity in discourse. For others, like Konrád and Drakulić, language carries with it important cultural

connotations in its grammatical distinctions between pronouns, to name only one of the linguistic strategies present in this study.

Language empowers these rhetors to articulate, differentiate, or reposition themselves against political and cultural contexts in discourse. As a poetic exile, Codrescu makes the major claim for the linguistic powers of exilic identity. Caught between worlds, severing his self from the political task of dissident intellectuals, Codrescu rearticulates his voice in terms of the poetic powers of exile, making his reinvention of identity a linguistic event. Codrescu attempts to create a coherent rhetorical persona in *Disappearance*, through the linguistic empowerment of his poetic voice. Carrying a native language as "an encoded memory of our heritage,"[8] and coexisting as exile, marking "the lag between two cultures, two languages, the space where you let go of one identity, invent another, and end up being more than one person though never quite two," language becomes Codrescu's main rhetorical resource in recreating symbolic geographies of *the Outside*, in reasserting dissent.[9] From these discursive loci between, from or in Romanian and American English, the poet expatriate empowers his identity as a voice of the counterculture.

Konrád and Drakulić, while revisiting their past in linguistic terms, they move along words of "we" versus "them," in order to recapture identity in linguistic and political terms. For these two, language becomes the main repository of the cultural and political connotations of former regimes in Eastern and Central Europe. Havel, who was imprisoned for examining words and their histories, explicates that in his country,

> [T]hat particular word–'socialism'–was transformed long ago into just an ordinary truncheon used by certain cynical, parvenu bureaucrats to bludgeon their liberal-minded fellow citizens form morning until night, labeling them 'enemies of socialism' or 'antisocialist forces.'...What a weird fate can befall certain words! At one moment in history , courageous, liberal minded people can be thrown into prison because a particular word means something to them, and at anther moment, people of the selfsame variety can be thrown into prison because that word has ceased to mean anything to them, because it has changed from a symbol of a better world into the mumbo jumbo of a doltish dictator.[10]

Klima remembers, too, that writers "had to pay a high price for *these words* (my emphasis) that take importance because of bans and persecution."[11]

Recalling the abusive use of language in communist times reminds the rhetors of their own power to build linguistic identities outside mainstream

discourse. In *Café Europa*, Drakulić's appeals, to remember "them" as the communist oppressors in order to resist the new nationalist regimes, invoke the powers of language for any rhetor in exile.

And the last rhetorical resource relevant to a rhetoric of exile relates to the flexible *reposition of a rhetor* in culture. Due to the rhetorical situations noted above, due to the cultural and political contexts to which these rhetors react by redefining themselves in expatriation and dissent, they also reveal that exile and exilic rhetorical actions reveal an unsettled rhetorical process. Repositioning themselves towards and against the world around them, these rhetors of resistance re-empower themselves as speakers of democracy by constantly shifting their voice in discourse. Addressing multiple contexts, the past or the future of their countries of origin, as well as the cultural dimensions of time and place, they legitimize their actions by creating *flexible* voices of resistance. Drakulić provides a great example for this unsettled process of reconstitution. By stirring several of her past and present voices, she empowers herself to articulate a future, where, according to the Istrian model, multiple identities can coexist in a constructive context of democracy. Using unsettling ethos and/or negation as a rhetorical appropriation for loci of dissent, the fluid and liminal position of these rhetors offers a fundamental reposition of speech for the discourse of democracy and resistance.

Rhetorical resources of resistance, language, and the rhetor's position in discourse, when responding to exile and dissidence, form the bases for some possible strategies that can modify these rhetors' condition and, therefore, their discursive action. Assisting the rhetor's redefinition of voice in response to dissidence and expatriation, these resources highlight the operative function of culture as inherent in the rhetorical process born of the public intellectuals' exile.

In addition, these critical intellectuals as rhetors respond to exile by emphasizing in their discourse the concept of cultural and rhetorical context. Paralleling McGee's conceptualizations of cultural fragmentation, text and context, the rhetorical con-text as a rhetorical and cultural cluster of exigencies becomes a constitutive part of these rhetors' voice in discourse. Not only do Konrád, Codrescu, and Drakulić respond, reject, or reconstruct the rhetorical situations and their exigencies in discourse, but in redefining rhetorical voice, these rhetors appeal to and transform expatriation or dissidence. Whether along temporal, locative, or political dimensions of their cultural contexts, these Eastern and Central European critical intellectuals

carry within their identity rhetorical relationships developed with intricate cultural contexts. Rhetorically, Konrád, Codrescu, and Drakulić redefine themselves either *within* or *against* cultural contexts in their participation in public discourse.

Consequently, if one is to conceptualize a rhetoric of exile, the need to problematize and articulate culture as constitutive of the rhetors' identity seems necessary. In this study, exilic discourse is seen to transform rhetors' voices as they respond to cultural contexts of time, place, or power, relocating redefinitions of expatriate identity within complex cultural and rhetorical relationships.

The Role of Critic and Dissident Discourse

Reflecting back on this rhetorical study, important questions on exile remain to be addressed when exploring the post-communist legacy of exilic discourse. First, how can a rhetoric of exilic reconstitution create novel relationships between text and context? I would argue that both text and context become culturally coexistent dimensions of rhetorical discourse of resistance, requiring then further exploration. Codrescu's culturally fragmented identity captures divergent contextual dimensions in his voice of resistance. Drakulić, an unsettled and unsettling rhetor, refuses to solve the critical problem between text and context, continuously redefining her fragmentation. Although McGee's rhetorical perspective of collapsing text and context remains significant for critical studies in our discipline, I contend that for rhetors of exile, the relationship functions differently. Rather than collapsing text and context in the cultural fragmentation of discourse, the relationship becomes transformative, as the rhetor and the critic have to address different cultural contexts and texts simultaneously. Exile makes rhetors recall *different* and possibly *divergent* cultural fragments within their rhetorical articulation of voice in discourse. Konrád, Codrescu, and Drakulić, as do all expatriate rhetors, enter a rhetorical action with a fragmented identity, with disparate personae, responding to rhetorical exigences of exile by living in different cultural contexts at the same time. In accordance with their lives in the margins, their rhetorical actions to recapture and legitimize voice in discourse invoke disparate temporal lines, or different cultural locations.

A critical perspective also aligns the critic with this quest. For in order to address the exiles' strategies for recapturing their rhetorical powers, a

critic needs to explore the complex relationships these rhetors' create with disparate cultural fragments of context and voice. And, because exile and its rhetors employ complex rhetorical actions in discourse, the relationship between voice and cultural context changes into a rhetorically tensioned interaction, for rhetor and critic at the same time.

Second, questions on the relationship between rhetor and audience appear substantial to pursue critical endeavors on discourse from the margins. What is the rhetorical significance of identity in cultural and rhetorical relationships with an audience? As the critic attempts to accommodate both the socio-cultural contexts in which exilic discourse takes place and these authors' evocation of past and reinvention of present identity, the rhetorical relationship between identity and identification becomes an intricate locus for rhetorical criticism. Burke's rhetorical interaction between identity and identification in language helps the critic reveal complex rhetorical constructions of identity against cultural dimensions of time, space, and power. Inherent to dynamic loci of motives, the process of identification draws into the analysis the rapport between the speaker and his or her audiences in cooperative public discourse. All three rhetors of exile analyzed here are successful public intellectuals, whose actions have transcended singular audiences and singular rhetorical contexts. Konrád's appeals to antipolitical stands, Codrescu's claims to counterculture as the antidote to consumerism and oppression, and Drakulić's powerful investigations of the meaning of dissidence in the post-communist Balkans all constitute effective rhetorical challenges to participation in the cultural and political arenas of democracy in the world.

This study focuses on *the other* part of the identity-identification relationship, namely, on the rhetorical construction of voice in exilic discourse. In using identity as a locus of motives, Konrád, Codrescu, and Drakulić renegotiate voice rhetorically, first with themselves, in their discursive actions. It is by vectoring the relationship between identity and identification towards the rhetor that I believe this perspective brings novelty to rhetorical studies. Such an approach recalls a reinvention of the rhetor, while interpellating culture in the rhetorical process. Consequently, I argue that by investigating ethos in adverse cultural contexts, one can address the transformative powers of culture and its rhetorical permeability as interstitial relationships between identity and identification in the public discourse from the margins.

In advocating critical endeavors at the intersection between cultural and political recreations of ethos and legitimation, discourse of Eastern and Central Europe dissent calls for a continuation of the journey where culture and rhetoric transform each other within democratic and global discourse.

After all, Michnik's call for democratic discourse implies also to continue and revisit the role of critical intellectuals in the new arenas of democracy in Eastern and Central Europe, since "the subject of democracy is people, not ideas," and only "democracy, with its human rights and institutions of civil society, can replace weapons with arguments."[12]

Notes

[1] Hauser's definition is as follows: "*A public sphere* may be defined as a *discursive space in which individuals and groups associate to discuss matters of mutual interests and, where possible, to reach a common judgement about them. It is the locus of emergence for rhetorically salient meanings* (61). Gerald A. Hauser *.Vernacular Voices: The Rhetoric of Publics and Public Spheres.*(Columbia, SC: U of South Carolina, 1999).

[2] Hauser, *Vernacular Voices* 60.

[3] Eva Hoffman, "The New Nomads." *Letters of Transit: Reflections on Exile, Identity, Language, and Loss* .Aciman, André, ed. (New York: The New Press, 1999): 50.

[4] André Aciman, "Foreword: Permanent Transients." *Letters of Transit: Reflections on Exile, Identity, Language, and Loss* .Aciman, André, ed. (New York: The New Press, 1999): 11.

[5] Aciman continues: "With their memories perpetually on overload, exiles see double, feel double, are double. When exiles see one place they're also seeing–or looking for–another behind it. Everything bears two faces, everything is shifty, because everything is mobile, the point being that exile, like love, is not just a condition of pain, it's a condition of deceit"(13).André Aciman, "Foreword: Permanent Transients." *Letters of Transit: Reflections on Exile, Identity, Language, and Loss* Aciman, André, ed. (New York: The New Press, 1999): 7-15.

[6] I treat these rhetorical resources in a Bitzerian sense, as he states in "The Rhetorical Situation" that: "[B]esides exigence and audience, every rhetorical situation contains a set of

constraints made up of persons, events, objects, and relations which are parts of the situation because they have the power to constrain decision and action needed to modify the exigence"(8).

[7] Shain is explicit about the political dimension of exile, while Hall and Said reflect mostly on its cultural resistance aspect. See Yossi Shain, *The Frontier of Loyalty: Political Exiles in the Age of the Nation-State* (Middleton, CT: Wesleyan, 1989) 15; Stuart Hall, "Cultural Identity and Diaspora," *Identity: Community, Culture, Difference*, ed. J. Rutherford (London: Lawrence & Wishart, 1990) 222-37; and Edward Said, *Representations of the Intellectual: The 1993 Reith Lectures* (New York: Pantheon 1994) 47-65.

[8] Hoffman, "The New Nomads" 50.

[9] Aciman, "Foreword"11.

[10] Vaclav Havel, "Words on Words,"*Writings on the East: Selected Essays on Eastern Europe from the New York Review of Books*. (New York: The New Work Review of Books, 1990): 12-13.

[11] Ivan Klima in Philip Roth, "A Conversation in Prague."*Writings on the East: Selected Essays on Eastern Europe from the New York Review of Books*. (New York: The New Work Review of Books, 1990): 112.

[12] Adam Michnik, "Gray is Beautiful," The Public Intellectual: Between Philosophy and Politics, Eds. Arthur M. Melzer, Jerry Weinberger, and M. Richard Zinman, (Lanham, MD: Rowman & Littlefield, 2003) 188.

EPILOGUE

What Now for Dissent in Post-Communism?

Most likely, the debate about the role of critical intellectuals in post-communist New Europe is not over. Writings by exiled or dissident voices of Eastern and Central Europe continue to carry important value for rhetorical, political, historical, and critical scholarship of contemporary times. Zagakewski repositions the roles of writers in post-1989 Europe, since dissident roles, voices and times, all are changing. His position is as follows:

> Who are we writers, those of use who have not entered the administration of new, transitional democracies? Now we represent just ourselves, our past and future, our mistakes, and *bons mots*. And—as far as political struggle agains bad, oppressive systems is concerned—we have turned into historians who can dwell on their remembrances for decades. I don't want to be misunderstood. I am not sneering at the historical function of literature, quite the contrary. But we are no longer oracles. We are writers, lonely and slightly comical figures, fighting with a while sheet of paper, exactly like our colleagues from Australia and Italy, San Marino and Andora.[1]

A large array of studies posits the question of the social, political, or historical role of dissidents, for 'other than being the guardians of memory and truth regarding authoritarian communism, or as individual writers and

poets," what *is* the dissidents' role after 1989?[2] From inside and outside of the former Iron Curtain, questions abound on the salient contributions of philosopher kings and dissidents whose writings assisted in the transition from "normal abnormality to abnormal normality"[3] of new political challenges for a new era of a New Europe.[4]

After communism, the public discourse on nationalism, on difference and tolerance, and on ethnic cleansing continues to raise questions in Eastern and Central Europe, in Western scholarship and in Eastern altogether.[5] What happens now? Do the lessons of communism proffer any better routes for new social, political, and cultural changes in any society? Does the democracy of the West become the only form of civil social existence in Eastern and Central Europe? Can public intellectuals' appeals remain operative in societies in transition, in times of social, cultural, and political changes?

The historical times, during and post the Communist era, have had a profound impact on the rhetorical discourse of public intellectuals in Central and Eastern Europe. Debates on the role of intellectuals in the 1989 revolutions as well as on the importance of resistance in post-communist times continue to stir international discussion Dismissal of critical intellectuals' legitimacy after 1989 and controversial views on their political and cultural roles in and after the fall of communism abound, leaving further rhetorical, cultural, and political investigations.[6] Concluding the 1989 events Konrád states that:

> Modern East European humanism, which came out of the dissident democratic movements and matured by batting the strut, spasms, and hysteria of collective egos, has taken deep root in our culture, and without it Hungary 1989 could not have taken place. I might add that this year's peaceful revolutions–our own and the analogous ones in a number of Central and East European countries–have opened a new chapter in the history of European autonomy.[7]

Rhetorical studies have started to address questions of post-communist rhetoric, locating a rhetoric of transformation and a rhetoric of transition as inherent discursive practices for dissidents and post-communist voices alike.[8]

And yet, what happens to reinvention of voice in relation to rhetorical and cultural perspectives on dissidence, exile, and democracy? Almost two decades after the demise of communism, Konrád, Codrescu, and Drakulić continue to face their identity of dissent, as they remain (like most dissident writers) questioned or revered, challenged or challenging, in changing times

for new civil arenas of democracy. Konrád and Drakulić write from within the political and cultural realm of discourse on their country and geographic area of origin. Their recent writings, some still autobiographical, reflect their continuous interest in the discourse of democracy in the region.[9]

Drakulić also remains in the discourse of resistance connected to the area, contributing both articles and books that reflect her interest in voice and democracy in the Balkans.[10] Recently, as an official witness in the trial of the former President of Serbia, Drakulić echoes in her writings of now her dissident voice during Tudjman's government in Croatia.[11] Codrescu's most recent writings revisit cultural resistance, in spite of the author's less frequent works on his own exilic identity.[12]

Summing the important moral and political roles critical intellectuals had provided throughout the last half of the twentieth century in Central and Eastern Europe, Tismaneanu reiterates that the public discourse on resistance and democracy is not over yet in this part of the world: "Those who think that dissidents' search for subjective freedom was just an isolated intellectual exercise, with no aftermath in the depressing world of postcommunist settlings of scores and moral turpitude" need to understand, that " *more than ever* (my emphasis*)*, democratic intellectuals are needed in politics if this most ancient human affair is to be a more hospitable place for truth, trust, and tolerance.[13]

While sharing political identity or cultural roles in the New Europe of the new millennium, dissident rhetoric reveals, according to Havel, that:

> The dissident movement was not typically ideological. Of course, some of us tended more to the right, others to the left, some were close to one trend in opinion or politics, others to another. What was essential was something different: the courage to confront evil together and in solidarity, the will to come to an agreement and to cooperate, the ability to place the common and general interest over any personal or group interests, the feeling of common responsibility for the world, and the willingness personally to stand behind one's own deeds. Truth and certain elementary values, such as respect for human rights, civil society, the indivisibility of freedom, the rule of law—these were notions that bound us together and made it worth our while to enter again and again into a lopsided struggle with the powers to be. [14]

Hence critical intellectuals' discourse, their voices of resistance in a free-ed world, in cultural and political contexts of redefined and redefining public spheres represent continuous goals for global democratic values. Like many

other dissidents, political exiles, and rhetors of resistance, Konrád, Codrescu, and Drakulić open a door towards important rhetorical quests on speakers' re-constitutive powers in and through discourse always already against neo-communist practices in Central and Eastern Europe. Exile and dissidence remain inherent part of their discourse on resistance and civil society, adding strength to the democratic discourse inside and outside their native lands.

Dissidents and former exiles engage in their works rhetorical reconstitution of voice to revisit politics, history and culture as discursive legacies for generations to come. For, as Hannah Arendt reminds us, "What remains? Language remains."[15]

Notes

[1] Adam Zagajewki, *Partisan Review*, 59.4 (1992): 690. See *Partisan Review* 59.4 (1992). Special Issue: Intellectuals and Social Change in Central and Eastern Europe.

[2] Barbara J. Falk provides an impressive and extensive study on the most important dissidents from Eastern and Central Europe, a mandatory read for most scholars interested in communist legacy in the New Europe. See Barbara J. Falk, *The Dilemmas of Dissidence in East-Central Europe: Citizen Intellectuals and Philosopher Kings* (Budapest: Central European UP, 2003) 359.

[3] Timothy Garton Ash, "'Neo-Pagan' Poland," *New York Review of Books* (11 January 1996): 14.

[4] Timothy Garton Ash, Adam Michnik, Vaclav Havel, Vladimir Tismaneanu, Barbara J. Falk, Tony Judt, to name a few, all continue to address the post-communist legacy of dissent in multiple studies published post-1989.

[5] See Barbara J. Falk, "The Dissident Contribution to Political Theory, *The Dilemmas of Dissidence in East-Central Europe: Citizen Intellectuals and Philosopher Kings* (Budapest: Central European UP, 2003) 313-365.

[6] Pertinent in this study and its main claims, several excellent collections bring additional light on the role of critical intellectuals in creating a rhetoric of resistance: Antohi, Sorin and Vladimir Tismaneanu, eds. *Between Past and Future: The Revolutions of 1989 and Their Aftermath*, (Budapest: Central European UP, 2000) András Bozóki, *Intellectuals and Politics in Central Europe*, (Budapest: Central European UP, 1999); Adam Michnik, *Letters from*

Freedom: Post-Cold War Realities and Perspectives, ed. Irina Grudzińska Gross, (Berkeley: U of California P, 1998).

[7] Konrád, *Melancholy*, 18-19.

[8] An excellent collection that can represent a solid starting point of scholarship was published in Poland in 2003. Jerzy Axer, Ed. *Rhetoric of Transformation*, (Warsaw, Warsaw UP, 2003).

[9] See George Konrád, "The Best of Both Worlds: Still Straddling East and West, Berlin Could Become Central Europe's World-Class City" *Time International*, (Nov 15, 1999):19; and George Konrád, *Stonedial*. Trans. Ivan Sanders.(San Diego: Harcourt Brace, 2000).

[10] Slavenka Drakulić, "Intellectuals as Bad Guys: The Revolutions of 1989: Lessons of the First Post-Communist Decade," *East European Politics and Societies*, 13.2 (1999): 271-278; Slavenka Drakulić, *S.: A Novel about the Balkans,* Trans. Marko Ivic (New York: Viking, 2000); Slavenka Drakulić, "'What's in a Name?' For People in the Countries of the East, Europe is a State of Mind" *Time International*, 10 Dec.1998: 165 and Slavenka Drakulić, "' We Are All Albanians,'"editorial, *Nation* 07 Jun. 1999: 6.

[11] Her most recent book is about war criminals and the war in the Balkans. See Slavenka Drakulić, *They Would Never Hurt a Fly: War Criminals on Trial in The Hague*, (New York; Viking, 2004).

[12] See for instance Andrei Codrescu, *The Devil Never Sleeps And Other Essays* (New York: St. Martin's, 2000) or Andrei Codrescu, *Thus Spake The Corpse: An 'Exquisite Corpse' Reader 1988-1998,* 2 vols. (Santa Rosa, CA: Black Sparrow P, 1999-2000).

[13] Vladimir Tismaneanu, "Fighting for the Public Sphere: Democratic Intellectuals under Postcommunism," *Between Past and Future: The Revolutions of 1989 and Their Aftermath,* eds. Sorin Antohi and Vladimir Tismaneanu (Budapest: Central European UP, 2000) 153-75.

[14] Vaclav Havel, *The Art of the Impossible: Politics and Morality in Practice.* Trans. P. Wilson. (New York: Alfred A. Knopf, 1997) 111-112.

[15] Hannah Arendt, *Essays in Understanding 1930-1954: Formation, Exile and Totalitarianism.* 1994. Ed. Jerome Kohn (New York: Schocken Books, 2005) 1.

BIBLIOGRAPHY

Aciman, André. "Foreword: Permanent Transients." *Letters of Transit: Reflections on Exile, Identity, Language, and Loss*. Ed. André Aciman. New York: The New Press, 1999. 7-15.

Aciman, André., ed. *Letters of Transit: Reflections on Exile, Identity, Language, and Loss*. New York: The New Press, 1999.

Antohi, Sorin. "Habits of the Mind: Europe=s Post-1989 Symbolic Geographies." *Between Past and Future: The Revolutions of 1989 and their Aftermath*. Eds. Sorin Antohi and Vladimir Tismaneanu. Budapest: Central European UP, 2000. 61-81.

Antohi, Sorin and Vladimir Tismaneanu, eds. *Between Past and Future: The Revolutions of 1989 and Their Aftermath*, Budapest: Central European UP, 2000.

Afkami, Mahnaz. *Women in Exile*. Charlottesville: UP of Virginia, 1994.

Arendt, Hannah. *Between Past and Future: Eight Exercises in Political Thought*, New York: Penguin Books, 1993.

—. *Essays in Understanding 1930-1954: Formation, Exile and Totalitarianism*. 1994. Ed. Jerome Kohn. New York: Schocken Books, 2005.

Aristotle, *The Art of Rhetoric*. Trans. J. H. Freese. Loeb Classical Library Ser. 193 1926; Cambridge: Harvard UP, 1961.

Ash, Timothy Garton. "Eastern Europe: Après Le Déluge, Nous." *Writings on the East: Selected Essays on Eastern Europe from the New York Review of Books*. New York: The New Work Review of Books, 1990. 21-53.

—. "Neo-Pagan' Poland." *New York Review of Books* (11 January 1996): 14.

Axer, Jerzy. Ed. *Rhetoric of Transformation*, Warsaw, Warsaw UP, 2003.

Bachelard, Gaston. *The Poetics of Space*. Trans. Maria Jolas. Boston: Beacon, 1969.

Bakhtin, M.M., *The Dialogic Imagination: Four Essays*. Trans. Caryl Emerson and Michael Holquist. Ed. Michael Holquist. Austin: U of Texas P, 1981.

Baranczak, Stanislaw. "Before the Thaw: The Beginning of Dissent in Postwar Polish Literature (The Case of Adam Wazyk=s >A Poem for Adults=)." *East European Politics and Societies*. 3 (1980): 10-15.

—. *Breathing Under Water and Other East European Essays*. Cambdrige: Harvard UP, 1990.

—. "Truth and Consequences." Rev. of *A Feast in the Garden*, by George Konrád. *New Republic*, 31 Aug. 1992: 42-46.

Bauman, Zygmunt. *Life in Fragments: Essays in Postmodern Morality*. Oxford: Blackwell, 1995.

—. "From Pilgrim to Tourist--Or A Short History of Identity." 1996. *Questions of Cultural Identity*. Eds. Stuart Hall and Paul Du Gay. London: Sage, 1997.

Benhabib, Seyla. *Situating the Self: Gender, Community and Postmodernism in Contemporary Ethics*. New York: Routledge, 1992.

Berend, Ivan T. *Central and Eastern Europe, 1944-1993: Detour from the Periphery to the Periphery*. Cambridge: Cambridge UP, 1996.

Bhabba, Homi. "The Other Question: Difference, Discrimination, and the Discourse of Colonialism." *Out There: Marginalization and Contemporary Cultures.* Eds. R. Ferguson et al. Cambridge: MIT P, 1992. 71-87.

Bethea, David M. *Joseph Brodsky and the Creation of Exile.* Princeton: Princeton UP, 1994.

Bitzer, Lloyd F. AThe Rhetorical Situation.@ *Philosophy and Rhetoric* 1 (1968): 1-14.

Black, Edwin. "The Second Persona." *Quarterly Journal of Speech,* 56 (1970): 109-119.

Bormann, Ernest G. "Fantasy and Rhetorical Vision: The Rhetorical Criticism of Social Reality." *Quarterly Journal of Speech* 58 (1972): 396-407.

Bozóki, András. *Intellectuals and Politics in Central Europe.* Budapest: Central European UP, 1999.

—. "Rhetoric of Action: The Language of the Regime Change in Hungary." *Intellectuals and Politics in Central Europe.* Ed. András Bozóki. Budapest: Central European UP, 1999. 263-285.

Brodsky, Joseph. "The Condition We Call Exile." *Altogether Elsewhere: Writers on Exile.* Ed. Marc Robinson. San Diego: Harcourt, 1994. 3-12.

Brown, J. F. *Hopes and Shadows: Eastern Europe After Communism.* Durham: Duke P, 1994.

Brummett, Barry. "Burke=s Representative Anecdote as a Method in Media Criticism." *Critical Studies in Mass Communication,* 1(1984): 161-176. Rpt. in *Contemporary Rhetorical Theory: A Reader.* Eds, John Louis Lucaites, Celeste Michelle Condit, and Sally Caudill. New York: Guilford, 1999. 479-494.

Burke, Kenneth. *Attitudes Toward History.* 1937. Berkeley: U of California P, 1969.

—. *A Grammar of Motives.* Berkeley: U of California P, 1969.

—. *Language as Symbolic Action: Essays on Life, Literature, and Method.* 1966. Berkeley, U of California P, 1968.

—. *The Philosophy of Literary Form: Studies in Symbolic Action.* Baton Rouge: Louisiana State UP, 1941.

—. *A Rhetoric of Motives.*1950. Berkeley: U of California P, 1969.

Chamberlain, Mary. *Narratives of Exile and Return.* New York: St. Martin=s P, 1997.

Chambers, Iain. *Migrancy, Culture, Identity.* London: Routledge, 1994.

Charland, Maurice. AConstitutive Rhetoric: The Case of the *Peuple Québécois.*@ *Quarterly Journal of Speech,* 73 (1987): 133-150.

AChiasma,@ *Webster: New Collegiate Dictionary.* 4th ed. 1977.

Cioran, Emile M. *Temptation to Exist.* Trans. Richard Howard. Chicago: Quadrangle, 1970.

Comfort, Susan Marguerite. AMemory, Identity, and Exile in Postcolonial Caribbean Fiction.@ Diss. U of Texas, 1994.

Condit, Celeste. "Kenneth Burke and Linguistic Reflexivity: Reflections on the Scene of the Philosophy of Communication in the Twentieth Century." *Kenneth Burke and Contemporary European Thought: Rhetoric in Transition.* Ed. Bernard L. Brock. Tuscaloosa: U of Alabama P, 1995. 206-63.

Codrescu, Andrei. *The Devil Never Sleeps And Other Essays.* New York: St. Martin=s, 2000.

—. *The Dog with the Chip in His Neck: Essays from NPR and Elsewhere.* New York: St. Martin=s P, 1996.

—. *The Disappearance of the Outside: A Manifesto for Escape.* Reading, MA: Addison-Wesley, 1990.

—. *The Hole in the Flag: A Romanian Exile=s Story of Return and Revolution.* New York: Avon, 1991.

—. *The Life and Times of an Involuntary Genius.* New York: George Braziller, 1973.

—. "Literature at the End of the Century: An Editorial Perspective." *Literary Review* 33 (1990): 157-62.

—. *The Muse Is Always Half-Dressed in New Orleans and Other Essays.* New York: St. Martin=s P, 1993.

—. "Notes of An Alien Son." *The Nation.* 12 Dec. 1994: 718-22.

—. "Return to Romania: Notes of a Prodigal Son." *Washington Quarterly*, 21 (1998): 3-21.

—. "Sensul diferentei a fost cu mine de cind m-am nascut." *Romania Literara*, 45, 12 Nov. 1997, 5 Apr.1998 <http://romlit.sfos.ro/www/html/rl745.htm>.

Codrescu, Andrei, ed. *Thus Spake The Corpse: An >Exquisite Corpse= Reader 1988-1998,* 2 vols. Santa Rosa, CA: Black Sparrow P, 1999-2000.

Cortazar, Julio. AThe Fellowship of Exile.@*Altogether Elsewhere: Writers on Exile.* Ed. Marc Robinson. San Diego: Harcourt, 1994. 171-79.

Courtois, Stéphane, Nicolas Werth, Jean-Louis Panné, Andrzej Packowski, Karel Bartošek, and Jean-Louis Margolin. *The Black Book of Communism: Crimes, Terror, Repression.* Trans. Jonathan Murphy and Mark Kramer. Cambdrige, MA: Harvard UP, 1999.

ACPJ Protests Journalist Trial in Croatia.@ *Editor and Publisher* 12 Oct. 1996: 25.

Culic, Irina. "The Strategies of Intellectuals: Romania under Communist Rule in Comparative Perspective." *Intellectuals and Politics in Central Europe.* Ed. András Bozóki. Budapest: Central European UP, 1999.43-73.

"Culture." Def. 3, 4b. *Webster: New Collegiate Dictionary.* 4th ed. 1977.

Dana, Kathleen Osgood. APerspectives on World Literature.@ Rev. of *The Disappearance of the Outside: A Manifesto for Escape*, by Andrei Codrescu. *World Literature Today*, 65.1 (1991): 197-99.

Davies, Robertson. *The Happy Alchemy: On the Pleasures of Music and the Theatre.* Eds. Jennifer Surridge and Brenda Davies. New York: Penguin, 1999. 318.

Dodd, Carley H. *Dynamics of Intercultural Communication*, 5th ed. Boston: McGraw-Hill, 1998.

Draga-Alexandru, Maria-Sabina. "Exiles from Power: Marginality and the Female Self in Postcommunist and Postcolonial Spaces." *The European Journal of Women=s Studies.* 7 (2000): 355-66.

Drakuli , Slavenka., *The Balkan Express: Fragments from the Other Side of War.* New York: Harper, 1993.

—. "On Becoming a Refugee.@ *The Balkan Express: Fragments From the Other Side of War.* New York: Harper, 1993. 28-35

—. "High-Heeled Shoes.@ *The Balkan Express: Fragments From the Other Side of War.* New York: Harper, 1993. 137-47.

—. "Introduction: The Other Side of War.@ *The Balkan Express: Fragments From the Other Side of War.* New York: Harper, 1993. 1-5.

—. "A Letter to My Daughter." *The Balkan Express: Fragments From the Other Side of War.* New York: Harper, 1993. 125-37.

—. "Overcome by Nationhood." *The Balkan Express: Fragments From the Other Side of*

War. New York: Harper, 1993. 49-53.

—. "The Smell of Independence." *The Balkan Express: Fragments From the Other Side of War*. New York: Harper, 1993. 53-60.

—. "And the President is Drinking Coffee on Jela ić Square." *The Balkan Express: Fragments From the Other Side of War*. New York: Harper, 1993. 106-114.

—. *Café Europa: Life After Communism*. New York: Penguin, 1996.

—. "Introduction: First-Person Singular." *Café Europa: Life After Communism*. New York: Penguin, 1996. 1-6.

—. "Buying a Vacuum Cleaner." *Café Europa: Life After Communism*. New York: Penguin, 1996. 109-118.

—. "My Father=s Guilt." *Café Europa: Life After Communism*. New York: Penguin, 1996. 143-60.

—. "People from the Three Borders." *Café Europa: Life After Communism*. New York: Penguin, 1996. 160-70.

—. "To Have and To Have Not." *Café Europa: Life After Communism*. New York: Penguin, 1996. 38-46.

—. *How We Survived Communism And Even Laughed*. New York: Norton, 1991.

—. E-mail to the author, 1 Feb. 1999.

—. E-mail to the author, 18 Feb, 1999.

—. E-mail to the author, 19 Jan. 2002

—. *Holograms of Fear*. Trans. Ellen Elias-Barsaic and Slavenka Drakuli . New York: Norton, 1992.

—. "How I Became a Witch: Nationalism, Sexism, and Postcommunist Journalism in Croatia." *Media Studies Journal* 13.3 (Fall 1999): 133-139.

—. "Intellectuals as Bad Guys: The Revolutions of 1989: Lessons of the First Post-Communist Decade." *East European Politics and Societies*, 13.2, (1999): 271-278.

—. *Marble Skin*, Trans. Greg Mosse. New York: Norton, 1994.

— . *S.: A Novel about the Balkans*. Trans. Marko Ivic. New York: Viking, 2000.

—. *They Would Never Hurt a Fly: War Criminals on Trial in The Hague*, New York; Viking, 2004.

—. "Voting Their Fears in Croatia." *New York Times* 21 Jun 1997, A21.

—. "'What=s in a Name?' For People in the Countries of the East, Europe is a State of Mind." *Time International*, Dec 10, 1998: 165.

—. "'We Are All Albanians.'" editorial, *Nation* 07 Jun. 1999: 6.*The Economist (US)*. 311.7599 (April 22, 1989) 16.

Ekiert, Grzegorz. *The State against Society: Political Crises and their Aftermath in East Central Europe*. Princeton, NJ: Princeton UP, 1996.

Eliade, Mircea. *1937-1960, Exile=s Odyssey*. Trans. Mac Linscott Ricketts. Chicago: U of Chicago P, 1988.

Falk, Barbara J. *The Dilemmas of Dissidence in East-Central Europe: Citizen Intellectuals and Philosopher Kings*. Budapest: Central European UP, 2003.

Falkenberg, Betty. "Memories Wrested From Oblivion." Rev. of *A Feast in the Garden*, by George Konrád. *New Leader*. 29 Jun. 1992: 17-9.

Farrell, Thomas. "Practicing the Arts of Rhetoric: Tradition and Invention." *Philosophy and*

Rhetoric 24(1991): 183-212. Rpt. in *Contemporary Rhetorical Theory: A Reader*. Eds, John Louis Lucaites, Celeste Michelle Condit, and Sally Caudill. New York: Guilford, 1999. 79-101.

Featherstone, Mike. "Travel, Migrations and Images of Social Life." *Undoing Culture: Globalization, Postmodernism and Identity*. London: Sage, 1995.

Ferenc, Feher, and Agnes Heller. *Hungary 1956 Revisited: The Message of a Revolution--A Quarter of a Century After*. London: George Allen, 1983.

Foucault, Michel. *The Archaeology of Knowledge and The Discourse on Language*. Trans. A. M. Sheridan Smith. New York: Pantheon, 1972.

—. *Power/Knowledge: Selected Interviews and Other Writings 1972-1977*. Trans. Colin Gordon, Leo Marshall, John Mepham, Kate Soper. Ed. Colin Gordon. New York: Pantheon, 1980.

Frank, Robert Edward. AA Rhetorical History of the 1989 Revolution in the German Democratic Republic: Calling Forth the People.@ Diss. U of Georgia, 1995.

Grigorescu-Pana, Irina. *The Tomis Complex: Exile and Eros in Australian Literature*. Berne: Peter Lang, 1996.

Habermas, Jurgen. "Further Reflections on the Public Sphere." Trans. Thomas Burger, *Habermas and the Public Sphere*. Ed. Craig Calhoun. Cambridge: The MIT P, 1966. 421-62.

—. *The Structural Transformation of the Public Sphere: An Inquiry into a Category of Bourgeois Society*. Trans. Thomas Burger. 8th ed. Cambridge, MA: The MIT P, 1996. 73-79.

Hall, Stuart. "Cultural Identity and Diaspora." *Identity: Community, Culture, Difference*. Ed. J. Rutherford. London: Lawrence & Wishart, 1990. 222-237.

—. "The Formation of A Diasporic Intellectual." *Start Hall: Critical Dialogues in Cultural Studies*. Eds. David Morley and Kuan-Hsing Chen. Routledge: London, 1996. 484-504.

—. "Signification, Representation, Ideology: Althusser and the Post-Structuralist Debates." *Critical Studies In Mass Communication*. 2 (1985): 91-114.

—. "Who Needs Identity?" 1996. *Questions of Cultural Identity*. Eds. Stuart Hall and Paul Du Gay. London: Sage, 1997. 1-18.

Halpert, Martha. "The Fifty-ninth International PEN Congress." *Partisan Review*, 3 (1993): 450-452.

Haraszti, Miklós. *The Velvet Prison: Artists Under State Socialism*. Trans. Katalin and Stephen Landesmann, and Steve Wasserman. New York: Farrar, Straus and Giroux, 1987.

—. "Soft Censorship." *Media Studies Journal*, 13.3 (1999): 78.

Hariman, Robert. "A Boarder in One=s Own House: Franz Kafka=s Parables of the Bureaucratic Style." *Political Style: The Artistry of Power* (Chicago: U of Illinois P, 1995): 141-177.

Harsanyi Doina and Nicolae Harsanyi, "Romania: Democracy and the Intellectuals." *East European Quarterly*, 27.2 (June 1993): 243-261.

Hauser, Gerald A. *Vernacular Voices: The Rhetoric of Publics and Public Spheres*. Columbia, SC: U of South Carolina, 1999.

Havel, Václav. *The Art of the Impossible: Politics and Morality in Practice*. Trans. P. Wilson.

New York: Alfred A. Knopf, 1997.

—. *Summer Meditations*. Trans. Paul Wilson. New York: Vintage, 1993.

—. *Letters to Olga*. Trans. Paul Wilson. New York: Knopf, 1988.

—. "The Power of the Powerless." 1979. Rpt. in *From Stalinism to Pluralism: A Documentary History of Eastern Europe Since 1945*, Ed. Gale Stokes, 2nd ed. New York: Oxford UP, 1996. 168-175.

—. "Words on Words." *Writings on the East: Selected Essays on Eastern Europe from the New York Review of Books*. New York: The New York Review of Books, 1990. 7-21.

Heim, Michael Henry. Translator=s Afterword. *The Melancholy of Rebirth: Essays from Post-Communist Central Europe, 1989-1994*. By George Konrád. San Diego: Harcourt Brace, 1995. 191-96.

Hoffman, Eva. *Lost in Translation: A Life in a New Language*. New York: Penguin Books, 1989.

—. "The New Nomads." *Letters of Transit: Reflections on Exile, Identity, Language, and Loss*. Aciman, André, ed. New York: The New Press, 1999. 35-65.

Ilie, Paul. *Literature and Inner Exile: Authoritarian Spain 1939-1975*. Baltimore: John Hopkins UP, 1980.

Ionesco, Eugène. *Présent Passé Passé Présent*. Paris: Mercure de France, 1968.

Iorgulescu, Mircea. "The Resilience of Poetry." *Times Literary Supplement*, 4529 (January 19, 1990): 61-64.

Ivekovic, Rada. "Women, Nationalism, and War: 'Make Love Not War.'" *Hypatia*, 8.4 (1993): 113-27.

"Jail Time for Croat Journalist." *Editor and Publisher* 2 May 1998: 48.

JonMohamed, Abdul R. "Wordliness-without-World, Homelessness-as-Home: Toward a Definition of the Specular Border Intellectual." *Edward Said: A Critical Reader*. Ed. Michael Sprinker. Cambridge, MA: Blackwell, 1992. 96-121.

Joris, L. "Looking Back at the Melancholic -Revolution, Traveling in Hungary, 1989-1990." *Hungarian Quarterly*, 34.131(Fall 1993):117-125.

Judt, Tony. "Nineteen Eighty-Nine: The End of Which European Era?" *Daedalus* 23.3 (1994): 1-19.

Kadare, Ismail. "We Must Leave This Country." *Icarus* 6 (1992): 59-71.

Kafka, Franz. *The Trial*. Trans. Willa and Edwin Muir. New York: Schocken Books, 1995.

—. Franz Kafka, *The Castle*. Trans.Willa and Edwin Muir. New York: Schocken Books, 1982.

Kakutani, Michiko. "Soul of Croatia Is Bared in Its Teeth." *New York Times* 21 Feb. 1997: C34.

Kaplan, Robert. *Balkan Ghosts: A Journey Through History*. New York: Vintage, 1994.

Keenan, Deborah, and Roseann Lloyd, eds. *Looking for Home: Women Writing about Exile*. Minneapolis: Milkweed, 1990.

Kennedy, Michael. "An Introduction to Eastern European Ideology and Identity in Transformation." *Envisioning Eastern Europe: Postcommunist Cultural Studies*. Ed. Michael D. Kennedy. Ann Arbor: U of Michigan P, 1994. 1-46.

Kenez, Peter. "Antisemitism in Post World War II Hungary." *Judaism: A Quarterly Journal of Jewish Life and Thought*, 50.2 (Spring 2001):144-54.

Kempny, Marian. "Between Tradition and Politics: Intellectuals after Communism." *Intellectuals and Politics in Central Europe.* Ed. András Bozóki. Budapest: Central European UP, 1999. 151-167.

Kirby, Kathleen M. *Indifferent Boundaries: Spatial Concepts of Human Subjectivity.* New York: Guildford P, 1996.

Kiš, Danilo. *Homo Poeticus: Essays and Interviews.* New York: Farrar, Straus, Giroux, 1995.

Klima, Ivan. "Introduction: Writing From the Empire Behind the Wall." Trans. James Naughton. *Description of a Struggle: The Vintage Book of Contemporary Eastern European Writing.* Ed. Michael March. New York: Vintage Books, 1994. xix-xxiv.

—. Interview. "A Conversation in Prague. By Philip Roth." *Writings on the East: Selected Essays on Eastern Europe from the New York Review of Books.* New York: The New Work Review of Books, 1990: 101-132.

Klumpp, James F. "The Rhetoric of Community at Century=s End." *Making and Unmaking the Prospects for Rhetoric.* Eds. Theresa Enos and Richard McNabb. Mahwak, NJ: Lawrence Erlbaum, 1997. 75-83.

—. "A Rapprochement Between Dramatism and Argumentation." *Argumentation and Advocacy* 29 (1993): 148-63.

Koestler, Arthur. *The Heel of Achilles: Essays 1968-1973* New York: Random House, 1974.

Kolankiewicz, George. "Elites in Search of a Political Formula." *Daedalus* 23.3 (1994): 143-57.

Konrád, George. *Stonedial.* Trans. Ivan Sanders. San Diego: Harcourt Brace, 2000.

—. *The Melancholy of the Rebirth: Essays from Post-Communist Central Europe, 1989-1994.* Trans. Michael Henry Heim. San Diego: Harcourt Brace, 1995.

—. "15 March: A Colorful Day." *The Melancholy of the Rebirth: Essays from Post-Communist Central Europe, 1989-1994.* Trans. Michael Henry Heim. San Diego: Harcourt Brace, 1995. 130-36.

—. "Foreword." Miklos Haraszti, *The Velvet Prison: Artists Under State Socialism.* Trans. Katalin and Stephen Landesman, and Steve Wasserman. New York: Farrar, Straus and Giroux, 1987. vii-xiv

—. "Hail and Farewell." *The Melancholy of the Rebirth: Essays from Post-Communist Central Europe, 1989-1994.* Trans. Michael Henry Heim. San Diego: Harcourt Brace, 1995. 181-91.

—. "Hedonists of the Brain." *The Melancholy of the Rebirth: Essays from Post-Communist Central Europe, 1989-1994.* Trans. Michael Henry Heim. San Diego: Harcourt Brace, 1995. 147-52.

—. "The Holiday Looks Back." *The Melancholy of the Rebirth: Essays from Post-Communist Central Europe, 1989-1994.* Trans. Michael Henry Heim. San Diego: Harcourt Brace, 1995. 123-30.

—. "Identity and Hysteria." *The Melancholy of the Rebirth: Essays from Post-Communist Central Europe, 1989-1994.* Trans. Michael Henry Heim. San Diego: Harcourt Brace, 1995. 97-106.

—. "Intellectuals and Domination in Post-communist Societies." *Social Theory in a Changing Society.* Eds. Pierre Bourdieu and J.S. Coleman. Boulder: Westview, 1991. 337-61.

—. "The Melancholy of Rebirth." *The Melancholy of the Rebirth: Essays from Post-*

Communist Central Europe, 1989-1994. Trans. Michael Henry Heim. San Diego: Harcourt Brace, 1995. 40-65.

—. "More Than Nothing: The Role of the Intellectual in a Changing Europe." *The Melancholy of the Rebirth: Essays from Post-Communist Central Europe, 1989-1994*. Trans. Michael Henry Heim. San Diego: Harcourt Brace, 1995. 78-96.

—. "A Self-Introduction." *The Melancholy of the Rebirth: Essays from Post-Communist Central Europe, 1989-1994*. Trans. Michael Henry Heim. San Diego: Harcourt Brace, 1995. vii-x.

—. "Something is Over." *The Melancholy of the Rebirth: Essays from Post-Communist Central Europe, 1989-1994*. Trans. Michael Henry Heim. San Diego: Harcourt Brace, 1995. 69-77.

—. "The Best of Both Worlds: Still Straddling East and West, Berlin Could Become Central Europe=s World-Class City." *Time International*, Nov 15, 1999:19.

—. "On Ivan Szelegnyi=s Birthday." Trans. Katalin Orban. On-line posting. 28 Jan. 1999 < http://www.hi. rutgers.edu/szelenyi60/konrad.htm>.

Konrád, George and Ivan Szelégnyi. *The Intellectuals on the Road to Class Power*. New York: Harcourt, Brace Jovanovich.1979.

Konrád, György. "Antipolitics." *Antipolitics* (1984) 93-4. Rpt. in *From Stalinism to Pluralism: A Documentary History of Eastern Europe Since 1945*. Ed. Gale Stokes, 2nd ed. New York: Oxford UP, 1996. 175-181.

—. *Antipolitics*. Trans. Richard E. Allen. San Diego: Harcourt Brace, 1984.

—. *The Case Worker*. Trans. Paul Aston. New York: Harcourt Brace, 1974.

—. *A Feast in the Garden*. Trans. Imre Goldstein. New York: Harcourt Brace, 1992.

Kristeva, Julia. " New Type of Intellectual: The Dissident." *The Kristeva Reader*. Trans. Sean Hand. Ed. Toril Moi. New York: Columbia UP, 1986.

—. *Strangers to Ourselves*. Trans. Leon S. Roudiez. New York: Columbia UP, 1991.

Kundera, Milan. *Milan Kundera and The Art of Fiction: Critical Essays*. Ed. Aaron Aji. New York: Garland, 1992.

Lepenies, Wolf. "The Future of Intellectuals." *Partisan Review*. 61 (1994): 111-20.

Lipstadt, Deborah. "Anti-Semitism in Eastern Europe Rears Its Ugly Head Again." *USA Today*. (Sept 1993), 122-125.

Lukes, Steven. "Principles of 1989: Reflections on Revolution." *Revolutions in Eastern Europe and the U.S.S.R.: Promises vs. Practical Morality*. Ed. Kenneth W. Thompson. Lanham: UP of America, The Miller Center Series, 1995. 149-65.

Manea, Norman. *On Clowns: The Dictator and the Artist*. New York: Grove, 1992.

Makine, Andrei. *Dreams of My Russian Summers*. Trans. Geoffrey Strachan. New York: Simon and Schuster, 1995. 223-26.

Marin, Noemi. "Eastern European Exile and its Contemporary Condition." *Migration: A European Journal of International Migration and Ethnic Relations*, 33/34/35 (2002): 155-71.

—. "The Rhetoric of Andrei Codrescu: A Reading in Exilic Fragmentation." *Realms of Exile: Nomadism, Diasporas ans Eastern European Voices,* Ed. Domnica Radulescu. Lanham: Rowman and Littlefield , 2002. 87-107.

—. "Slavenka Drakulic: Dissidence and Rhetorical Voice in Postcommunist Eastern Europe."

East European Politics and Societies, 15.3 (2002): 678-697.

Markovich, Stephen C. "Democracy in Croatia: Views From the Opposition."@ *East European Quarterly*, 32 (1998): 83-94.

Matvejevic, Predrag and Vidosav Stevanovic. "Between Asylum and Exile." Interview with Jasmina Sopova, *UNESCO Courier* 50.4 (1997): 4-8.

Melzer, Arthur M., Jerry Weinberger, and M. Ruchard Zinman, eds. *The Public Intellectual: Between Philosophy and Politics.* Lanham: Rowman and Littlefield, 2003.

Michnik, Adam. "Gray Is Beautiful.," *The Public Intellectual: Between Philosophy and Politics.* Eds. Melzer, Arthur M., Jerry Weinberger, and M. Ruchard Zinman, Lanham: Rowman and Littlefield, 2003. 177-189.

—. *Letters from Freedom: Post-Cold War Realities and Other Perspectives.* Ed. Irina Grudzi|ska Gross. Berkeley: U of California P. 1998.

—. *Letters from Prison and Other Essays.* Trans Maya Latynski. Berkeley: U of California P, 1985.

—. "What We Want to Do and What We Can Do." *Telos* 47 (1981): 67.

Milosz, Czeslaw. *The Captive Mind.* Trans. Jane Zielonko. New York: Vintage, 1981.

Minh-ha, Trinh T. "Not You/Like You: Post-Colonial Women and The Interlocking Questions of Identity and Difference." *Making Face, Making Soul: Creative and Critical Perspectives by Women of Color.* Ed. Gloria Anzaldua. San Francisco: Aunt Luie Foundation Books, 1990. 371-75.

Mungiu, Alina. "Romanian Political Intellectuals before and after the Revolution." *Intellectuals and Politics in Central Europe.* Ed. András Bozóki. Budapest: Central European UP, 1999. 73-101.

Munif, Abdelrahman. "Exile and the Writer." *Critical Fictions: The Politics of Imaginative Writing.* Ed. Philomena Mariani. Seattle: Bay P, 1991. 108-11

McAdams, Michael C. *Croatia Myth and Reality: The Final* Chapter. Arcadia, CA: CIS Monographs, 1997.

—. "C. Michael McAdams Responds to Michiko Kakutani=s New York Review of Slavenka Drakulic=s *Ghost of Communist Past.*" *The Zajednicar* 9 Apr. 1997.

McGee, Michael Calvin. "The >Ideograph=: A Link Between Rhetoric and Ideology." *Quarterly Journal of Speech* 66 (1980): 1-16.

—. "Text, Context, and the Fragmentation of Contemporary Culture." *Western Journal of Speech Communication* 54 (1990): 274-90.

McKerrow, Raymie E. "Critical Rhetoric: Theory and Praxis." *Communication Monographs* 56 (1989): 91-111.

McQuade, Molly. "Andrei Codrescu: A Not-So-Prodigal Son Returned to Revolution in Romania, and Wrote a Book about It." *Publishers Weekly,* 238.23 (May 24, 1991): 39-41.

Nelson, Daniel B. "Romania." *The Legacies of Communism in Eastern Europe.* Zoltan Baranyi and Ivan Volgyes, Eds. Baltimore: The John Hopkins UP, 1995. 198-227.

Nico, Israel. "Tropics of Exile: Conrad, Adorno, Rushdie." Diss. Yale U, 1995.

Pacepa, Ion Mihai. *Red Horizons: The True Story of Nicolae and Elena Ceau∏escu=s Crimes, Lifestyles, and Corruption.* Washington, D.C.: Regnery Gateway, 1987.

Papastergiadis, Nikos. *Modernity as Exile: The Stranger in John Berger=s Writing.*

Manchester, UK: Manchester UP, 1993.

APrizes,@ *World Literature Today* 65 (1991): 782.

Partisan Review 59.4 (1992). Special Issue: Intellectuals and Social Change in Central and Eastern Europe.

Radulescu, Domnica, ed. *Realms of Exile: Nomadism, Diasporas and Eastern European Voices,* Lanham, MD: Rowman and Littlefield Press-Lexington Series, 2002.

Radhakrishnan, R. *Diasporic Mediations: Between Home and Location.* Minneapolis: U of Minnesota P, 1996.

Robbins, Bruce. *Secular Vocations: Intellectuals, Professionalism, Culture.* London: Verso, 1993.

Robertson, George, et al., Eds. *The Traveller=s Tales: Narratives of Home and Displacement.* London: Routledge, 1994.

Robinson, Marc, ed. *Altogether Elsewhere: Writers on Exile.* San Diego: Harcourt Brace, 1994.

Rosteck, Thomas. Introduction. *At the Intersection: Cultural Studies and Rhetorical Studies.* Ed. Thomas Rosteck. New York: Guilford P, 1999.1-25.

Rose, P. I. "Thoughts about Refugees and Descendants of Theseus." *International Migrations Review* 15 (1981): 9-13.

Rosenberg, Tina. *The Haunted Land: Facing Europe=s Ghosts After Communism.* New York: Random, 1995.

Roth, Philip. "A Conversation in Prague." *Writings on the East: Selected Essays on Eastern Europe from the New York Review of Books.* New York: The New Work Review of Books, 1990: 101-132.

Said, Edward W. "Reflections on Exile." *Altogether Elsewhere: Writers on Exile.* Ed. Marc Robinson. San Diego: Harcourt Brace, 1994. 137-50.

—. "Representing the Colonized: Anthropology=s Interlocutors." *Critical Inquiry* 15 (1989): 205-25.

—. *Representations of the Intellectual: the 1993 Reith Lectures.* New York: Pantheon, 1994.

Sakharov, Andrei. "Our Understanding of Totalitarianism." *Towards a New Community: Culture and Politics in Post-Totalitarian Europe.* Eds. Peter J. S. Duncan and Martyn Rady. London: U of London, 1993.

Sarup, Madan. *Identity, Culture, and the Postmodern World.* Ed. Tasneem Raja. Athens, GA: U of Georgia P, 1996. 46-67.

Shain, Yossi. *The Frontier of Loyalty: Political Exiles in the Age of the Nation-State* Middleton, CT: Wesleyan, 1989.

Shelley, Percy Byshe. *The Complete Poetry of Percy Byshe Shelley.* Eds. Donald H. Reiman and Neil Fraistat. Baltimore: John Hopkins UP, 2000.

Simon, Janos. "Post-Paternalist Political Culture in Hungary: Relationship Between Citizens and Politics During and After the >Melancholic Revolution= (1989-1991)." *Communist and Post-Communist Studies,* 26.2 (June 1993):226-239.

Skilling, Gordon H. *Samizdat and an Independent Society in Central and Eastern Europe.* Columbus: Ohio State UP, 1989.

Smith, Anna. *Julia Kristeva: Readings of Exile and Estrangement.* New York: St. Martin=s P, 1996.

Smith Auerbach, Irena."The Question of Their Speech: Plotting Exile in the Life and Work of Henry James and Vladimir Nabokov." Diss. U of California, Los Angeles, 1995.

Solzhenitsyn, Aleksandr I. *The Gulag Archipelago, 1918-1956: An Experiment in Literary Investigation.* Trans. Thomas R. Whitney. New York: Harper and Row, 1974.

Sontag, Susan. Introduction. *Homo Poeticus: Essays and Interviews*, by Danilo Kiš. New York: Farrar, Straus, Giroux, 1995. vii-xv.

Sorkin, Adam J. "The Paradox of the Fortunate Fall: Censorship and Poetry in Communist Romania." *The Literary Review*, 45.14 (Summer 2002): 886-912.

Sprinker, Michael, ed. *Edward Said: a Critical Reader.* Cambridge, MA: Blackwell, 1992.

Steiner, George. "Introduction." Franz Kafka, *The Trial.* Trans. Willa and Edwin Muir. New York: Schocken Books, 1995.: vii-xxi.

Stokes, Gail, ed. *From Stalinism to Pluralism: A Documentary History of Eastern Europe since 1945.* New York: Oxford UP, 1991.

Tanner, Marcus. *Croatia: A Nation Forged in War.* New Haven: Yale UP, 1997.

Tismaneanu, Vladimir. "Fighting for the Public Sphere: Democratic Intellectuals under Postcommunism." *Between Past and Future: The Revolutions of 1989 and Their Aftermath.* Eds. Sorin Antohi and Vladimir Tismaneanu. Budapest: Central European UP, 2000: 153-75.

—. *Fantasies of Salvation: Democracy, Nationalism, and Myth in Post-Communist Europe.* Princeton : Princeton UP, 1998.

—. "Hole in the Flag." Rev. of *The Hole in the Flag: A Romanian Exile=s Story of Return and Revolution*, by Andrei Codrescu. *Orbis*, 35 (1991): 623.

—. "Knowing and Doing." *Village Literary Supplement.* 10 (1995): 15-18.

—. *Reinventing Politics: Eastern Europe from Stalin to Havel.* New York: Free P, 1992.

Turner, Victor. *From Ritual to Theatre: The Human Seriousness of Play.* New York: PAJ, 1982.

Ugresi , Dubravka. *The Culture of Lies: Antipolitical Essays.* Trans. Celia Hawkesworth. University Park: Pennsylvania State UP, 1998.

Vladislav, Jan. "Exile, Responsibility, Destiny." *Literature in Exile.* Ed. John Glad. Durham: Duke UP, 1990. 14-28.

Verdery, Katherine. *National Identity Under Socialism: Identity and Cultural Politics in CeauȚescu=s Romania.* Berkeley: U of California P, 1991.

Zamfir, Mihai. Foreword. *History and Legend in Romanian Short Stories and Tales.* Trans. Ana Cartianu. Bucharest: Minerva, 1983. i-xix.

Zagajewki, Adam. *Partisan Review*, 59.4 (1992): 690.

INDEX

McGee, Michael Calvin, 29n.46, 70n.114,
70n.116, 7–100, 112n.126–
129,113n.131, 113n.132, 139, 164
McKerrow, Raymie, 29n.48,54, 55, 109n.82
Michnik, Adam, ,13, 24n.1, 25n.16, 31, 33,
58, 60n.4, 61n.13,166, 167n.12,172n.6
Milosz, Czeslav, 8n.6, 101n.2
Mungiu, Alina, 76, 102n.10, 103n.22

Pacepa, Mihai Ion, 113n.134
Perlmutter, Andrei, 76
Poland
–KOR, 4
–Orange Initiative, 4

Rosteck, Thomas, 7, 12n.33

Said, Edward, 8n.9,17, 17n.23,
26n.21,26n.22,71n.124, 71n.126,
71n.128, 73, 101n.3, 111n.109, 125,
167n.7
Sakharov, Andrei, 25n.17, 60n.4
Solzhentsyn, Aleksandr, 2, 8n.6
Soviet Union, 4, 43
Steiu, Andrei, 103n.19

Tanner, Marcus, 119,
146n.15,147n.21,152n.91
Tismaneanu, Vladimir, 4, 8n.4, 9n.16,
25n.13, 25n.15, 31, 60n.6, 60n.9,
62n.17, 68n.81, 70n. 111, 105n.37,
106n.42, 144n. 1–2
Tudjman, Franjo, 18,120, 122, 171
Tzara, Tristan, 93

Ugresic, Dubravka, 6, 117, 120, 122, 145n.4,
147n.22,148n.37

Verdery, Katherine,25n.17,60n.6, 62n.21,76
Vladislav, Jan, 10n.18, 61n.15

Zagakewski, Adam, 169, 172n.1
Zamfir, Mihai, 108n.66